C000231078

British Military Panoramas: Battle in the Round, 1800-1914

Ian F. W. Beckett

 Helion & Company

Helion & Company Limited
Unit 8 Amherst Business Centre
Budbrooke Road
Warwick
CV34 5WE
England
Tel. 01926 499 619
Email: info@helion.co.uk
Website: www.helion.co.uk
Twitter: @helionbooks
Visit our blog at blog.helion.co.uk

Published by Helion & Company 2022
Designed and typeset by Mary Woolley (www.battlefield-design.co.uk)
Cover designed by Paul Hewitt, Battlefield Design (www.battlefield-design.co.uk)

Text © Ian F. W. Beckett 2022
Images © as individually assigned

Cover: 'Study of Yvon's Battle of Ulundi Panorama' (1881). (National Army Museum, London, with permission)

ISBN 978-1-915113-84-9

British Library Cataloguing-in-Publication Data.
A catalogue record for this book is available from the British Library.

For details of other military history titles published by Helion & Company Limited contact the above address or visit our website: http://www.helion.co.uk.

We always welcome receiving book proposals from prospective authors.

Contents

List of Illustrations

Abbreviations

ASKB: Anne S. K. Brown Military Collection
BL: British Library
BM: British Museum
BOD: Bodleian Library
CUL: Cambridge University Library
CWAC: City of Westminster Archives Centre
EXBD: Bill Douglas Cinema Museum
GL: Guildhall Library
GRI: Getty Research Institute
JJC: John Johnson Collection
LMA: London Metropolitan Archives
NAL: National Art Library
NAM: National Army Museum
NLS: National Library of Scotland
RC: Royal Collections
UKTC: University of Kent Theatre Collection
V&A: Victoria and Albert Museum
YCBA: Yale Center for British Art

Preface

I first encountered a 360° panorama painting in 1964 on my first overseas holiday. We were returning from what was, for the family, a pioneering three-week camping expedition to the south of France in those days before package holidays had really taken off. There were so relatively few British cars on continental roads that any encounter was an occasion for waving and horn honking. My interest in military history was already strong and we came back through Belgium en route to visit Dunkirk, from which my father had been evacuated with the rest of the British Expeditionary Force in 1940. It was at Waterloo, therefore, that I saw Louis Dumoulin's 1912 panorama. It made a striking impression.

Over the years, I visited other panoramas in Europe and North America, but it was only some 15 years ago, when I was fortunate enough to be speaking on one of the now vanished and much lamented Swan Hellenic cruises that the then national chairwoman of the National Association of Decorative and Fine Arts Societies (NADFAS) suggested that I apply to speak to their branches. I am not an art historian and demurred until she pointed out the truly eclectic range of subjects catered for by the organisation. The cruise in question was to the Black Sea. As usual, I had taken passengers on a tour of the Crimean War battlefields including a visit to Franz Roubard's 1905 panorama of the defence of Sebastopol against the allied armies, as well as the modern large-scale diorama of the Soviet attack on Sebastopol in 1944, the lower exterior terrace of which afforded an excellent view over the 1854 battlefield of Balaclava. It seemed, therefore, that panoramas would make a suitable subject for NADFAS, now known as the Arts Society.

I have continued, as it were, to collect panoramas on my travels and this study of British nineteenth century military panoramas is the result. At an early stage, I contacted Peter Harrington from the splendid Anne S. K. Brown Military Collection at Brown University, Providence, Rhode Island, who I had known since teaching at the US Naval War College, Newport, Rhode Island in 1992-93. In enquiring after the collection's holdings, it transpired that Peter, the author of an important study on British military art, also had a particular interest in panoramas and had spoken on the subject to the one of the annual meetings of the International Panorama Council. I wish to record his invaluable assistance with this project. I am also grateful for the assistance of Glyn Prysor, Robert Mclean, Robert Fleming, Penny Hutchins and Amy English of the National Army Museum,

Clair Waller of the Theatre Collection of the University of Kent, Francis Gotto of the University of Durham Sudan Archive, Courtney Matthews of the Library of Congress, Dr Phil Wickham of the Bill Douglas Cinema Museum at the University of Exeter, Guy Baker and Wendy Hawke of the London Metropolitan Archives, Mark Lynch of the National Portrait Gallery, Niki Russell of the University of Glasgow Library, Julie-Anne Lambert of the Bodleian Library, Jane Muskett of Chetham's Library, Freya Levett of the Victoria & Albert Museum, Laura Callery of the Yale Center for British Art, Andrew Moore of the University of Sheffield Special Collections and Archives, Barbara Seebald of the Munich City Archives, Rory Lalwan of Westminster City Archive, Philippine de Beauregard of Notre Dame de France à Londres, and Michael Mallinson from the Fleischer Omdurman Panorama Restoration Project at Peebles. In 2005, I was given the chance by the general manager, Gerard Bony, to view the remaining hidden fragments of Ernst Fleischer's Omdurman panorama at the Peebles Hotel Hydro, where parts of Fleischer's Bannockburn panorama are more prominently displayed. Quotations from the Royal Archives appear by gracious permission of His Majesty the King.

Thanks are also due to Duncan Rogers and Dr Christopher Brice at Helion.

Introduction

Originating in Britain in the 1780s, 360° panorama paintings - or cycloramas as they were known in the United States - represented a vehicle not only for mass popular entertainment, but also a means of exposing the wider public to art. The panorama was extremely popular in the first half of the nineteenth century and, after a revival, in the last quarter of the nineteenth century. It is thought that over 300 large-scale panoramas were painted worldwide in the course of the nineteenth century, and that as many as 100 million people worldwide may have viewed one between 1870 and 1900.[1] Not only do a surprisingly large number of (mostly late) nineteenth century examples survive, but they are also still being produced in many parts of the world. From the beginning, battle was a popular panorama subject. Readers may be familiar with those at Gettysburg (1884); Atlanta (1887); Lucerne (1881), representing the internment of Charles-Denis Bourbaki's French army in Switzerland in 1871; Wroclaw (1894), commemorating the 1794 Battle of Racławice between Tadeusz Kòsciuszko's Polish insurgents and the Russians; Innsbruck (1896), depicting the 1809 Battle of Bergisel between Andreas Hofer's Tyrolean insurgents and French and Bavarian forces; Prague (1897), showing the 1434 Battle of Lipany between the Protestant Hussites and Imperial Catholic forces; Sebastopol (1905); Borodino (1912); and Waterloo (1912).

Modern military examples tend to be in Russia, China, and North Korea. They are also to be found at Plevnen in Bulgaria (1977), representing the 1877 Turkish defence of Plevna against the Russians; Heliopolis near Cairo (1988), showing the 1973 Egyptian crossing of the Suez Canal in the Yom Kippur War; and Istanbul (2009), depicting the Ottoman capture of Constantinople in 1453. Saddam Hussein commissioned one depicting the Arab victory against the Persians in 637 AD, which opened in Baghdad in 1978. More recently, one of the 'Battle of the Nations' in 1813 was displayed in Leipzig in 2013-15. As befitting the country where the panorama phenomenon began, battle panoramas were just as popular in Britain. There are parts of two late nineteenth century survivals at Peebles, whilst contemporary photographs exist for both these two and another late panorama no longer extant.

1 Bernard Comment, *The Painted Panorama* (New York: Harry Abrams Publishers, 1999), p.66.

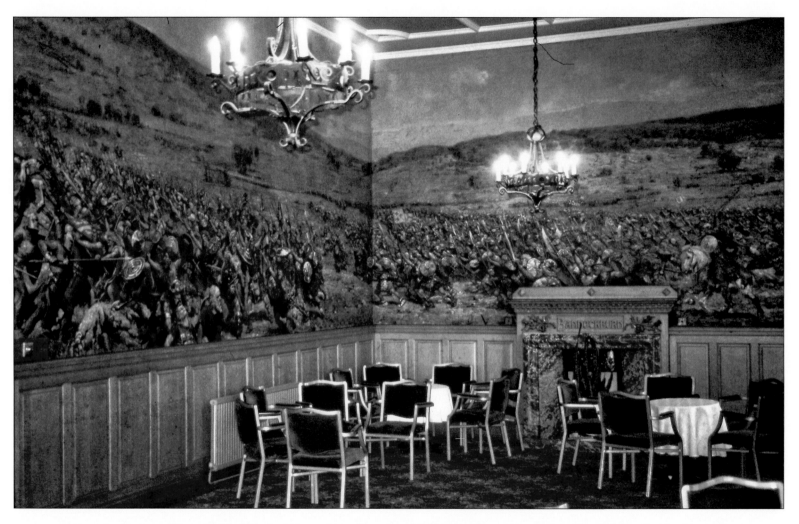

Surviving sections of Ernst Phillip Fleischer's Bannockburn Panorama (1888) in the Dining Room of the Hotel Hydro, Peebles. [Author]

1

The Panorama Phenomenon

Typically, a panorama was displayed in a rotunda, and was approached through a darkened corridor, the viewer ascending some kind of staircase (often a spiral one) and emerging onto a platform at the centre of the scene. It was usually lit from above and, by the late nineteenth century, often had a *faux terrain* - false terrain - at the bottom to suggest even more that the foreground blended into the painting. A description of the lower gallery of the celebrated Leicester Square double rotunda from 1860 conveys well the nature of a panoramic presentation,[1]

> As the principle of construction and arrangement is the same in all, it will suffice to describe it as developed in the lowest and largest room. The circular picture here is ninety feet in diameter, and is about ten thousand square feet in area. The circular stage from which it is viewed is thirty feet in diameter, so that the painting is on all sides at a distance of thirty feet from the eye of a spectator standing at the circumference of the stage. The light is admitted from a skylight, which is concealed from view by a canopy that overhangs the stage. The vast area of canvas is suspended from a hoop at the top of the apartment, about three hundred and eighty-three feet in circumference. Over this hoop it is tightly strained, the lower extremity of the canvas being attached to a similar hoop below, and heavily weighted... The canvas, when strained in the manner described, owing to its elasticity, necessarily bulges, assuming in some degree the form of a sail distended by the wind. The consequence of this, that the horizon of the picture, which is level with the eye of the spectator, is in fact the point nearest to him; while the objects in the foreground - that is at the lower part of the picture - are at the greatest distance from his eye. The tendency of this defect is obviously to diminish the illusion, which would manifestly be greater if the foreground were nearer to the eye, and the distance more remote... It might be supposed that these pictures, placed as they are for exhibition at a distance of thirty or forty feet from

1 'Panoramas', *Chambers Journal* 13 (1860), pp.33-35, at pp.33-34.

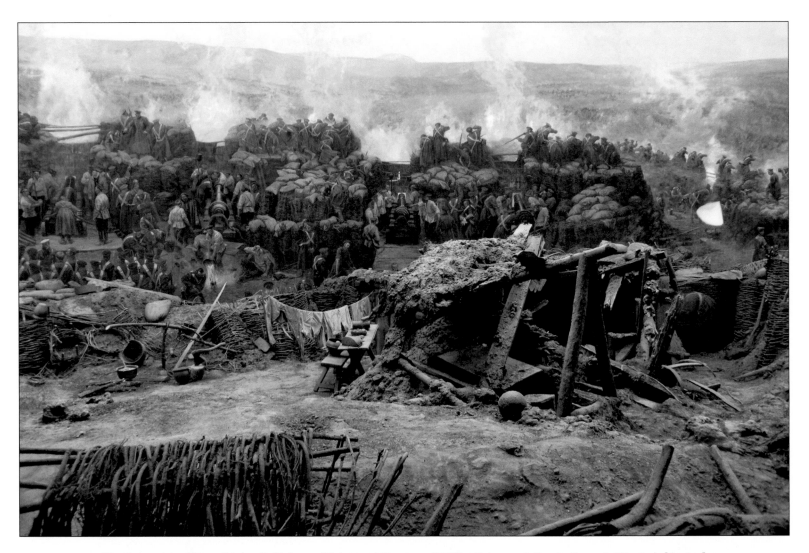

The *faux terrain* of Franz Roubard's Defence of Sebastopol Panorama (1905) at Sebastopol, Russia (formerly Ukraine). [Author]

the spectator, have been somewhat roughly and coarsely painted. The fact, however, is just the reverse. The canvas used for the purpose is of the very finest description that is manufactured… The more important parts of the panorama are painted with pencils of the finest sable, so delicate as to make lines as fine as a hair, each of which, however, is perceptible by the eye of the spectator. Zinc-white is used instead of lead, and the oils employed are of the purest quality that can be manufactured.

While tongue in cheek, *Punch* described something of the sensation of visiting a panorama of the Charge of the Light Brigade at Balaclava (25 October 1854) at the Royal London Panorama in 1881,[2]

Turnstiles to right of them, Turnstiles to left of them, Go the Six Hundred Thousand! - at a shilling a head. The entrance to the Panorama is suggestive of something between a heathen temple (with turnstiles), a theatre, a music-hall, a church (with turnstiles, of course), and a mausoleum. You are not allowed to go straight before you, but have at once to turn to the left and descend… After the first twenty steps there is a refreshment-stall, apparently let into the wall. Here a military person, in uniform, with medals, was regaling himself… At the bottom of the steps there are two passages open before you, one to "the right of them" and one to "the left of them." …I suspect that the veteran who I passed on the landing above ought to be here prepared to receive visitors. In the absence of this distinguished sentinel from his post, take the left and you'll choose right. Along tortuous passages, until, if you happen to be alone, you are about to give up finding the Panorama at all, and are beginning to feel like a Babe in the Wood without the other babe, then you come upon a heavy oriental curtain, which you lift nervously under the impression that you have lost your way, and wandered somehow out of the Panorama into a Turkish bath… You lift the curtain; you pass beyond the mystic veil'; you ascend - thank heaven, at last you ascend! - and far off - up above you a voice is heard, shrilly and clearly, "Book of the Panorama, Six-*pence*! Panorama and Guide, "Six-*pence*!" Then another voice adds, "This way down; this way down" - and blessing your stars that there is at least one sweet little cherub who sits aloft to keep watch for the visitor, you cheer up and reach the top - only to see nothing at all, except a lot of people crushing against some other obstacle, and looking at something which you hope is the Charge of Balaclava… Go straight before you, elbow everyone out. Here you will be edged in with several other people with elbows as energetic and powerful as your own, and here you will have to remain until you fight your way to another position. Take care your hat is not knocked off into the sham battle-field…But for all this - 'tis a clever picture, and - there's money in it.

2 *Punch*, 23 Apl. 1881.

The novelty of the experience in the 1790s can be imagined and panoramas proved immensely popular. Not surprisingly for such a popular art form, the art critics did not consider panoramas art at all but a means of satisfying, as the French writer on art and architecture, Quatremère de Quincy, put it in 1823, 'the pleasure of the senses, [which is] the only one in truth that vulgar people demand of the arts and, moreover, the only one they will receive'.[3] That had been a widely view held in certain quarters. Hester Piozzi, the writer and lexicographer, suggested in 1794 that panoramas were 'a mere deception, *ad captandum vuigus*' (to ensnare the vulgar).[4] It should be noted, however, that de Quincy and Piozzi were members of metropolitan literati. A shilling was well beyond the pockets of the labouring classes, and the barbs were aimed at the aspirant 'middling sort'. Having said that, Fanny Anne Burney, a great niece of the novelist, was told by one panorama operator in 1840 that, whilst few 'mechanicals' visited, the Waterloo panorama then being shown at Leicester Square was an exception: 'That was a *national* subject, and was sure to interest all ranks.'[5] Interestingly, however, de Quincy suggested in 1837 that compared to even large-scale conventional battle paintings, to capture the essence of battle, 'only the vast and special expanse of the panorama can suffice'.[6]

Whilst recognising the technical difficulties, the critics tended to see them as a mechanical reproduction rather than artistry per se. John Constable, for example, believed that a panorama was 'without the pale of art because its object is deception' in the sense that 'real' art was not intended to trick the viewer into believing they were looking at reality.[7] Battle painting generally was equally regarded as falling short of 'high art', its principal proponents in Britain failing regularly to be recognised by election as Royal Academicians.[8]

On the other hand, both Charles Dickens and John Ruskin believed panoramas were educational in broadening the horizons of those who would otherwise never see such distant sights.[9] Ruskin characterised the Leicester Square panorama as 'an educational institution of the highest and purest value and ought to have been supported by the Government as one of the most beneficial school instruments in London'.[10] What was termed 'rational

3 Comment, *Painted Panorama*, p.116.
4 Hester Piozzi, *British Synonymy: or An attempt at regulating the choice of words in familiar conversation* 2 vols. (London: G. G. & J. Robinson, 1794), vol I, p.163.
5 Margaret Rolt (ed.), *A Great-Niece's Journals: being Extracts from the Journals of Fanny Anne Burney (Mrs Wood) from 1830 to 1842* (London: Constable & Co., 1926), pp.307-08.
6 Katie Hornstein, 'Episodes in Political Illusion: The Proliferation of War Imagery in France, 1804-56', Unpub. PhD, Michigan, 2010, p.203.
7 Ralph Hyde and Scott Wilcox, *Panoramania! The Art and Entertainment of the 'All-Embracing' View* (London: Trefoil Publications for the Barbican Art Gallery, 1988), p.28.
8 Joany Hichberger, *Images of the Army: The Military in British Art, 1815-1914* (Manchester: Manchester University Press, 1988), pp.68-71.
9 Comment, *Painted Panorama*, p.64, 86-87.
10 John Ruskin, *Praeterita: Outlines of Scenes and Thoughts* 2 vols. (London: George Allen, 1886), vol I, p.200.

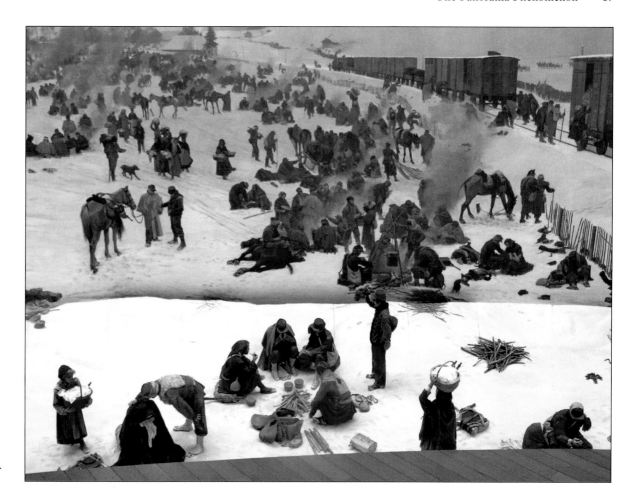

The *faux terrain* of Édouard Castries's Bourbaki Panorama (1881) at Lucerne, Switzerland. [Author]

entertainment' - that with an 'improving' educational or instructional focus - was certainly seen as preferable to less salubrious entertainment in public houses, beer halls, 'gin palaces', cheap dancing rooms, fairgrounds, and traveling freak, peep, and waxwork shows. One of Robert Barker's early advertisements for Leicester Square in 1801 stressed that he 'was determined to spare no expense or trouble to bring forward scenes of useful information as well as gratifying amusement…'.[11]

Few ordinary Britons in the nineteenth century would ever have the opportunity to see European, let alone world cities. Until the *Illustrated London News* was first published in 1842 - it had no rivals until *The Illustrated Times Weekly Newspaper* was published between 1855 and 1872, and then *The Graphic* from 1869 and *Black and White* from 1891- there were few means by which the public at large could really envisage world events. Even after the 1840s, the periodicals 'not only triggered a fascination in particular subjects but also offered the raw material with which to create panoramas. And it offered the same subjects but in striking colour.'[12] It was also history without complication for, unlike much of the art displayed at the Royal Academy, 'panoramas did not require a classical education; they had no allegorical allusions to decide, no mythological figures to identify'.[13]

There was another advantage, as noted by *Blackwood's Magazine* after viewing a panorama of Pompeii at Leicester Square in 1824,[14]

> What cost a couple of hundred pounds and half a year a century ago, now costs a shilling and a quarter of an hour. Throwing out of the old account the innumerable miseries of travel, the insolence of public functionaries, the roguery of innkeepers, the visitations of banditti, charged to the muzzle with sabre, pistol, and scapulary, and the rascality of the custom-house officers, who plunder, passport in hand, the indescribable *désagréments* of Italian cookery, and the insufferable annoyances of that epitome of abomination, an Italian bed.

As an art form, panoramas presented particular problems in transferring flat sketches into a cylindrical form and adjusting horizontals to compensate for distortions.[15] The spherical shape of a suspended canvas with a bulge in the vertical centre meant that a line drawn directly on the canvas would appear curved from a distance. Corrections were required, with an emphasis on avoiding perspective divergences. Invariably, topographical sketches

11 *Morning Chronicle*, 21 Apl. 1801.
12 Peter Harrington, 'Entertaining Battles: Panoramas of War in Victorian Britain', in Gabriele Koller (ed.), *The Panorama in the Old World and the New* (Amberg: Buero Wilhelm Verlag, 2010), pp.64-69.
13 Elisa Milkes, 'A Battle's Legacy: Waterloo in Nineteenth Century Britain', Unpub. PhD, Yale, 2002, p.370.
14 Stephan Oettermann, *The Panorama: History of a Mass Medium* (New York: Zone Books, 1997), p.113.
15 *The Panorama Phenomenon: The World Round* (Den Haag, NL: Panorama Mesdag, 2006), pp.15-17, 27-28.

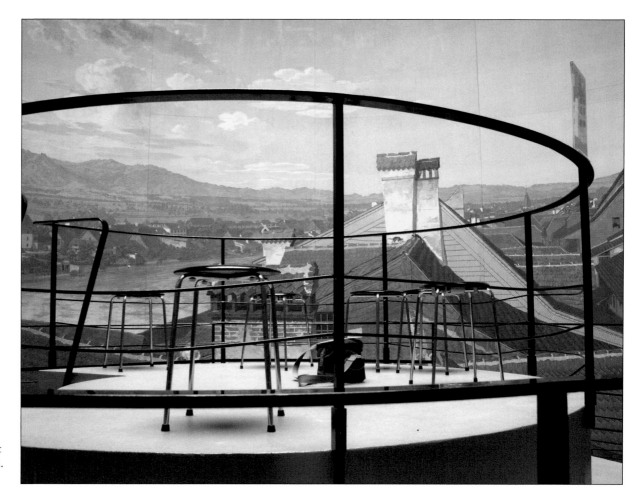

The small scale of early panoramas is evident from this photograph taken across the viewing platform of the Wocher Panorama (1814) at Thun, Switzerland – the oldest surviving example in the world. [Author]

The exterior of the 1895 rotunda at Paul Philippoteaux's Jerusalem Cyclorama (1882) at Ste-Anne-de-Beaupré, Quebec. [Author]

were made, which required travel to the location in question.[16] In the case of battle scenes, testimony was sought from witnesses. Later, photographs could be used rather than field sketches.

The first panoramas were rarely more than 40' in diameter so that the viewer was very close to the canvas. Marquand Wocher's panorama of the town of Thun in Switzerland painted in 1814, and the oldest surviving example in the world, has a diameter of 37'. It is still lit by natural light. There could be a sense of dizziness as a result of being so close to the canvas. It was said that Queen Charlotte felt sea sick when visiting Robert Barker's panorama of the Fleet at Spithead in May 1793. [17] By the 1860s a standard size evolved for ease of interchange between rotundas of between 40'and 60' high, and around 400' long. It meant that completed canvasses were extremely heavy. Wooden panorama buildings had also given way to often elaborate iron-frame constructions. By the late nineteenth century, there were also specialised commercial companies - many based in Brussels - trading in panoramas and transporting them around Europe or further afield. They were usually rolled up in crates, often five or six tons in weight. Not all such companies survived, a number going bankrupt or failing to raise capital in the first place.

Typically, later panoramas were produced by teams working in studios on tracked tiered platforms using a grid system under the direction of a lead artist. Theodore Davis, who had sketched the American Civil War (1861-65) for *Harper's Weekly*, advised the artists on the production of the Battle of Atlanta Panorama. His article, 'How a Great Panorama is made', published in 1886, provides a comprehensive guide to the methods of the later nineteenth century battle panorama artists. It was a complex process. Considerable research was required on the action with all available sources, illustrations, and photographs consulted before a visit to the field. A commanding point would be chosen for sketches, perhaps using a specially constructed platform. The outline having been decided, a 'composition' would be prepared by stretching a 40' x 5' canvas on a frame, overlaid with white drawing paper, on which a charcoal sketch of the whole would be roughed out. This would then be converted into a pen and ink drawing, with the charcoal dusted off and totally removed by rubbing the paper with bread crumbs. The drawing would be divided into a square grid. The drawing would then be traced and transferred to a small canvas of the same size, equating to one tenth the scale of the actual panorama. The principal artist would then indicate degrees of colour, light and shade on this 'dummy'. The large studios would have a stock of uniforms and weaponry available and hired models would be posed to perfect the figures. Wooden frames were used for those posing as if mounted. The actual full size canvas would be hung in the studio with its circular iron track and 'cars' of different heights. It would be primed and sized and a base of 'whiting' - white lead and oil - applied. The 'dummy' would have been photographed and projected on to the canvas to the size required.

16 Henry Aston Barker's papers in the National Library of Scotland are disappointing from the perspective of researching battle panoramas, but testify to his travels in the south of England and more especially, to Paris, Athens, and Constantinople. See National Library of Scotland (hereafter NLS), MS. 9647-9653.

17 'The Panorama with memoirs of its inventor, Robert Barker, and his son, Henry Aston Barker', *Art Journal*, Feb. 1857, p.47.

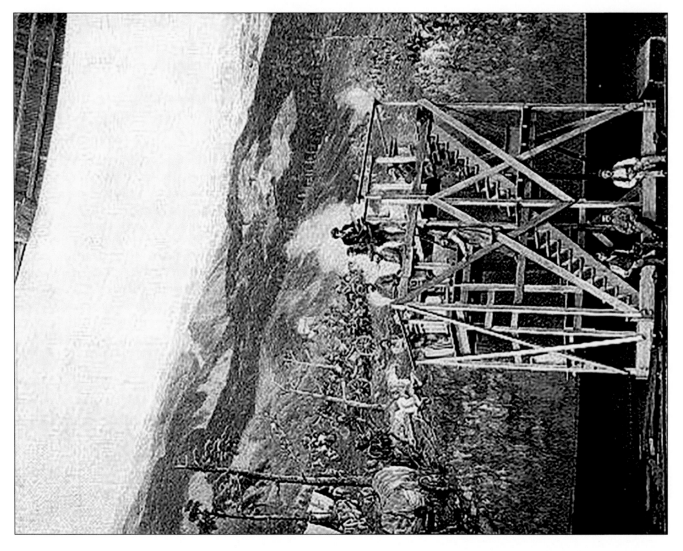

Panorama artists at work from Theodore Davis, 'How a Great Panorama is Made', *St Nicholas* 14 (Dec. 1886), pp. 99-112, at p.105.

Within a panorama team, some would specialise in landscape or sky, some in trees and other vegetation, some on horses or other animals, and some on figures. More often than not, the number of figures projected on the canvas from the study would be too few and would need to be substantially supplemented. Once the canvas was completed, it would be rolled on a spool for transportation to the rotunda, where the *faux terrain* would have already been constructed. All the time, maintenance of perspective was paramount, this also applying to the *faux terrain* which had to conform to the perspective of the whole. Davis told the story of an old woman visiting a European panorama of the Battle of Sedan (1-2 September 1870) who climbed over the railings on to the *faux terrain* and looked like 'Gulliver's wife among the Lilliputians'. On returning to the platform amid much laughter, she exclaimed, 'Oh, my! How they do grow when you get back, away from them.'[18]

As they were represented as a genuine reproduction of reality, panorama accuracy was demanded. This was particularly so in battle panoramas in terms of weapons and uniforms as veterans would often turn up with friends and family to recount their role in great events.[19] Nonetheless, creating battle scenes was not the same as achieving accuracy in the depiction of a city or a landscape. Weapons and uniforms were one thing but the action quite another, especially if this was of an historical rather than a contemporary nature.

Invariably, there was a focus on one particular moment. Many panoramas devoted to Waterloo (18 June 1815), for example, tended to highlight the climatic repulse of Napoleon's Imperial Guard. However, the canvasses would almost always incorporate other dramatic incidents that had achieved wider public recognition in the received version of a battle. An illusion would be created of an overall form and pattern to the event rarely apparent to participants. Even if witnesses were interviewed, their perspective would be limited. The Duke of Wellington famously suggested that the history of a battle 'is not unlike the history of a ball! Some individuals may recollect all the little events of which the great result is the battle won or lost; but no individual can recollect the order in which, or the exact moment at which, they occurred, which makes all the difference as to their value or importance.'[20] It has been suggested that the overall impression of a panorama - not least the size - would be sufficient to fit in with fallible memories of visiting veterans.[21]

18 Theodore Davis, 'How a Great Panorama is Made', *St Nicholas* 14 (Dec. 1886), pp.99-112, at p.111.
19 Comment, *Painted Panorama*, p.129.
20 Wellington to Croker, 8 Aug. 1815, in Colonel John Gurwood, *The Dispatches of Field Marshal the Duke of Wellington* 2nd edn., 8 vols. (London: Parker, Furnivall & Parker, 1844-47), VIII, pp.231-32.
21 Michael Kutzer, 'Researching the Battlefield: How Exact was the Panorama Painters' Work?' in *More Than Meets the Eye: The Magic of the Panorama* (Amberg: Büro Wilhelm Verlag, 2019), pp.144-49.

There is no evidence that visitors to any British military panoramas whilst they were being painted were able to pay for a soldier to bear their likeness as happened with at least one American Civil War panorama in the United States in the 1880s.[22] Preparation might be less extensive than advertised, press and artists alike having an interest in verifying the amount of work undertaken 'to elevate the importance and the value of their paintings'.[23] The topography would be right and the positions of units accurate enough, but much of the canvas would be filled inevitably with invented details.

Battle panoramas were also likely to be sanitised, death often distant, with the enemy 'receiving the brunt of the violence'.[24] A former rifle volunteer in Britain who had become a member of the Bechuanaland Border Police noted in the aftermath of the attack on a Matabele (Ndebele) position in November 1893, 'I seemed to have seen it all in a panorama somewhere, especially when I looked at the dead Kaffirs on the ground.'[25] Moreover, whilst platforms (and, later, foreground) contributed to the illusion, there was no sound and no movement. Occasionally, there might be a moving platform or a narration. More usually, there were guidebooks, explanatory plans, or diagrams in the form of anamorphic drawings provided for the audience. These invariably had a numbered key identifying particular points or individuals. Thus, whilst presenting a composite view of a battle, the panorama would suggest a certain sequence in which images were to be viewed rather than haphazardly, although not necessarily suggesting any particular logic.[26] The events, however, would have been familiar to the audience from the press so that this would not have been a drawback. They would have expected to see key moments and personalities in a dramatic representation of the news.

It was also often possible to purchase small souvenir reproductions rolled in a tube. In most cases, it is these descriptive keys and guides that have survived for British examples of the art form although, as indicated earlier, there are contemporary photographs of three panoramas from the late nineteenth century. Panoramas themselves were notoriously prone to fire and damp. In a sense they were ephemeral and could be discarded when paying customers ceased to visit. Many were simply cut up.

It is suggested that the early battle panoramas helped condition the British public to accept an imperial message and 'to see themselves as participants in the countless linkages and networks being established between the metropolis and the wider world'.[27] Whilst Britain was to emerge from the Revolutionary and Napoleonic Wars (1793-1815) as an unchallenged global power, the consciousness of empire at that point was somewhat

22 Kutzer, 'Researching the Battlefield', p.148.
23 Ibid.
24 Harrington, 'Entertaining Battles', pp.64-69.
25 *Volunteer Service Gazette and Military Gazette*, 6 Jan. 1894.
26 Alison Griffiths, '"Shivers Down Your Spine": Panoramas and the Origins of the Cinematic Re-enactment', *Screen* 44 (2003), pp.1-37, at pp.14-15.
27 Denise Oleksijczuk, *The First Panoramas: Visions of British Imperialism* (Minneapolis, MN: University of Minnesota Press, 2011), p.3.

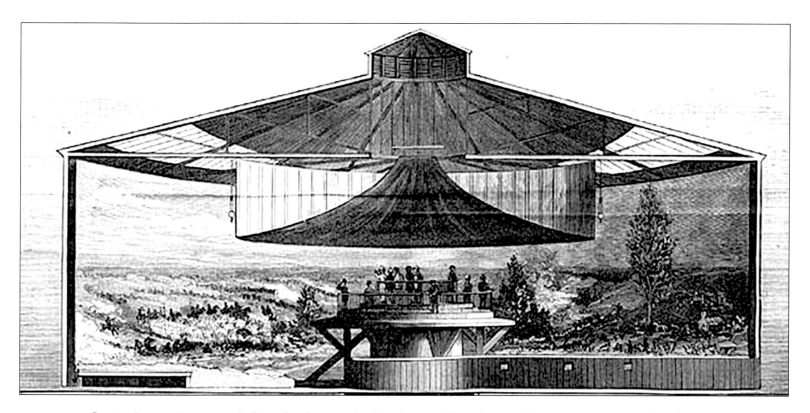

Section showing the viewing platform of an American battle cyclorama, 6 November 1886 from *Scientific American* 55 (1886), p.287.

less than it was to become later in the nineteenth century. In that respect, it has been argued that, whilst they might arouse patriotic feelings, the military panoramas were more 'about the thrill of a powerful reality effect, combined with the drama of military action'. Viewers were mostly 'expecting powerful emotions'.[28] The immersive experience of battle panoramas always provided their audience with a sense of vicarious participation in great events and stepping into history. Placed at the centre of events, the audience's emotions were channelled towards the celebration of national triumph. That would only increase with imperial expansion so that panoramas were an essential but now largely forgotten component in the wider projection of imperial ideology within British popular culture.

28 Hélène Ibata, 'The Orient at Leicester Square: Virtual Visual Encounters in the First Panoramas', in Hélène Ibata, Caroline Lehni, Fanny Moghaddassi, and Nader Nasiri-Moghaddam (eds), *Geographies of Contact: Britain, the Middle East and the Circulation of Knowledge* (Strasbourg: Presses Universitaires de Strasbourg, 2017), pp.191-204, at p.196.

2

The Development of the Panorama

The first patent for what became known as panoramas was acquired in June 1787 by Robert Barker (1739-1806), an Irish miniaturist based in Edinburgh, for what he called 'la nature à coup d'oeil', literally nature at a glance: [1]

> By the invention called La Nature a Coup d'Oeil, [it] is intended, by drawing and painting and proper disposition of the whole, to perfect an entire view of any country or situation as it appears to an observer turning quite around; to produce which effect the painter or drawer must fix his station, and delineate correctly and connectedly every object which presents itself to his view as he turns around, concluding his drawing by a connection with where he began. He must observe the lights and shadows how they fall, and perfect his piece to the best of his abilities. There must be a circular building or framing erected, on which this drawing or painting may be performed; or the same may be done on canvas or other materials, or fixed or suspended on the same building or framing to answer the purpose compleat [sic]. It must be lighted entirely from the top, either by a glazed dome or otherwise, as the artist may think proper. There must be an enclosure within the said circular building or framing, which shall prevent an observer going too near the drawing or painting, so as it may, from all parts it can be viewed, have its proper effect. This enclosure may represent a room or platform, or any other situation, and may be any form thought most convenient, but the circular form is particularly recommended, of whatever extent this inside enclosure may be. There must be over it, supported from the bottom or suspended from the top, a shade or roof, which in all directions should project so far beyond this enclosure as to prevent an observer seeing above the drawing or painting, when looking up. And there must be without this enclosure another

1 Robert Barker, 'Specification of Mr Barker's Patent for displaying Views of Nature at large, by Oil-Painting, Fresco, Water-Colours, etc.', *The Repertory of Arts and Manufactures* Vol. IV (London: Lowndes, Robinson, Elmsly, Richardson, Debrett, and Bell, 1796), pp.165-67; Hyde and Wilcox, *Panoramania*, pp.17-21; Oettermann, *Panorama*, pp.98-105.

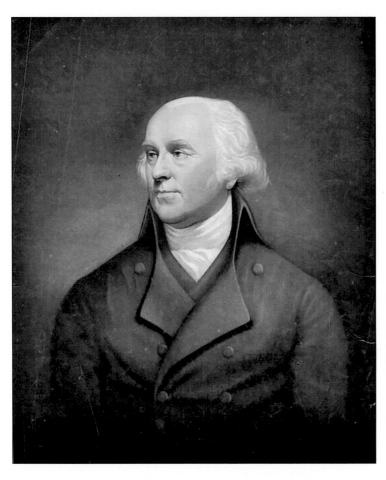

Robert Barker (1739-1806), after J. Singleton. [National Portrait Gallery, London]

interception to represent a wall, paling, or other interception, as the natural objects represented, or fancy may direct, so as effectually to prevent the observer from seeing below the bottom of the drawing or painting: by means of which interception nothing can be seen on the outer circle but the drawing or painting intended to represent nature. The entrance to the inner enclosure must be from below, proper building or framing being erected for that purpose, so that no door or other interruption may disturb the circle on which the view is to be represented. And there should be below the painting or drawing proper ventilators fixed, so as to render a current circulation of air through the whole, and the inner enclosure may be elevated at the will of an artist, so as to make the observers, on whatever situations he may wish they should imagine themselves, feel as if really on the spot.

Artists had executed panoramic but flat representations of landscape long before Barker. There was, for example, Sebald Beham's contemporary six part woodcut of the siege of Vienna of 1529-30 which fitted together to provide an unusual 360° bird's eye view in the manner of the anamorphic guides produced for panoramas.[2] Barker's conception, however, was an entirely new means of artistic expression and display.

2 James Clifton and Leslie Scattone, with Emine Fetvacaı, Ira Gruber and Larry Silver, *The Plains of Mars: European War Prints, 1500-1825 from the Collection of the Sarah Campbell Blaffer Foundation* (New Haven, CT: Yale University Press with the Museum of Fine Arts, Houston, 2009), p.43.

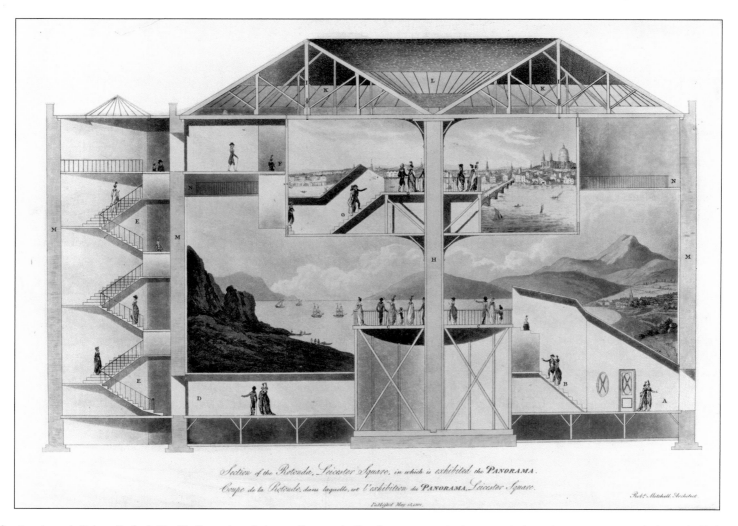

Section through Robert Barker's Double Rotunda at Leicester Square, the London panorama in the upper circle, and a marine view in the lower, by Robert Mitchell (May 1801). [British Museum Images/The Trustees of the British Museum]

Barker opened a temporary wooden rotunda in Castle Street, Edinburgh and displayed a semi-circular 180° painting of the city in distemper as viewed from Calton Hill, charging 3s.0d entrance. It was immediately successful, and Barker took it to London in 1789 to display in another temporary rotunda in the Haymarket. It was in June 1791 that the term panorama was first applied by Barker in his advertisements. In 1792 he exhibited a second semi-circular panorama, this time of the view of London from the roof of the Albion Mills, just south of Blackfriars Bridge, moving to another temporary rotunda in Charing Cross. Barker had greater ambitions and, on 14 May 1793, he opened a new permanent double rotunda in Cranbourn Street just off Leicester Square to exhibit his new 360° view of London in the upper gallery. It was coupled in the lower gallery with a view - the first in oils - of the fleet at Spithead, including 36 ships of the line, where it had been collected for the so-called 'Russian Armament' of 1791. This was to be an abortive threatened retaliatory foray into the Baltic when British access to the port of Ochakov was endangered by the Russians during the Russo-Turkish War (1787-91). As suggested earlier, the lower circle at Leicester Square was 90' in diameter: it was 57' high.

Robert Barker died in 1806 and the business was taken over by his son, Henry Aston Barker (1774-1856). Another son, Thomas Edward Barker, who was not himself an artist, had opened a rival double rotunda to that of his father in Surrey Street off the Strand in partnership with the artist, Ramsay Reinagle (1775-1862), in 1802. Reinagle later claimed he had invented the panorama at the age of ten![3] Robert Barker's patent expired in 1801, which may have led to his son beginning his rival attraction. The patent, however, was for 360° panoramas so there were soon other rotundas in the 'Great Room' at No 5 Spring Gardens off St James's, and at the Lyceum, its entrance in the Strand opposite what is now Lancaster Place, offering 180° canvasses. Other rotundas appeared subsequently in many provincial centres including Aberdeen, Birmingham, Dublin, Edinburgh, Glasgow, Liverpool, and Manchester. Charles Halkerston's painting of Princes Street, Edinburgh from The Mound in 1843, for example, shows the rotunda operated by Messrs. Marshalls, which is advertising a (presumably moving) panorama of Waterloo.[4] Very quickly, the panorama phenomenon spread to Europe and to the United States. By the late nineteenth century, it had also extended to Australasia and Japan.

Thomas Barker sold out to his brother and John Burford in December 1816, the Strand rotunda closing in 1831 and becoming the Strand Theatre on what is now the site of Aldwych Tube Station. In turn, Henry Aston Barker, who married a daughter of Captain William Bligh, sold the Leicester Square rotunda in 1826 to John Burford and his son, Robert. John Burford died that same year, but Robert Burford (1791-1861) continued to operate Leicester Square until he died in 1861. His son, Robert William Burford continued for a while until Leicester Square was finally closed in December 1863. To some extent Leicester Square was eclipsed in later years by the Colosseum [sic] in Regent's Park, which opened in 1829, although the latter's panorama of London as seen from the bell tower of St Paul's Cathedral went unchanged throughout its existence.

3 Royal Academy, Clausen Mss, CL/3/1, Reinagle to unknown recipient, 22 Mar. 1847.
4 Edinburgh City Art Centre, CAC7/1982.

The interior of Notre Dame de France, the former Leicester Square Rotunda. [Notre Dame de France à Londres/Gary Heiss]

Panoramas were less popular by mid-century and the Leicester Square rotunda was purchased by the Catholic Church for the French community in London in the 1880s as Notre Dame de France. It was blitzed in 1940, but was restored in 1953, and retains the form of the original rotunda, the modern entrance in Leicester Place. The Colosseum, meanwhile, closed in 1864 and was demolished in 1875, just before a major revival in the panorama business. Driven in Europe by nationalism and in the United States by interest in the American Civil War, major studios in Belgium and Germany thrived at least until the eve of the Great War. In Britain the revival saw new rotundas opened including the Royal London Panorama on the site of the former Saville House in Leicester Square in 1881. It was followed that same year by others at the Crystal Palace, Alexandra Palace, and in York Street, Westminster (later the National Panorama and the Niagara Hall) opposite St James's Park underground station. The latter was designed by W. E. Riley. The Grand National Panorama opened in Ashley Place, Victoria behind the Army and Navy Stores in a building designed by Emeric Tyler in 1889. Earls Court also hosted panoramas including, in 1899, the Feszty panorama (1894), which depicts the arrival of the Magyars in what was to become Hungary in 896 AD and is now exhibited at Opusztaszer in Hungary.[5] Similarly, rotundas opened anew in Edinburgh, Glasgow, and Manchester. By 1914 the rotundas had gone. Niagara Hall became an ice rink in 1895, and was later used simply as a garage.

5 Plans for the Westminster and Ashley Place rotundas can be found in the London Metropolitan Archives (hereafter LMA), GLC/AR/BR/14/018; GLC/AR/BR/22.BA/000151, 000981, 001262, and 003320. Petitions by residents opposed to the Ashley Place rotunda are in GLC/AR/BR/22/BA/005850. Licences for the Crystal Palace panorama are at CPT/045/A-C. Plans for the panorama building at Earls Court are in LCC/AR/TH/02/036.

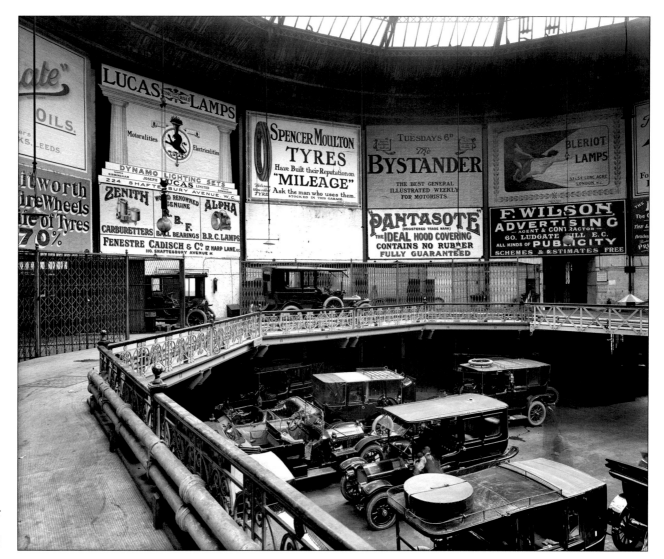

The Westminster Panorama (later Niagara Hall) as a garage for the Wolseley Tool and Motor Car Company, 31 May 1913. [Historic England]

3

The Barkers and their Rivals

Robert Barker was quick to understand the attraction of battle scenes alongside contemporary views of distant cities and lands. The naval victory of Admiral Lord Howe off Ushant - the Glorious First of June (1 June 1794) - was featured at Leicester Square in 1795, although, somewhat surprisingly, also Admiral Hood's inconclusive action at Groix (23 June 1795) in 1796. Nelson's victories at the Nile (1 August 1798), Copenhagen (2 April 1801), and Trafalgar (21 October 1805) were all celebrated. [1] Nelson met Henry Aston Barker in Palermo in 1799, and thanked him for the role of the Nile panorama in keeping the victory in the public's eye. Subsequently, Nelson viewed the Copenhagen panorama in May 1802, pronouncing it 'the most correct picture of any event I have ever seen'. [2]

 A version of Robert Barker's Trafalgar panorama by William Heath (1794-1840), just 10'6" in diameter and 32' long, and dating from around 1820, is thought to be a small scale promotional attraction from a print shop. It is held in the National Maritime Museum, but is too fragile to be displayed. [3] After Trafalgar, naval subjects were far less frequent, although Henry Aston Barker produced panoramas of the Anglo-Dutch bombardment of Algiers (27 August 1816), designed to help supress the operations of Barbary pirates in enslaving Europeans. Similarly, Robert Burford displayed panoramas of the Battle of Navarino (20 October 1827), and the bombardment of St Jean d'Acre (3 November 1840). [4] The subject of the first was the

1 Bodleian Library (hereafter BOD), John Johnson Collection (hereafter JJC), Entertainments 6 (59-65).
2 Oettermann, *Panorama*, pp.109-10; Richard Altick, *The Shows of London* (Cambridge MA: Belknap Press, 1978), p.137.
3 Margarette Lincoln (ed.), *Nelson and Napoleon* (London: National Maritime Museum, 2005), pp.260-61; National Maritime Museum, PAJ3938.
4 University of Kent Theatre Collection (hereafter UKTC), Lennox-Boyd Panoramas, 41, *Battle of Navarin. Grand New Peristrephic Panorama*, and 54, *A Description of the Panorama of the Destruction of Algiers* (London, 1826); British Library (hereafter BL), 014577893/014610380/014595178: *Description of a view of the bombardment of St Jean d'Acre, with the surrounding country, now exhibiting at the Panorama, Leicester Square* (London: Nichols, 1841); also in National Art Library (hereafter NAL), 200.B.271; Guildhall Library (hereafter GL), S PAM 211; GRI, N7436.52.17 A37; and Yale Center for British Art (hereafter YCBA), DP361. B8.

Robert Ker Porter (1777-1842), engraving by Thomas Woolnoth, after George Henry Harlow
(1822). [The Bill Douglas Cinema Museum, University of Exeter]

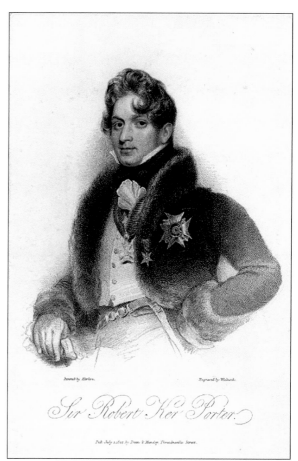

destruction of the Ottoman combined Turkish and Egyptian fleet by a joint British, French, and Russian squadron, thereby effectively ensuring Greek independence. The second was a combined British, Austrian, and Ottoman operation to compel the independently minded and ambitious Pasha of Egypt, Muhammed Ali, to renounce claims to Crete and the Hijaz in return for Ottoman recognition of his rule in Egypt and the Sudan.

The only battle panorama produced in Britain after 1918 was the 180° panorama of Trafalgar (1928) by the marine artist, William Lionel Wylie (1851-1931) now displayed at the Royal Naval Museum in Portsmouth. Wylie was apparently inspired by viewing Dumoulin's 1912 panorama at Waterloo. His work was intended primarily to raise funds for the restoration of Nelson's flagship, HMS *Victory*. [5]

Despite the prominence of the Leicester Square rotunda, it was actually the rival rotunda in the Lyceum that featured the first British military as opposed to naval panorama. This was 'The Great Historical Picture of the Storming of Seringapatam', a 180° painting, 21' high and 120' long covering 2,550 sq. ft. of canvas, by the Scottish artist, Robert Ker Porter (1777-1842). A friend of Henry Aston Barker and a pupil of Benjamin West, and aged only 19, Porter supposedly completed the work in situ in just six weeks. [6]

Henry Angelo, a well-known fencing master (like his father), was taken to a Royal Academy dinner by the engraver, James Heath. Heath pointed Porter out to Angelo 'at the same time mentioning the yards of paint intended to be employed in his Siege of

5 Valerie Billing, *The Panorama of the Battle of Trafalgar* (Portsmouth: Royal Naval Museum, 2002), pp.7-11.
6 Altick, *Shows of London*, p.135.

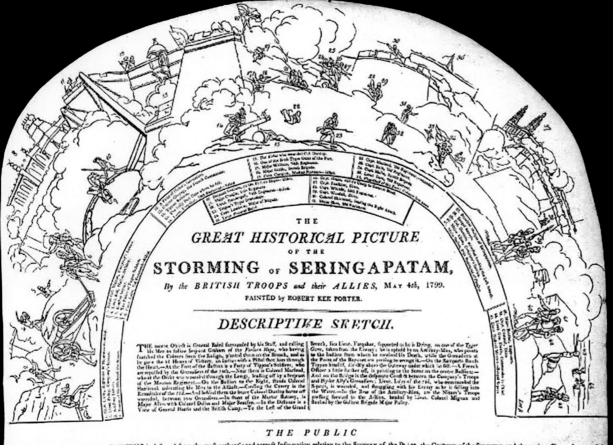

Descriptive Sketch of Porter's Storming of Seringapatam Panorama (1800). [The Bill Douglas Cinema Museum, University of Exeter]

Seringapatam'. The youthful Porter struck Angelo more a *petit maître* than an artist fit to undertake such work. But what was my surprise and gratification when I saw his panorama!'[7] Similarly, Porter's mentor, Benjamin West, described the painting as 'a wonder in the art; a work of such dimensions, finished throughout, in a brevity of time which any other man would demand even to sketch out his design'.[8] In reality, Porter was assisted by another aspiring young artist, the 14 year old William Mulready, who later enjoyed success as an artist in his own right. Seringapatam was exhibited from April 1800 to January 1801. Mulready painted many of the figures.

Tipu Sahib (Fateh Al Tipu) of Mysore and his father, Haidar Ali, had long been thorns in the side of Britain's East India Company, Haidar having sided with the Company's French rivals. French influence on the sub-continent was greatly eroded during the Seven Years War (1756-63), but Haidar and Tipu remained French allies. Mysore proved a formidable enemy through three successive Anglo-Mysore Wars (1767-69, 1780-84, and 1790-92). Indeed, Haidar inflicted a major defeat on Company forces including the 73rd Highlanders at Pollilur in September 1780, taking over 200 European captives. Haidar Ali died in 1781 and Tipu was forced to give up two of his sons as hostages in 1792 as a result of his defeat in the third conflict. News of Tipu's formal alliance with the French in 1798 resulted in a further British declaration of war in February 1799. The fall of Tipu's fortress at Seringapatam (Sriringapatna) and his death on 4 May 1799 were widely celebrated in artistic and theatrical terms.[9] Ironically, Tipu had equally commemorated his father's victory at Pollilur in a series of murals at his summer palace in the city, the Dariya Daulat Bagh, which the British subsequently characterised as grotesque and lacking in perspective compared to their own artistic celebrations of victory.[10]

Porter's Seringapatam proved immensely popular. As at Leicester Square, admission was 1s.0d. The bibliographer, Thomas Frognall Dibdin, recalled in his memoirs the profound impression Porter's canvas had on him,[11]

It was as a thing dropt from the clouds - all fire, energy, intelligence, and animation. You looked a second time, the figures moved, and were commingled in hot and bloody fight. You saw the flash of cannon, the glitter of the bayonet, the gleam of the falchion. You longed to

7 Henry Angelo, *Reminiscences of Henry Angelo: With Memoirs of His Late Father and Friends.* 2 vols. (London: Henry Colburn & Richard Bentley, 1830), II, pp.109-10.
8 'Recollections of the late Sir Robert Ker Porter', *The Athenaeum*, 25 Mar. 1843, pp.289-90.
9 Peter Harrington, *British Artists and War: The Face of Battle in Paintings and Prints, 1700-1914* (London: Greenhill Books, 1993), pp.55-64; Daniel O'Quinn, *Staging Governance: Theatrical Imperialism in London, 1770-1800* (Baltimore, MD: John Hopkins University Press, 2006), pp.312-48.
10 Janaki Nair, 'Tipu Sultan, History Painting and the Battle for "Perspective"', *Studies in History* 22 (2006), pp.97-143.
11 Thomas Frognall Dibdin, *Reminiscences of a Literary Life* 2 vols. (London: John Major, 1836), I, pp.146-47.

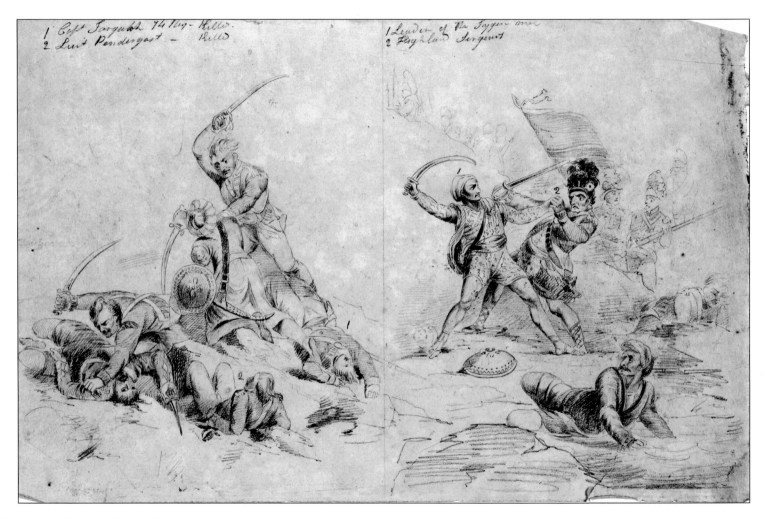

Preliminary Sketch for Porter's Seringapatam, depicting to the left, Captain James Farquhar and Lieutenant James Prendergast, who were both killed, and to the right, a Highland Sergeant fighting 'the leader of the Tyger men' (1800). [Library of Congress]

be leaping from crag to crag with Sir David Baird, who is hallooing his men on to victory! Then, again, you seemed to be listening to the groans of the wounded and the dying - and more than one female was carried out swooning.

As was common with all early battle panoramas, as made clear by the 'descriptive sketch' provided as a key, several incidents were depicted as a continuous narrative. The roles of prominent officers such as Baird, and the death or wounding of others such as Sergeant Graham of the Bombay (European) Regiment, who led the forlorn hope, were highlighted: 'The centre Object is General Baird surrounded by his Staff, and calling his Men to follow Serjeant Graham of the *Forlorn Hope*, who having snatched the Colours from the Ensign, planted them on the Breech, and as he gave the 3d Huzas of Victory, an Indian with a Pistol shot him through the Heart.' Tipu was shown on the battlements, but the sally port where his body was found was also pointed out.[12]

In addition to the descriptive key, a separate guide to the Mysore campaign with 'Notes, Descriptive and Explanatory, Collected from Authentic Materials' was also sold in conjunction with the exhibition of Porter's canvas for 1s.6d. The notes had been collected 'to assist the design, and regulate the execution' of the painting. The 'fate of European possession on the plains of Hindostan' hung on the campaign. The action's outcome in overthrowing 'one of the most powerful tyrants of the east' was 'as complete and as just a revolution, as can be found on the records of history'. It would also usher in 'such an increase of revenue, resource, commercial advantage, and military strength to the British establishment in India, as must for years to come ensure a happy and prosperous tranquillity, not only to the Company's possessions, but to the native principalities, and to millions of inhabitants on the fertile plains of Hindostan'.[13] The lengthy booklet of over 130 pages, including the order of battle, the list of those killed and wounded, and the descriptive key, was published in at least five editions. As a preface, it featured a fairly lurid image of a hand-to-hand combat between a man of the 74th Highlanders and one of Tipu's guards, adapted and much magnified from an incident depicted on the canvas below the

12 Victoria and Albert Museum (hereafter V&A), E.572-1926; National Army Museum (hereafter NAM), 1961-12-428; BL, 002962815/002962816: *The Grand Historical Picture of the Storming of Seringapatam by the British troops and their allies, May 4th, 1799. Painted By R. K. Porter* (Hull, 1800); BL, no reference number: *Descriptive sketch of the Storming of Seringapatam, as exhibited in the great historical picture painted by Robert Ker Porter* (Edinburgh, 1800); YCBA, Folio A 2016 3h: *The Grand Historical Picture of the Storming of Seringapatam by the British troops and their allies, May 4th, 1799: painted by Robert Ker Porter* (Manchester: Shelmerdine, 1800); BOD, JJC , Entertainments 7 (17) and (19), anamorphic plan; University of Exeter, Bill Douglas Cinema Museum, Ralph Hyde Collection (hereafter EXBD), 100062, printed advertisement.

13 BL, 016140559, 016859832, 016860384, 002587862 002597863, 002597864, 002597865: *Narrative Sketches of the Conquest of the Mysore, effected by the British Troops and their Allies, in the Capture of Seringapatam, and the Death of Tippoo Sultaun, May 4, 1799 with Notes, Descriptive and Explanatory, Collected from Authentic Materials* (London: Justins, 1800; Edinburgh, 1801; Bath: McGye, 1803; Hull: W & M Turner, 1804).

figure of Graham. The booklet also detailed the treasures captured at Seringapatam. It cost Porter £220 to exhibit the canvas but he made a profit of £1,202.14s.7½d whilst it was at the Lyceum.

It has been suggested that the 'emotional centre' of Porter's Seringapatam was less Baird and his staff than Graham's sacrifice and that of a number of junior officers seen wounded or dying. It anticipated a shift in the emphasis of British battle art from commanders to at least junior officers and some NCOs, the depiction of, and focus upon, the ordinary soldier becoming a common theme by the 1850s. Suffering was also a theme of Porter's subsequent correspondence arising from his visit to observe the Peninsular War (1808-14) published as *Letters from Portugal and Spain* (1809). There are differing interpretations as to whether Porter's Seringapatam made death meaningful in a national cause to its audience in a way that shielded it from the realities, or whether it furnished individuals with sensations that the mind might otherwise repress. This tends to be discussed in terms of the perceived influence of early nineteenth century romanticism upon cultural forms, although it is by no means clear how far ordinary viewers of the panorama would have necessarily interpreted it in this light. Generally, it is argued, Porter helped shape war as a media spectacle, but one also allowing the audience 'to visualise and imagine war from the vantage point of the soldier and his subjective experience of war'.[14]

Certainly, a contemporary description of the painting laid a great deal of emphasis upon those depicted such as Captain Cormick (Madras Pioneers) 'killed near the upper part of the rampart', Captain Owen (77th Foot) 'who points towards the Indian from whom he received his death wound', Captain Macleod (73rd Foot) 'who being wounded in the lungs, is conducted off the ground', Lieutenant Colonel Dunlop (77th Foot) 'wounded and borne off between two grenadiers', and Captain Lardy (Swiss Regiment de Meuron) 'binding his wounded arm, in order that he may rejoin the storming party'. Thus, it would 'prove a gratifying promise to the perspective of military prowess, that the names and persons of the most distinguished of Valour's sons, will live to after ages in the glowing colours of the canvas, as well as in the annals of their country'.[15]

14 Mary Favret, *War at a Distance: Romanticism and the Making of Modern Wartime* (Princeton, NJ: Princeton University Press, 2010), pp.217-19; Philip Shaw, *Suffering and Sentiment in Romantic Military Art* (Farnham: Ashgate, 2013), pp.26-29; Neil Ramsey, 'Horrid Scenes and Marvellous Sights: The Citizen-Soldier and Sir Robert Ker Porter's Spectacle of War', *Romanticism on the Net* 46 (2007) at https://www.erudit.org/en/journals/ron/2007-n46-ron1782/016132ar/
15 'Sir Robert Ker Porter', *Public Characters of 1800-1801* (Dublin: J. Moore, 1801), pp.137-41, at pp.140-41.

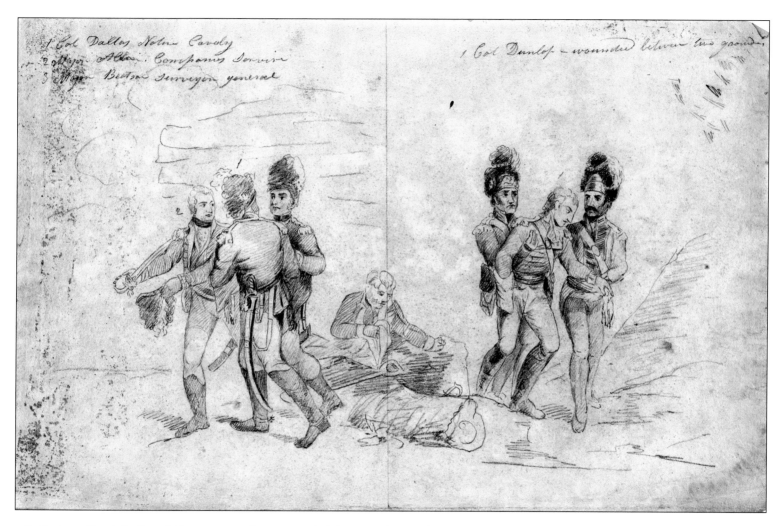

Preliminary Sketch for Porter's Seringapatam, depicting to the left in consultation, Colonel Thomas Dallas, Major Alexander Allan, and Major Alexander Beatson, and on the right, the wounded Colonel James Dunlop being assisted by two grenadiers (1800). [Library of Congress]

Porter appears to have drawn on the testimony of the two officers - Majors Alexander Allan and Alexander Beatson - who carried the despatches of the Governor-General of India to London.[16] The landscape of Seringapatam, however, was well known from artistic depictions from the three earlier Anglo-Mysore Wars.[17]

The canvas was displayed subsequently in Belfast, Bury St Edmunds, Chester, Cork, Dublin, Edinburgh, Glasgow, Liverpool, Plymouth, and Tavistock. An anonymous Dublin diarist was particularly taken when the canvas was displayed in a building specially erected for it on College Green. It had engaged 'the attention of everyone here' and sales of the accompanying booklet were substantial. Whilst noting the depiction of events and admiring the shading, perspective and foreshortening, the diarist was struck most by the 'rich and fanciful dresses of the East, the curious and magnificent architecture of their Mosques and Zenanas, and other novelties in European eyes' that rendered it 'more interesting'.[18] Exhibited in Dublin just six months after the Act of Union with Britain and three years after the Irish Rebellion (1798), Porter's canvas - and similar exhibitions in Ireland - may have served to reinforce union in artistic terms, granting the Irish a 'participatory role' in imperial victories.[19]

The East India Company declined to purchase the canvas, and plans to send it to India did not materialise.[20] Instead, it seems to have been sent to Philadelphia in 1805. Back in Britain, it was shown at Bristol in 1825 and at Nottingham in 1827 before falling victim to fire in a London warehouse.[21]

A series of three prints of the Seringapatam canvas - together some nine feet long - were engraved from oil sketches by John Vendramini between January 1802 and January 1803 under the patronage of the Commander-in-Chief of the Madras Army, Lieutenant General George Harris, who had held ultimate responsibility for the campaign.[22] They sold for six guineas a set. Porter showed the central print to King George III, to whom

16 Pauline Rohatgi, 'From Pencil to Panorama: Tipu in Pictorial Perspective', in Anne Buddle (ed.), *The Tiger and the Thistle: Tipu Sultan and the Scots in India, 1760–1800* (Edinburgh: National Gallery of Scotland, 1999), pp.39-55, at p.52.

17 Rosie Dias, 'Memory and the Aesthetics of Military Experience: Viewing the Landscape of the Anglo-Mysore Wars', *Tate Papers* 19 (2013) at https://www.tate.org.uk/research/publications/tate-papers/19/memory-and-the-aesthetics-of-military-experience-viewing-the-landscape-of-the-anglo-mysore-wars.

18 Royal Irish Academy, MS 24K14, quoted in Fintan Cullen, 'Union and Display in Nineteenth Century Ireland', in Dana Arnold (ed.), *Cultural Identities and the Aesthetics of Britishness* (Manchester: Manchester University Press, 2004), pp.111-33, at p.114.

19 Ibid, pp.116-17.

20 Harrington, *British Artists and War*, p.64.

21 Hyde and Wilcox, *Panoramania*, 65; *Notes & Queries* 6th ser. 11 (25 Apl. 1885), p.330.

22 National Museums of Scotland, M.1952.626; Royal Collections (hereafter RC), RCIN 751106.

it was dedicated, in February 1802.[23] The other two prints were dedicated respectively to the East India Company, and to the Governor-General, Richard, 1st Marquess of Wellesley, elder brother of Arthur Wellesley, the future Duke of Wellington. The prints also came with a descriptive sketch.[24] Additionally, Porter executed a smaller version (23" x 110") of the painting, which is in the private collection of the Earl of Stair.[25] Eight study sketches for the panorama survive in the Library of Congress in Washington, albeit one of which also appears to have drawings of ancient Romans and mermaids.[26]

Porter painted a number of other 180° panoramas for the Lyceum, including one of Napoleon Bonaparte's victory over the Austrians at Lodi in Italy (10 May 1796), and one of the veteran Russian general, Alexander Suvorov's defeat of the French at St Gotthard (24-26 September 1799). They are known to have been displayed in Russia and in New York and Philadelphia after being shown at the Lyceum.[27] Porter's portrayal of Suvorov may have played a role in his appointment as historical painter to Tsar Alexander I of Russia in 1804-06. Porter, who was knighted by the Prince Regent in 1813, returned to Russia on a number of occasions and died there in 1842.

The Seringapatam panorama itself was followed at the Lyceum by another by Porter featuring the defence of Acre against Napoleon by Sir Sidney Smith (20 March to 21 May 1799). It appears to have been around 50' x 30-40'. A descriptive key survives, as does an engraving, together with a

23 EXBD, 100041, Extract from Porter diary, 16 Feb. 1802.
24 UKTC, Lennox-Boyd Panoramas, 32.
25 Harrington, *British Artists and War*, pp.334-35. See also David Robinson, 'The Great Pictures of Robert Ker Porter', in Gabriele Koller (ed.), *The World of Panoramas* (Amberg: Büro Wilhelm Verlag, 2003), pp.34-37.
26 Library of Congress, DLC/PP – 2001:068, DRWG 1 - Unattributed, Nos. 42-49 [LCCN: 2016649163-201664971.]
27 Hyde and Wilcox, *Panoramania*, p.58; Harrington, *British Artists and War*, pp.73-74; BL 017934495: *The Battle of Lodi; with an accurate sketch of General Buonaparte's campaigns in Italy. Chiefly intended as a companion to the great historical picture by R. K. Porter, now exhibiting at the Lyceum. [With a sketch of the picture.]* (London, 1803); also in Cambridge University Library (hereafter CUL), Microfiche. Ser. 31.5818; BOD, JJC, Entertainments 7 (13), anamorphic plan of Lodi; Entertainments 7 (14) anamorphic plan of St Gotthard; EXBD, 77713/100068, handbills for Lodi.

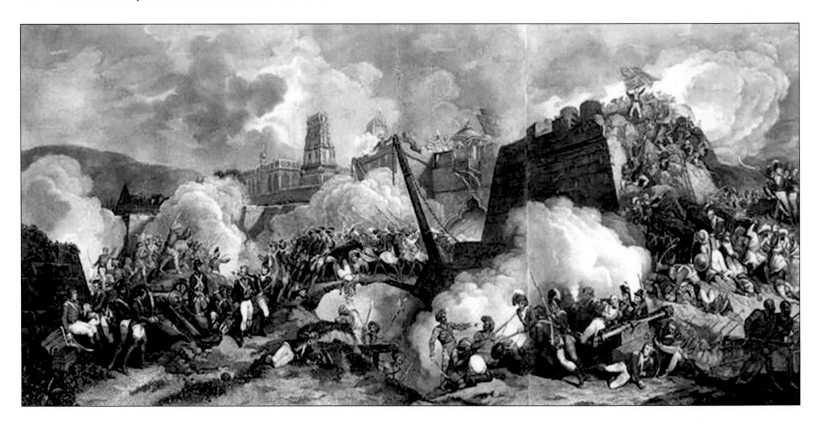

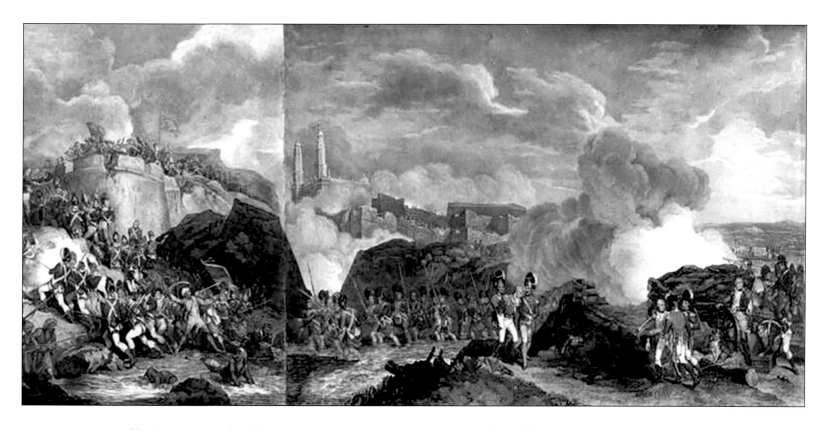

The three prints produced by John Vendramini from Porter's Seringapatam (1800). [National Army Museum, London]

German version in a university collection in Marburg.[28] Part of the panorama was also shown as an engraving in the *Naval Chronicle* in 1815.[29] The operations on land and sea, which led to the abandonment of Napoleon's attempt to extend his conquest of Egypt into Syria, were all fully covered with Sydney Smith, Sir John Douglas, who commanded British marines, Ghezar Pacha [Jezza Pasha], who commanded the Ottoman garrison, and Napoleon himself all depicted. [30] It was again successful, *Journal London and Paris* suggesting that many went back to see the painting several times: 'The political importance of the event depicted, the variety of the scene, the enthusiasm with which the artist has painted it, and the great resemblance of the portraits to the participants in the battle have awakened an extraordinary amount of interest in the exhibit.' [31]

The National Army Museum possesses what is thought to be a study for the right hand portion of Porter's 'The Great Historical Picture of the Battle of Alexandria' (21 March 1801). [32] This was the culmination of the British expedition to oust the French from Egypt, Napoleon having abandoned his army to return to France in August 1799. The original French occupation of Egypt in 1798, Nelson's victory at the Nile that effectively isolated the French army, and the subsequent British land victory all fed public interest in Britain. Napoleon's army had been accompanied by a number of scholars - *savants* - and those antiquities seized from the French, including the Rosetta Stone, were to form the nucleus of the British Museum's Egyptian and sculpture collections.[33]

Porter's panorama is believed to have measured 22' x 135'. There are surviving preliminary sketches of the British landing, Sir Sydney Smith leading marines, sailors dragging artillery, a Janissary gunboat, and also of the British commander, Sir Ralph Abercromby, and his French opponent,

28 BL, 010880965: *The Siege of Acre: or, Descriptive collections relative to the late scene of contest in Syria, between the British and Turkish force, under the orders of Sir W. Sidney Smith, and the Republican French, commanded by General Buonaparte: Chiefly intended as a companion to the great historical picture, painted by Robert Ker Porter* (London: Glendinning, 1801); 000049454/ 019843321: *An Historical Sketch of the Battle of Alexandria, and of the Campaign in Egypt, illustrative of the great picture now exhibiting in the Lyceum, Strand, painted By R. K. Porter* (London: Scarlett, 1802.); EXBD, 100065: *A Series of Sketches including the Principal Objects in the Great Historical Picture of the Siege of Acre, with explanatory references annexed* (London: Glendinning, 1801); BOD, JJC, Entertainments 7 (10) and (11), anamorphic plan; EXBD, 100067, German version; Oettermann, *Panorama*, 116; Harrington, *British Artists and War*, pp.76-77.
29 *Naval Chronicle* 34 (1815), p.216.
30 *Star*, 3 Apl. 1801.
31 *Journal London and Paris* 7 (1801), p.113.
32 NAM 1999-10-12.
33 Holger Hoock, 'The Battle of the Nile and its Cultural Aftermath', in Lincoln (ed.), *Nelson and Napoleon*, pp.65-71; Tim Clayton and Sheila O'Connell (eds), *Bonaparte and the British: Prints and Propaganda in the Age of Napoleon* (London: British Museum, 2015), pp.71-84.

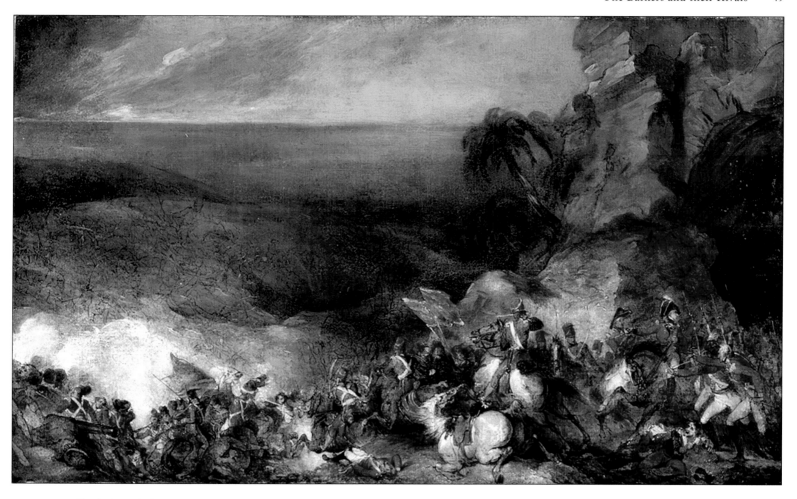

Study for right hand portion of Porter's Battle of Alexandria Panorama (1801). [National Army Museum, London/Bridgeman Images]

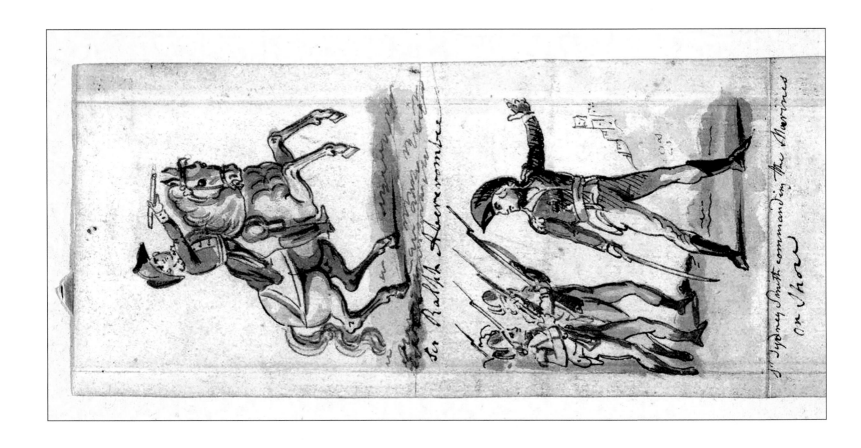

Preliminary Sketch for Porter's Battle of Alexandria Panorama showing Sir Ralph Abercromby, Sir Sidney Smith leading Marines, sailors dragging a canon, and a view of Pompey's Pillar at Alexandria (1801). [Victoria and Albert Museum, London]

Jacques-François Menou, in the Victoria and Albert Museum.[34] A descriptive guide additionally survives.[35] The landscape was somewhat generalised and undefined such that the visual effect of the details of the battle prevailed over any patriotic message, the latter being left to the accompanying narrative in the descriptive sketch.[36] That so many of Porter's sketches survive for his panoramas was due to them being sold off in 1843.[37]

Opening at the Lyceum on 3 May 1802, the Alexandria canvas was advertised as being on the same scale as the Seringapatam and Acre panoramas, 'comprehending at one view the most interesting points of contest between the English and French Armies…. the event which terminated a destructive war, so much to the glory of the British, and finally restored to Europe the blessings of Peace'.[38] The experience was heightened by a drum and trumpet accompaniment.[39] Whilst the expulsion of the French from Egypt was politically and culturally significant, its impact on the opening of the negotiations that led to the Treaty of Amiens (25 March 1802) between Britain and France - the only brief pause in Anglo-French hostilities between 1793 and 1814 - was less than Napoleon's concern to be free to send substantial reinforcements to reconquer Haiti from the slave rebellion of Toussaint L'Ouverture. Undoubtedly, however, the campaign did much to restore the reputation of the British army and pave the way for future success in the Peninsular War.[40]

Porter depicted various officers in the Alexandria panorama, sketching them from life. Among those who provided information was Lieutenant Benjamin Ansley of the 3rd Guards, who described details of French uniforms and requested that his 'effigy' appear in the painting in return. Porter duly showed Ansley being carried wounded from the field.[41] The radical journalist, William Cobbett, however, disputed Porter's depiction of the standard of the French 'Invincible' Regiment (actually the 21st Légère) being captured by Sergeant Sinclair of the 42nd Highlanders, stating it was

34 V&A, SD. 814:1 (0148073), and SD 814:1-3 (0148074).
35 BL, 000049454; UKTC, Lennox-Boyd Panoramas, 30, *The Great Historical Picture of the Battle of Alexandria painted by Robert Ker Porter*; EXBD, 100060: *An Historical Sketch of the Battle of Alexandria and of the Campaign in Egypt; illustrative of the Great Picture now exhibiting in the Lyceum, Strand, and painted by Robert Ker Porter* (London: Spragg, 1802); also GL, PAM 1898; CUL, Microfiche. Ser. 31.6082.
36 Ibata, 'Orient at Leicester Square', p.197.
37 *The Athenaeum*, 9 Oct. 1880.
38 *The Times*, 6 May 1802.
39 Alison Griffiths, '"The largest picture ever executed by Man": Panoramas and the Emergence of Large-screen and 360-Dgree Technologies' in John Fullerton (ed.), *Screen Culture: History and Textuality* (London: John Libbey, 2004), pp.199-220, at p.212.
40 Piers Mackesy, *British Victory in Egypt, 1801: The End of Napoleon's Conquest* (London: Routledge, 1995), pp.231, 234-41.
41 Harrington, *British Artists and War*, pp.81-82.

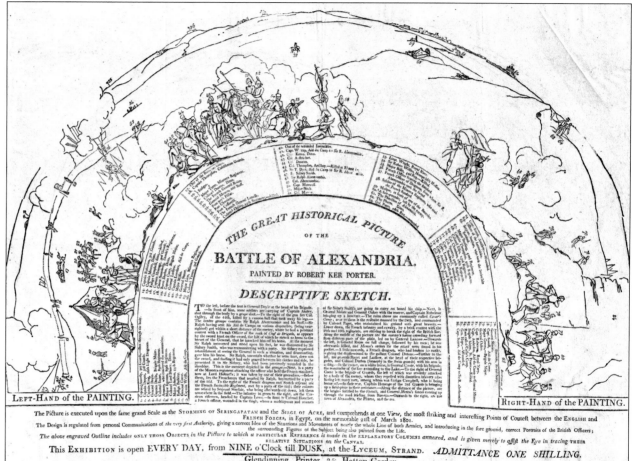

Descriptive Sketch of Porter's Battle of Alexandria Panorama (1801). [Lennox-Boyd Panoramas Collection, Special Collections and Archives, University of Kent]

taken instead by a French emigré named Antoine Lutz serving in Stuart's Minorca Regiment, who were mostly Germans.[42] Cobbett intended a 'complete refutation of certain Statements, which have appeared in the Public Papers, under the title of "Proceedings of the Highland Society," as well as the Statements and Representation in the Pamphlet and Panorama of Mr Robert Ker Porter, lately exhibited in London, and now, according to report, exhibiting in Dublin'.[43] Cobbett was technically correct for the 42nd had first taken but then lost the standard, at which point it was recaptured by Lutz.[44]

Porter's Acre and Alexandria panoramas were on exhibition in Dublin together in 1803, but the ship carrying them back to England was wrecked in January 1804. The Alexandria canvas was saved but in so damaged condition as to be irreparable, whilst the Acre canvas was lost entirely.

A different panoramic view of the Alexandria battle was that by Samuel James Arnold, a dramatist and theatrical entrepreneur, which was exhibited in the Great Room at Spring Gardens with a musical accompaniment.[45] Reminding his audience that the gallery was 'well warmed' and 'a Person attends regularly to communicate any Information on the subject', Arnold presented his 180° version as based upon the despatch of General Sir John Hey-Hutchinson, now Lord Hutchinson, who had assumed command after Abercromby's death. In addition, he had derived 'the local Information from the first Authorities, and most correct Drawings made on the Spot, and has been honoured with several interesting Anecdotes concerning the Action'. Nonetheless, Arnold cautioned that, although it was impossible to 'convey any adequate Idea of them' in the descriptive sketch, they were 'represented at large' in the actual painting.

The short-sighted Abercromby got too close to the battle line and was engaged by a French 'officer of rank' in hand-to-hand combat, the hilt of the Frenchman's sword hitting and bruising his chest as the blade passed under his arm. Abercromby fell from his horse. Sir Sidney Smith was soon on the scene and, as his sword was broken, Abercromby gave him that of the Frenchman. Abercromby was in pain from his bruised chest, but his son noticed blood on his father's breeches. Abercromby insisted it was only a spent ball, but subsequently collapsed and was found to have been fatally shot through the thigh. In a separate incident Smith offered his orderly's horse to an officer who had lost his, the orderly then promptly being killed by a cannon ball as he was about to dismount.[46] Porter chose to show Abercromby mounted, having offered the Frenchman's sword in return for Smith's

42 Cobbett's *Weekly Political Register*, 18 Dec. 1802.
43 *Sun*, 21 Dec. 1802.
44 Mackesy, *British Victory*, pp.127-28.
45 UKTC, Lennox-Boyd Panoramas, 31: *The Battle before Alexandria on the 21st of March, 1801, painted by Samuel James Arnold, is now on view, at the Great Room, Spring Gardens*; BOD, JJC, Entertainments 7 (34); EXBD, 100079, advertisement; Oliver Grau, *Virtual Art: From Illusion to Immersion* (Cambridge, MA: MIT Press, 2003), p.133 fn., 64.
46 Mackesy, *British Victory*, pp.128-29, 136-37.

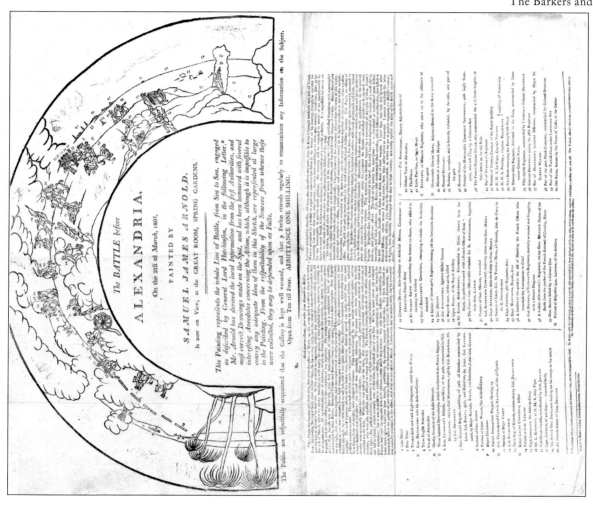

Descriptive Plan for Samuel James Arnold's Battle of Alexandria Panorama (1801). [Lennox-Boyd Panoramas Collection, Special Collections and Archives, University of Kent]

horse. By contrast, Arnold had Abercromby 'thrown from his Horse, in personal contest with a French officer of rank'. Arnold correctly stated that the hilt of the Frenchman's sword had bruised Abercromby's chest but wrongly implied that the general was shot at the moment of wresting the sword from the Frenchman since he appeared already bandaged. Smith was shown commanding some seamen, although Arnold noted that Abercromby had given Smith the Frenchman's sword, Smith enabling Arnold to copy it.

Arnold's version was not successful, the *Journal London and Paris* suggesting that, compared to Porter, he had 'not grasped the nature of the panorama as a totality'. It made a more favourable impression on a second viewing when it happened that an organ was being played majestically and loudly downstairs.[47] Subsequently, Arnold's canvas was shown in Edinburgh. A much more successful showing at Spring Gardens in 1804 was that of 'The Pandemonium of Boulogne' by John Serres, viewing Napoleon's invasion camp as seen from British warships stationed offshore.[48] On display in London until 1808, it was shown subsequently in Birmingham, Glasgow, and Norwich. Interestingly, from the opposite point of view, in 1806 Pierre Prévost's Paris rotunda exhibited a panorama of the French camp at Boulogne and the invasion flotilla, having previously shown one depicting the 1793 English evacuation of Toulon.[49]

Porter's last panorama, and also his only 360° canvas, was of the Battle of Agincourt (25 October 1415). Mulready was again involved in the production. After initial display at the Lyceum in 1805, it was shown in New York in 1809, exhibited in the Egyptian Hall in Piccadilly sometime after the building's opening in 1812, and presented to the City of London in 1819. It was discovered wrapped in newspaper and in poor condition from damp in the vaults of the Guildhall in 1834 and, according to Porter's sister, taken for a much older work that had been placed there for safety during the Great Fire of London in 1666! It was still described as in poor condition in 1856, and was no longer on display by 1866, although it appears to have remained at the Guildhall until at least 1910.[50] Indeed, in 1880, it was described as amongst the 'civic lumber' of the Guildhall that had been used occasionally as a screen but had now been cut into three sections. It had been recently 'disinterred' and was 'in a terribly dilapidated condition', rats having gnawed the edges of the canvas. Only around 100' was presentable. It was being displayed temporarily while a committee decided what to do with it. In apparent ignorance of the disappearance of Porter's Seringapatam and Acre canvasses, the *Illustrated London News* suggested that all

47 Oettermann, *Panorama*, p.119.
48 Ibid, pp.125-26.
49 Isabelle Leroy, *Le Panorama de la Bataille de Waterloo: Témoin exceptionnel de la saga des panoramas* (Liège: Commission Royale des Monuments, Sites et Fouilles, 2009), p.24.
50 Dibdin, *Reminiscences*, pp.145-46, fn; Oettermann, *Panorama*, p.118; Walter Thornbury, *Old and New London* 2 vols. (London: Cassell, Petter and Galpin, 1878), vol. I, pp.389-90.

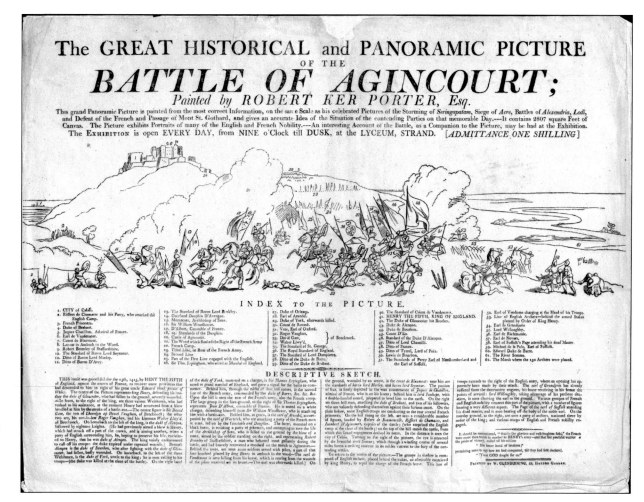

Descriptive Key for Porter's Battle of Agincourt Panorama (1812). [Bodleian Libraries, University of Oxford. John Johnson Collection: Entertainment folder 14 (6)]

three might be displayed together. However, the periodical was dismissive of a canvas only remarkable for its size, and considered the best solution would be 'to present it to our American cousins, who have room for it and like big things'.[51] Its ultimate fate is unknown.

A descriptive key survives for the 2,807 sq. feet of canvas. Calais was shown in the far distance although it would not have been visible from Agincourt and 'Agincourt Castle' - long since disappeared - appearing prominently on a hill in the background seems of prodigious size. King Henry V was at the centre on foot 'defending his brother the duke of Gloucester, who had fallen to the ground, severely wounded' and seemingly in combat with the Duke de Alençon. There was a flurry of English and French standards behind them including the Royal Standard and the Standard of St George. The focus was very much on dismounted English knights fighting French mounted knights with representations of 'many of the English and French nobility'. Only a few of the English archers who had made such a contribution to the victory were depicted.[52] Porter also allowed his imagination free range, including a scene of a cottage with smoking chimney, and a French woman dressed as a man, who had followed her husband and was bent over his fallen body in grief.[53]

The Barker brothers, meanwhile, displayed a series of panoramas depicting other British battles. Corunna (16 January 1809) was shown at the Strand by Thomas Edward Barker in 1814-15. Napoleon's attempt to exert more pressure on Britain by excluding British goods from Europe through the 'Continental System' had led to his intervention in the Spanish peninsula in 1807. Sent with 9,000 men to support the Portuguese, the then Sir Arthur Wellesley won an initial victory at Vimeiro (21 August 1808). The victory was thrown away by the arrival of his cautious superiors, Sir Hew Dalrymple and Sir Harry Burrard. The Convention of Sintra allowed the French to evacuate Portugal in British ships. An army under Sir John Moore was then committed to assist the Spanish, who had risen against French occupation. Napoleon himself took the field in October 1808 to crush resistance, forcing the greatly outnumbered Moore to conduct an epic winter retreat to the sea. The army was evacuated successfully from Corunna and Vigo in January 1809, but Moore was mortally wounded by a cannon shot, surviving long enough to know that victory had been obtained over the pursuing French. Famously, Moore was buried on Corunna's ramparts and left 'alone with his glory' as the army withdrew to the ships.

The viewpoint of the canvas was from the heights occupied by the French army. Indeed, the foreground was 'wholly occupied by French, chiefly Voltigeurs, who possessed great advantage from the nature of the ground, being screened by furze bushes, pieces of rock, and old stone walls'. The

51 *Illustrated London News*, 25 Sept. 1880; *The Athenaeum*, 9 Oct. 1880.
52 NAM 1971-02-33-6; BOD, JJC, Entertainments 14 (6); British Museum (hereafter BM), 2010.7081.7446; GRI, N7436.52.F7 A3: *An historical account of the reign of Henry the Fifth, intended as a companion to the great historical picture of the memorable Battle of Agincourt / painted by Robert Ker Porter, Esq., now exhibiting at the Lyceum, Strand* (London: Glendinning, 1805).
53 Anne Curry, *Agincourt* (Oxford: Oxford University Press, 2015), p.171.

1814.

BARKER'S PANORAMA, STRAND,

Between Somerset House and Surrey Street.

BATTLE OF CORUNNA.

The VIEW is taken from the Heights occupied by the Advance of the French Army.

IMMEDIATELY opposite the Entrance, (in the distance,) is the Town and Harbour of Corunna. The Vessels outside the Harbour are the English Transports. Lower down is the Village of Monitos; below that, and spreading to the right, is Elvina,—in this Village and its Vicinity lays the principal Scene of Action. On the left is a road by the side of an old wall, behind which was posted the 4th regiment, who kept up a tremendous and successful fire on the left column (of attack) of the French army; behind them, a little to the right, is the Reserve under Major-General Paget, which is just arriving from Monitos.

Near a few trees on the right of the Village, is seen the 42d Regiment charging the head of the French central column; in their rear, and a little higher, is the fall of SIR JOHN MOORE, who had just given orders for the 42d to charge, nobody being near him but Captain Hardinge and a few soldiers.

The 50th Regiment, commanded by Majors Napier and Stanhope, are driving the French out of the village; the latter, and both Ensigns of the 50th, carrying the colours, fall at this moment.

Major Napier, with some men, is more advanced; he was wounded and taken Prisoner.

The Regiments immediately above Sir John Moore are the Guards, the Royals, and the 26th. Over them, upon the Heights are the 36th, 76th, 51st, 81st, 59th, and 2nd. At the declivity on the right side of the Hill is the Village of Piedra-Longa, by the side of the Burgo River, where the Piquets, supported by some Light Troops, are warmly engaged with the Enemy in the Valley.

Beyond the River is the Village of Peulo, surrounded by enclosed Fields; a little further is the French Encampment.

On the Heights on this side the River, are the Enemy's Batteries protecting the descent of the French columns. Proceeding round, the Heights are occupied by the French Lines.

Over the Entrance is the Parsonage of the Curate of Elvina, used by the French as an Hospital. A little to the right is another French Battery; it was from this that Sir John Moore received his Death-wound. Lower down the French are descending and taking up a position with their artillery.

The 95th, which had made a dash and nearly reached the Pinewood, were obliged to retire, by the advance of a French column on the top of a lower ridge beyond that valley called the Vale of Castro; the 95th are keeping their ground on the Hill and in the Valley, a little to the right, the 52 [in the Plain] advance to their support. Above them is the Village of Someso. General Fraser's Division, under Major-Gen. Fane and Brig.-Gen. Beresford, are still farther off near Bionio; they were posted there to prevent any attack on that side. A little to the right are the Heights of St. Margaritta, distinguished by some wind mills.

The Inlet on the left of Corunna is called Orson's Bay.

The foreground of the Picture is wholly occupied by French, chiefly Voltigeurs, who possessed great advantages from the nature of the ground, being screened by furze bushes, pieces of rock, and old stone walls.

List of the British Forces in the Action.

Lieut.-Gen. Hope.

1. M.-Gen. Bentinck's Brigade { 4th, 42d, 50th }
2. M.-G. Manningham's { 26th, royal, 81st }
3. M.-G. Ward's { 1st, 3d } 1st grds.

4. Maj.-Gen. Leith's { 51st, 59th, 76th }
5. Major-Gen. Hill's { 2d queen's, 5th, 14th, 32d }
6. Col. Crawford's { 36th, 71st, 92d }

L.-Gen. Fraser.

7. M.-G. Beresford's { 6th, 9th, 23d, 43d }
8. Brig.-Gen. Fane's { 38th, 79th, 82d }

RESERVE.

9. M.G. Paget { ... }
10. B.-G. Disney's { 20th, 52d, 95th, 98th, 91st }

THE LARGE CIRCLE CONTAINS

A VIEW OF BERLIN.

Printed by J. Adlard, 23, Bartholomew Close.

Description of Thomas Edward Barker's Battle of Corunna Panorama (1814). [Lennox-Boyd Panoramas Collection, Special Collections and Archives, University of Kent]

Anamorphic Plan for Henry Aston Barker's Siege of Badajoz Panorama showing in the lower circle at Leicester Square, with a view of Malta in the upper (1810). [British Museum Images/The Trustees of the British Museum]

42nd Highlanders were shown charging a French column and, 'in their rear, and a little higher, is the fall of Sir John Moore, who had just given orders for the 42nd to charge, nobody being near him but Captain Harding and a few soldiers'. The French battery whose shot mortally wounded Moore was also identified. Major Charles Napier was also shown leading the 50th Foot just prior to being seriously wounded and captured whilst both regimental ensigns 'fall at this moment'. Napier was released subsequently and, as General Sir Charles Napier, rose to be Commander-in-Chief in India in 1848-49. A list of the British forces engaged formed part of the description.[54]

Henry Aston Barker's view of the siege of Flushing (11-18 August 1809) during the Walcheren expedition was on show at Leicester Square from March 1810 to November 1812. The intention was to seize Flushing and Antwerp to prevent French use of the Scheldt and provide a diversion to aid the Austrians although the latter had been already defeated at Wagram (5-6 July 1809) before the expedition disembarked. The panorama was a straight-forward depiction of the town with the British fleet beyond, although showing several buildings alight from bombardment. Subsequently, it was shown in Birmingham and Liverpool.[55] Henry Aston Barker's canvasses were always highly finished, neatness and precision being seen as hallmarks of such a 'polished gentleman'.[56]

The heroic aspects of the retreat to Corunna and the death of Moore no doubt inspired this first depiction of a British land battle by either of the Barker brothers. Although Flushing was taken, it was perhaps a more surprising choice as the campaign itself was hardly a successful venture. It led to considerable controversy, not least through the parliamentary enquiry into its conduct, and the over 4,000 deaths of British troops from disease compared to just 106 combat deaths. [57]

The Peninsular War had several potential subjects of interest to the public beyond Corunna. Henry Aston Barker chose the siege of Badajoz (16 March to 6 April 1812), which was featured at Leicester Square between April 1813 and July 1814. The scene was 'the state of the town, with the

54 UKTC, Lennox-Boyd Panoramas, 40, *Barker's Panorama, Strand. Battle of Corunna.*
55 UKTC, Lennox-Boyd Panoramas, 47, *The view of Flushing during the Siege* (1810); BL, 014603577: *Explanation of the beautiful view of Messina, in Sicily, taken from the Light House, and painted upon 10,000 square feet of canvas, by Henry Aston Barker, now exhibiting in the great rotunda of the Panorama, Leicester Square. The upper circle contains an interesting view of the Siege of Flushing, the town in flames, etc.* (London: Adlard, 1810); 005016782: *The view of Flushing during the siege* (London: Adlard, 1811); 015331412: *The view of Flushing during the siege. The Large Circle contains a view of Malta* (London: Adlard, 1810); V&A, 14783-6; YCBA, Folio A 2016 3p; BOD, JJC, Entertainments 6(17a) and (17b), are copies of the anamorphic plans; EXBD, 100139 is an account of the panorama's appearance in New Street, Birmingham.
56 Henry Aston Barker 'Obituary', *Gentleman's Magazine*, Oct. 1856, pp.515-518.
57 Martin R. Howard, *Walcheren, 1809: The Scandalous Destruction of a British Army* (Barnsley: Pen & Sword, 2012); Idem, 'Walcheren, 1809: A Medical Catastrophe', *British Medical Journal* 319 (1999), pp.1642-45.

Guide to Henry Aston Barker's Siege of Badajoz Panorama (1812). [Yale Center for British Art]

breaches formed in its Works, and the situation of the British troops a few hours previous to the Assault; also our Trenches lined with Soldiers; advanced Batteries firing upon the town, and Lord Wellington reconnoitring in one of the Approaches'.[58] Not perhaps surprisingly, there was no reference to the British sacking of the town amid the collapse of discipline in the aftermath of its storming.[59] The accompanying brochure included extracts from four of Wellington's despatches on the siege. Lieutenant Colonel John Luard of the 16th Dragoons later recorded how he had taken two civilians - possibly Barker and Robert Burford - to sketch the siege lines a few days before the assault and how they threw themselves to the ground and crawled on all fours at every cannon shot.

Badajoz was also the subject of a presentation by the former NCO in the 15th Light Dragoons, Philip Astley, at Astley's Amphitheatre in Westminster Bridge Road, Lambeth, this being the first of the hippodromes.[60] Astley's and other theatrical establishments had been staging representations of the Revolutionary and Napoleonic Wars from the beginning. Although panoramas were frozen in time compared to theatrical re-enactments, the former effectively

58 *London Courier and Evening Gazette*, 5 Oct. 1813; BL, 014585111: *A Short Description of Badajoz, and surrounding country; with extracts from the London Gazette, explanatory of the picture exhibiting in the Panorama, Leicester Square, representing the siege in 1812* (London: Adlard, 1813); NAL, 200.B.271: *A short description of Badajoz, and the surrounding country: with extracts from the London Gazette: explanatory of the picture exhibiting in the Panorama, Leicester Square, representing the siege in 1812: taken from the Fort La Picurina* (London: Adlard, 1813); also GL, S PAM 300; and YCBA, B1977.14.20192.

59 Gavin Daly, '"The Sacking of a Town is an Abomination": Siege, Sack and Violence to Civilians in British Officers' Writings in the Peninsular War - The Case of Badajoz', *Historical Research* 92 (2019), pp.160-82.

60 Jacinto Marabel, 'Badajoz 1812, provecho y espectáculo de la ciudad tomada', *Boletín de la Real Academia de Extremadura de las Letras y las Artes* 24 (2016), pp.279-92; 25 (2017), pp.315-43, at pp.331-33.

placed the audience at the centre of the event. It is suggested, therefore, that Astley's staging of the storming of Seringapatam only after the success of Porter's panorama and other similar subsequent theatrical re-enactments elsewhere used panoramas as 'primary referents', thereby 'indirectly acknowledging the superiority of their competitors' realisation of war'.[61]

The war in the Peninsula had two distinct phases, the British largely on the defensive until 1812, and then largely on the offensive. The first phase was characterised by the sporadic pattern of Wellington's advances into Spain and retirements back to Portugal, albeit interspersed with several victories. It allowed Britain to break the strategic deadlock after Trafalgar. Assisting the Portuguese and Spanish gave Britain new allies and a foothold on the continent. It also denied Napoleon access to Spanish and Portuguese colonies in the New World, with which Britain could now profitably trade. By absorbing more of Napoleon's disposable forces, the war further reduced the likelihood of any invasion attempt on Britain itself, or a descent on the British Caribbean. Bounded as it was on three sides by the sea, the Peninsula enabled Britain to exert maritime strength in full. The mountainous and barren terrain swallowed superior French forces in occupation duties and compensated for numerical British weakness. It also helped the British avoid military entanglements elsewhere, so that the main burden of the land war was undertaken by Austria, Prussia, and Russia with Britain using its underlying economic strength to subsidise its allies.

In many respects, it was Salamanca (22 July 1812) that fully established Wellington's reputation in Britain, but it was the victory at Vitoria (21 June 1813) that Barker chose to depict, presumably as Joseph Bonaparte, imposed by his brother as King of Spain, had been present. Wellington himself considered his greatest victories to be Assaye against the Marathas in India (23 September 1803), and Nivelle (10 November 1813) as he pushed across the Pyrenees towards France.[62]

Vitoria was shown from July 1814 to April 1815. The focal point of the 'splendid victory'[63] was immediately behind Wellington and his staff, with John Byne Skerrett's 2nd Brigade to the left, and Hew Dalrymple Ross's Chestnut Troop of the Royal Horse Artillery to the right.[64] The programme guide gave a fairly straight forward description, including an order of battle and a lengthy extract from Wellington's despatch as printed

61 Gillian Russell, *The Theatre of Wars: Performance, Politics and Society, 1793-1815* (Oxford: Oxford University Press, 1995), p.78.
62 Huw Davies, 'Moving Forward in the Old Style: Revisiting Wellington's Battles from Assaye to Waterloo', *British Journal for Military History* 1, 3 (2015), pp.2-23.
63 *The Times*, 28 Nov. 1814.
64 Anne S. K. Brown Military Collection, Brown University, Providence (hereafter ASKB) BDR: 227359, UKTC, Lennox-Boyd Panoramas, 10-11, *Explanation of the View of the Splendid Victory gained by the Marquis of Wellington over the French Army on the Plains of Vittoria*; BL, 014597363: *Description of the view of the battle of Vittoria, and the great victory gained by the Marquis of Wellington over the French army under Joseph Bonaparte, now exhibiting in Henry Aston Barker's Panorama, Leicester Square* (London: Adlard, 1814); also NAM, 1994-01-1-91; EXBD, 12879/70479; City of Westminster Archive Collection (hereafter CWAC), A 137 (007); and YCBA, DC233.V3 B37 1814, Folio A2016 3k.

in the *Extraordinary Gazette* of 3 July 1813. It explained that the action was shown at the point that the French centre and left had given way and Wellington ordered the 15th Hussars and 'Household Troops' to charge. Had an earlier time been chosen then the view would have been less extensive and the city of Vitoria 'would also have been so distant as to become very indistinct from any other station'. *The Military Register* highly approved of the representation 'of so proud a wreath to British glory': [65]

> Of this picture (so strictly military) it is but justice to say that the coup d'oeil is magnificent; and that it gives a better idea of the nature of the action, than can possibly be conveyed by the most elaborate description. Of the figures, it may be remarked, that they are drawn with a truth, animation, and discretion of grouping seldom seen in paintings of this nature… No circumstance tending to heighten the illusion produced by the Panoramic mode of painting has escaped the attention of the artist, as for instance the undulating appearance in the formation of the lines, occasioned by the inequalities of the ground, and the skirmishing of the light troops, in the corn-fields, in the fore-ground, which are seen trodden down by the "iron foot" of war, and the hopes of the reaper blasted… It might be here remarked as a trifling defect that the shadows of the buildings are scarcely blue and cold enough for the degree of light which it seems the wish of the artist to represent as falling on them.

Subsequently, in comparing the Vitoria panorama to Barker's panorama of the Battle of Paris, the *Military Register* noted that Barker had not apparently sketched the battlefield himself and it was 'not completely faithful in the delineation of the town of Vittoria [*sic*]'. It also pointed to a defect of the rotunda in which the central pillar holding up the canopy 'obstructs at every turn of the head the view of the spectator, and continually obliging him to dodge around it, confuses the relation of the different parts to each other, and destroys an illusion which, but for this impediment, would be the completest of the art'.[66] As in the case of the Vitoria panorama, the figures in the Paris panorama were painted by John Augustus Atkinson (1775-1831).

 A different perspective was that of the novelist and lady-in-waiting to Caroline, Princess of Wales, Lady Charlotte Bury. She was not unacquainted with military matters. Her father, the 5th Duke of Argyll, who died in 1806, had fought the Jacobites at Culloden (16 April 1746) and had reached

65 *The Military Register*, 11 May 1814.
66 Ibid, 12 Apl. 1815.

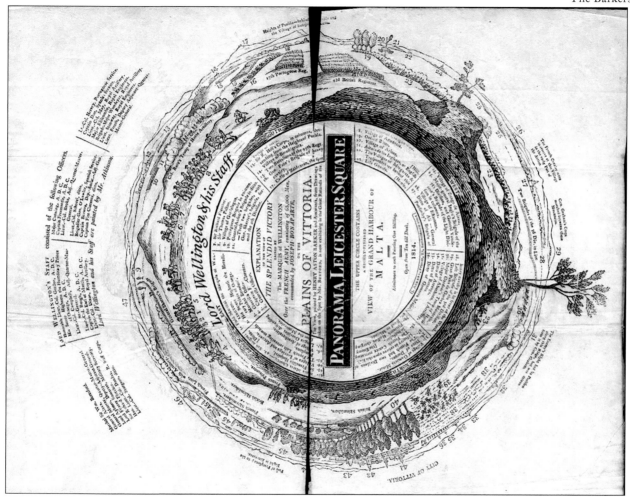

Anamorphic Plan for Henry Aston Barker's Battle of Vitoria Panorama showing in the lower circle at Leicester Square, with a view of Malta in the upper (1814). [Lennox–Boyd Panoramas Collection, Special Collections and Archives, University of Kent]

the rank of Field Marshal. Her first husband, John Campbell, who had died in 1809, had been an officer in the 3rd Foot Guards and had also commanded the Argyll Militia. She visited the panorama on 23 June 1814,[67]

> I went to see a panorama of Vittoria [*sic*]. It gave *too faithful* a representation of a scene of battle; and a stranger, a gentlemanlike looking person, who was there, with his arm in a sling; and had been at Vittoria the day after the battle was fought, said it was most exactly portrayed. The dead and the dying were lying strewn about; and yet, even in gazing at the representation, I sympathised with the enthusiasm of the living, and the glory of the conquerors, more than with the sufferings of the fallen… The view, too, of *Lord Wellington* and the other generals, coolly gazing around and reconnoitring the evolution of thousands, although involved in smoke and dust and danger, gave a grand idea of the qualities necessary to a commander, and raised the scale of intellectual glory ten thousand times above that of mere personal valour.

There were also panoramas of the allied victories in the Battles of Leipzig (16-19 October 1813),[68] and Paris (30-31 March 1814).[69] At the former, the Rocket Brigade of the Royal Horse Artillery commanded by Captain Richard Bogue, and firing Congreve rockets, was the only British unit present as Austrian, Prussian, Russian and Swedish forces decisively defeated Napoleon. Bogue was killed. The allies invaded France in 1814, Wellington's army, as already indicated, pushing across the Pyrenees, whilst the Austrian, Prussian, and Russian forces crossed the Rhine. The latter allied contingents attacked Paris in March 1814 and forced its surrender. Napoleon, who was at Fontainebleau abdicated on 6 April 1814. He was exiled to Elba but returned dramatically in March 1815, the 'Hundred Days' culminating in his defeat at Waterloo on 18 June and his second permanent exile to St Helena in July 1815. The Battle of Paris canvas was lost in a fire whilst displayed in New York in January 1821.[70]

Eclipsing all the Barker canvasses at the Strand and Leicester Square, however, was Henry Aston Barker's panorama of Waterloo. As the climax of almost 22 years of continuous warfare against Revolutionary and Napoleonic France, it was not unexpected that Waterloo would be celebrated and

67 Charlotte Bury, *Diary Illustrative of the Times of George the Fourth comprising the secret history of the court during the reigns of George III and George IV* 4 vols. (London: H. Colburn, 1839), vol. II, pp.8-9.
68 UKTC, Lennox-Boyd Panoramas, 46, *Descriptive Sketch of the Grand Historical Painting of the Great Battle of Leipsic.*
69 NAM 1997-05-83; UKTC, Lennox-Boyd Panoramas, 15, *Henry Aston Barker's Panorama, Leicester Square. Description of the Representation of the Battle of Paris.*; BL, 015333218: *Description of the Representation of the Battle of Paris, fought on the 30th of March, 1814. The view was taken on the Butte St. Chaumont, the heights on which the Treaty of Chaumont was signed* (London: Adlard, 1815).
70 *Boston Commercial Gazette*, 22 Jan. 1821.

commemorated in all manner of presentations to the public. Philip Astley had died in 1814 but the business continued, having phenomenal success with its Waterloo show at Astley's Amphitheatre. It ran for 144 consecutive performances from April 1824 and was revived in 1825, 1828, 1853, and 1854. William Bullock exhibited Napoleon's carriage at the Egyptian Hall in Piccadilly. Waterloo was commemorated in art for decades to come beginning with the British Institution's prize competition in 1816. When Sir David Wilkie's 'Chelsea Pensioners Reading the Waterloo Despatch' was exhibited at the Royal Academy in 1822, a rail had to be erected to keep the crowds from getting too close to the canvas.

The so-called 'Waterloo Churches', erected under 1818 legislation, were not actually intended as part of any war memorialisation, but there were utilitarian reminders such as Waterloo Bridge (1817) and Waterloo Station (1848), even if the proposed national monument was never built and that on Edinburgh's Calton Hill never completed. The Waterloo Museum was set up in Pall Mall in November 1815, the Waterloo Chamber at Windsor Castle completed in 1831, and two famous models by Captain William Siborne (1838 and 1844) exhibited at the Egyptian Hall. The Waterloo Medal issued in 1815 was the army's first campaign medal for all ranks. The exclusive all-male Wellington Banquet was held annually at the Duke's London residence of Apsley House from 1822 to 1852.[71]

Visitors thronged Waterloo itself, making it Europe's first mass tourist attraction, Sergeant-Major Edward Cotton of the 7th Hussars soon opening his museum there. Relics - genuine or otherwise - were eagerly sought by visitors. Less prosaic were 'Waterloo teeth' - dentures made from teeth extracted from the battlefield dead - and the importation of battlefield bones through Hull in the 1820s to be ground into fertiliser.[72] As noted by the protagonist, 'Harry Austin', in the novel, *Guards, Hussars, and Infantry*, in 1838,[73]

I shall not be far wrong in asserting that there exists not in the United Kingdom, man, woman, or child who has not either seen pictures or panoramas of Waterloo, heard songs on Waterloo, read books on Waterloo, talked for weeks about Waterloo, and full two-thirds of the adult population could not rest until they journeyed forth to have a look at Waterloo.

71 Luke Reynolds, 'Who Owned Waterloo? Wellington's Veterans and the Battle for Relevance', Unpub. PhD, CUNY, 2019, pp.107-30.
72 For the wider cultural impact, see Alan Forrest, *Waterloo* (Oxford: Oxford University Press, 2015), pp.99-129; Susan Pearce, 'The *Matériel* of War: Waterloo and Its Culture', in John Bonehill and Geoff Quilley (eds), *Conflicting Visions: War and Visual Culture in Britain and France, c. 1700-1830* (Farnham: Ashgate, 2005), pp.207-26; A. V. Seaton, 'War and Thanatourism: Waterloo, 1815-1914', *Annals of Tourism Research* 26 (1999), pp.130-58; Frederick Burwick,'18 June 1815: The Battle of Waterloo and the Literary Response', *BRANCH: Britain, Representation and Nineteenth-Century History (2016),* found at http://www.branchcollective.org/?ps_articles=frederick-burwick-18-june-1815-the-battle-of-waterloo.
73 *Guards, Hussars, and Infantry, Adventures of Harry Austin*. By An Officer. 3 vols. (London: Saunders and Otley, 1838), vol. III, p.311.

It was hardly surprising therefore, that Waterloo would result not only in a great deal of art in general,[74] but also in panoramas. On the continent, one was commissioned by the Amsterdam publisher, Evert Masskamp, in 1818 and painted by J. Kamphuizen with the assistance of L. Moritz, C. de Kruif, and C. L. Hansens. The focus was on the wounding of the Prince of Orange (later King Willem II of the Netherlands), who was hit by a musket ball in his left shoulder towards the end of the battle. After display in Amsterdam, it was exhibited in Aix-la-Chapelle and Brussels.[75] It accorded with the desire of the House of Orange to portray the Prince's heroism in order to bolster its popularity in the newly unified state of Belgium and the Netherlands. [76] Maaskamp, who testified to the success of the panorama in Brussels in February 1819, was meant to supply prints of it to Wellington but, when he requested payment in October 1820, Wellington denied receiving any copies.[77]

Henry Aston Barker visited the battlefield at a very early stage, gathering personal testimonies from 'Officers at Head-quarters'. He was then assisted by the Scottish-born artist, John Burnet, whilst the figures were the work of John Masey Wright (1777-1866), who had also painted the figures for the Corunna and Vitoria panoramas.[78]

There is some confusion between Waterloo canvasses shown at the Strand and Leicester Square. Thomas Edward Barker displayed a Waterloo panorama at the Strand in January 1816. [79] It was then certainly exhibited appropriately enough in Wellington Street in Bristol, but also in Exeter and Birmingham.[80] As indicated previously, the Strand rotunda was not sold to Henry Aston Barker until December 1816. The Strand version singled out a number of officers for attention as well as the Highland regiments. What seems to have been the Strand version, judging by the advertisement

74 Harrington, *British Artists and War*, pp.94-102, 107-111.
75 Michael Putter, 'A Very Naïve and Completely New Manner: Pieneman, History Painting and the Exhibitions of the Battle of Waterloo', *Rijksmuseum Bulletin* 63 (2015), pp. 196-227, at p.207; Evelyn Fruitema and Paul Zoetmulder (eds), *The Panorama Phenomenon* (The Hague: Foundation for the Preservation of the Centenarian Mesdag Panorama, 1981), p.88; Leroy, *Panorama de la Bataille de Waterloo*, pp.93-95.
76 Forrest, *Waterloo*, pp.166-71.
77 Wellington Archives, Hartley Library, University of Southampton, WP1/618/19 Maaskamp to Wellington, 25 Feb. 1819, and notes; WP1/654/12, Maaskamp to Wellington, 18 Oct. 1820, and notes.
78 Oettermann, *Panorama*, p.112.
79 *Morning Post*, 29 Jan. 1816; *The Times*, 2 Mar. and 6 Mar. 1816; BL, 002239127 [also EXBD, 17421]: *A description of the defeat of the French army, under the command of Napoleon Bonaparte, by the allied armies, commanded by Feld Marshal his Grace The Duke of Wellington, and also Field Marshal Prince Blucher, in front of Waterloo, on the 18th June, 1815; now exhibiting in Barker's Panorama, Strand, near Surry-Street* (London: Adlard, 1816).
80 *Exeter Flying Post*, 18 July 1818; *Bristol Mirror*, 12 Oct. 1816; *Birmingham Gazette*, 22 July and 16 Sept. 1816.

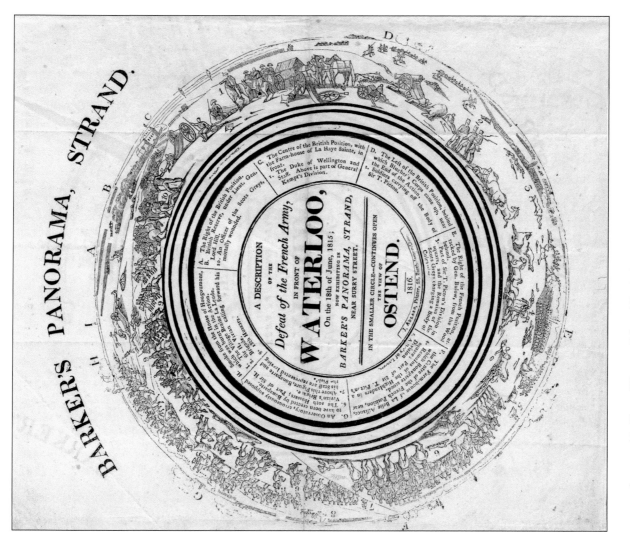

Anamorphic Plan of Thomas Edward Barker's Waterloo Panorama showing in the larger circle at the Strand, with a view of Ostend in the smaller circle (1816). [Lennox-Boyd Panoramas Collection, Special Collections and Archives, University of Kent]

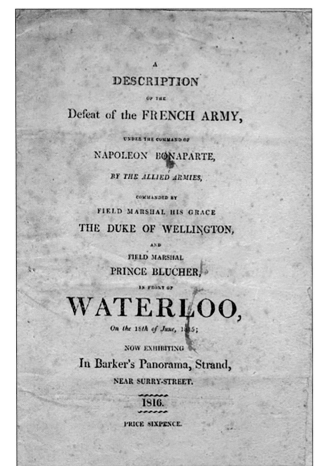

ascribing it to Mr Barker of the Strand, also appeared at Edinburgh in October 1818: men of the 42nd Foot were admitted gratis for two nights.[81]

Whilst it is sometime suggested that the Waterloo panorama from the Strand was simply transferred to Leicester Square, it is clear that a separate canvas by Henry Aston Barker was shown continuously at Leicester Square from 25 March 1816 until 9 May 1818.[82] Barker added a more elevated viewing platform at Leicester Square in May 1816.[83] The Leicester Square version was 360' x 45'.[84]

The view point was behind the farm of Mont St Jean where Henry Aston Barker had constructed 'a small stage sufficiently elevated to see into the valleys and clear the objects'. The focus was the French Imperial Guard's attack on Peregrine Maitland's Guards

81　Peter Hofschröer, *Wellington's Smallest Victory: The Duke, the Model Maker and the Secret of Waterloo* (London: Faber & Faber, 2005), p.20; *Caledonian Mercury*, 17 Oct. 1818.

82　*The Times*, 18 Mar., 8 July, 16 Sept., 18 Nov. 1816.

83　*The Times*, 13 May 1816.

84　BL, 014597455: *Description of the field of battle, and disposition of the troops engaged in the action fought on the 18th June, near Waterloo; illustrative of the representation of that great event in the Panorama, Leicester Square* (London: Adlard, 1816); also NAM 1990-06-31; NLS, Crawford. FR.394; GRI, N7436.52.B4 W3; EXBD, 17420/17422/70478; GL, PAM 4955; YCBA, DC243 D4; CUL, PAM.7.81.17; and UKTC, Lennox-Boyd Panoramas, 1u, *Explanation of the Battle of Waterloo now exhibiting at Leicester Square*; 23 and 24, *A Description of the Defeat of the French Army in front of Waterloo: Key to the Original Picture painted by Mr Barker of London*; YCBA, Folio AD57: *Explanation of the Battle of Waterloo / painted on the largest scale from drawings taken on the spot by Mr. Henry Aston Barker; now exhibiting in the Panorama, Leicester Square; the upper circle contains a view of the city of St. Petersburg* (London, 1817). BL 009274319 is a copy of *A Description of the field of battle, and disposition of the troops engaged in the action…* printed in Quebec by Bedard in 1817.

Brigade, Maitland's advance, and the flanking attack of Frederick Adam's 3rd Brigade. To one side, however, was featured the earlier charge of the 1st and 2nd Life Guards with the death of the well-known pugilist, Corporal Shaw of the 2nd Life Guards. To the other was Wellington with his military secretary, Lord FitzRoy Somerset, albeit that Wellington was identified as No 1 in the descriptive key. With the usual inclusion of multiple events such as the earlier charge of the Life Guards, it also showed the wounding of the Prince of Orange, Marshal Ney having one of his horses shot under him, the fatal wounding of both Wellington's ADCs, Alexander Gordon, and also his Deputy Quartermaster-General, William De Lancey, and the 92nd Highlanders supposedly charging with the Royal North British Dragoons (later the Royal Scots Greys) by holding on to their stirrups. Barker's guide indicated that 'a liberty has been taken, as to time, in introducing the glorious charge made by the Highlanders, and General Ponsonby's brigade of cavalry' some hours before the climatic focus of the panorama. He also admitted that whilst Wellington was shown near to Maitland's Guards, 'to say where he actually was, at this period, is impossible' as the Duke had gone to all parts of the battlefield during the course of the day. Identified as No 48, on the key, Napoleon was a distant figure seen 'the moment before his flight'. It was described by advertisements 'as a magnificent view of the Battle of Waterloo at the moment of Victory, painted on the largest scale'.[85]

The panorama played into the perceived 'correct' version of the battle, as established by Wellington's official despatch, which was published in London on 22 June 1815. Thus, it was emphatically a British victory. Not least there was emphasis upon the decisiveness of Maitland's attack on the Imperial Guard. Rival claims were made for the role of the 52nd Foot of Adam's Brigade, which Wellington declined to acknowledge.[86] Even more significantly, there was the thorny issue of the impact on the battle's outcome of the arrival of the Prussians, they being seen only distant on the horizon at the decisive moment in Barker's panorama. Siborne, for example, was compelled under pressure to modify his first, larger model of Waterloo, by removing no less than 20,000 Prussian figures - a quarter of the whole 80,000 figures - to reflect Wellington's version of events.[87] Wellington maintained that the arrival of the Prussians only began to take effect with the British repulse of the Imperial Guard after 1930 hours whereas Prussian pressure on the French right flank had increased steadily from around 1630 hours onwards.

85 *The Times*, 18 Mar. 1816; *London Courier and Evening Gazette*, 8 June 1816.
86 Nigel Sale, *The Lie at the Heart of Waterloo: The Battle's Hidden Last Half Hour* (Stroud: History Press, 2014); Gareth Glover, *The Great Waterloo Controversy: The Story of the 52nd Foot at History's Greatest Battle* (London: Frontline Books, 2020).
87 Hofschröer, *Wellington's Smallest Victory*, pp.104, 196. The controversy over the Prussian role is reflected by the contrasting views of Peter Hofschröer in his *The Waterloo Campaign: Wellington, his German Allies and the Battles of Ligny and Quatre Bras* (London: Greenhill Books, 1998) and *1815 - The Waterloo Campaign: The German Victory* (London: Greenhill Books, 1999), and John Hussey, *Waterloo: The Campaign of 1815* 2 vols. (London: Greenhill Books, 2017). These followed several exchanges between Hofschröer and Hussey in the journal, *War in History*.

Entrance to the panorama was just 1s.0d. The guide was prefaced with lines from Joseph Addison's 'The Campaign', addressed to the Duke of Marlborough in 1705, a panegyric on the victory at Blenheim (13 August 1704): 'Rivers of blood I see, and hills of slain/An Iliad rising out of one campaign.' It also included lines from Walter Scott's popular poem, 'The Field of Waterloo', penned by Scott after his visit to the field in August 1815 and published in October 1815. Priced at 6d, the guide provided a narrative together with the British order of battle and an anamorphic plan.

On the way out, spectators could also buy a set of eight prints by Barker engraved by Burnet for a guinea, proceeds to be given to a national commemorative painting suggested by the Prince Regent. Each 23" x 11", these could be fitted together to form a complete view of the battlefield. These showed the farm at La Haye Saint, the orchard around La Haye Saint, the plateau of Mont St Jean, the 'crest of the hill on which the Imperial Guard were charged', the village of Braine La Leude, the village of Mont St Jean, the forest of Signe, and the 'road and hedge' leading to Ter La Haye.[88] So popular was the panorama that it netted Barker a profit of £10,000 within a few months.

The 'Hermit in London' - the essayist, Felix McDonogh - described seeing the canvas in September 1818. His description of the crowd in *The Literary Gazette*, which was then widely published in the provincial press, is worth quoting at length:[89]

There were groups of all classes, and feelings of as many descriptions: The man and woman of quality, proud to distinguish in the canvas some hero who added lustre to their name - the female of sensibility, who heaved the thick sigh for some relative or bosom friend, shrouded in the mould of glory; and who, though distant the place and period, could scarcely check the falling tear - the military spectator who had been an actor in the scene, and who, pride beaming in his countenance, yet wrapt in silence, looked on the representation of that awful and eventful reality - or the garrulous but worthy veteran, who saw his own deeds of arms live in the pictured story; and who, bereft of an arm or a leg, and leaning on a friend, indulged in the gratifying account of what his country owed him. There was also the Exquisite *militaire*,[90] youthful and blooming, affected and vain, lounging with an air of *sans souci*, a tooth-pick or violet in his mouth, a quizzing-glass either suspended round his neck or fixed in the socket of his eye, seeming to disdain taking an interest in the thing…Here were idlers looking at

88 Edinburgh University Library, Special Collections, GP 237 Coll-1101; CWAC, A14A7551.
89 Felix McDonogh, *The Hermit in London: Or, Sketches of English Manners* (London: Henry Colburn & Co., 1821), pp.125-30; *Cambridge Chronicle and Journal*, 4 Sept. 1818; *Carlisle Patriot*, 5 Sept. 1818; *Chester Courant*, 8 Sept. 1818.
90 By 'Exquisite *Militaire*', McDonogh meant a military fop or dandy, usually portrayed as a young officer without actual war experience sporting a tight uniform and increasingly unwieldy headgear. Such was a common target of contemporary cartoonists and printmakers such as George Cruikshank and William Heath in the years following Waterloo.

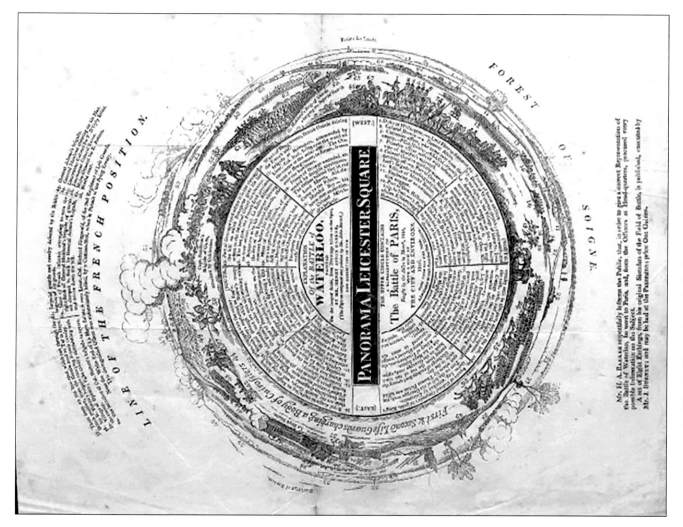

Anamorphic Plan for Henry Aston Barker's Battle of Waterloo Panorama at Leicester Square showing in the lower circle, with the Battle of Paris in the upper circle (1816). [Lennox-Boyd Panoramas Collection, Special Collections and Archives, University of Kent]

the action merely as a picture; and there were vacant countenances, staring at nothing but the company: - in one place, a fat Citizen come in merely to rest himself; and, in another, a pretty brunette, of the second class, whose only business was to meet my Lord. In a third corner, I could see a happy couple enjoying the short space previous to a permanent union, and who came here for fashion's sake… This couple took as much interest in the Battle of Waterloo as the Great Fire of London. At the entrance were some jealous painters looking out for defects in the piece, and in the doorway, was a covey of beauties, surrounded by fashionables, who seemed scarcely to know why they came here, and enjoying nothing but their own conversation.

William Wordsworth was scathing, believing the Waterloo panorama a delusive spectacle that suppressed the imagination, and cheapened the meaning of the event, which thereby was lost as poetic medium.[91]

The Waterloo canvas then went on tour but it is difficult to disentangle it from that of the Strand canvas. It was briefly back in Leicester Square in 1820-21.[92] The canvas ultimately went to Boston. At some point, it returned to Leicester Square again and remained on display until it more or less fell apart, the canvas then disintegrating in a damp cellar.[93]

In 1842 Robert Burford decided to have it repainted for Leicester Square using Henry Aston Barker's original notes and drawings and at least part of the original canvas.[94] Some 'corrections' were made to the position of troops 'by reference to official sources'. It was also 'much more carefully and highly-finished than that of its predecessor, because the latter was brought out a *pièce de circonstance*, and bore evident marks of having been executed with great haste'.[95]

Once more the climax of the battle was the familiar theme: [96]

91 Gillen Wood, *The Shock of the Real: Romanticism and the Visual Culture, 1760-1860* (Basingstoke: Palgrave, 2001), pp.109, 115.

92 *Morning Chronicle*, 18 Oct. 1820; 24 Jan. 1821; 21 Mar. 1821.

93 Oettermann, *Panorama*, 11; *Bell's Weekly Messenger*, 26 Mar. 1842; Henry Aston Barker 'Obituary', pp.515-518.

94 Altick, *Shows of London*, p.195; *Naval and Military Gazette and Weekly Chronicle of the United Service*, 26 Mar. 1842; NAM 1964-09-88; BL, 014597479 *Description of a view of the Battle of Waterloo; with the disposition of the troops engaged in the action, fought on the 18th of June, 1815, now exhibiting at the Panorama, Leicester Square* (London: Brettell, 1842); also GL, A 9.1 NO 7 IN 67; CWAC, A14A7618; and YCBA, DP361.B8.

95 *Morning Post*, 22 Mar. 1842.

96 Ibid.

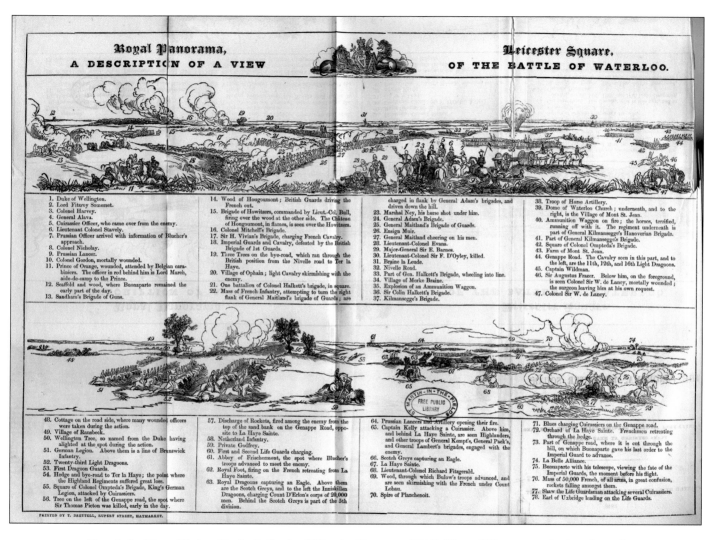

Descriptive Plan of Robert Burford's Battle of Waterloo Panorama (1842). [City of Westminster Archive Centre]

The Imperial Guards, supported on the right and left by the Cuirassiers, are in the midst of their grand and final effort, being charged in front and on both flanks by the English, and the French columns seem already in confusion… At some distance Hougoumont is discerned, and is enveloped in flames. In another direction dark masses of troops are seen debouching from a wood, and advancing upon the rear of the French: they are the Prussians.

The arrival of the Prussians was suitably only as the Imperial Guard was being repulsed. The viewpoint was to the rear of La Haye Saint, close to Wellington's position for much of the day:[97]

Of course, His Grace is the most conspicuous figure in the Panorama. He is represented on horseback in the foreground, with his hat off, waving his men on to the last decisive charge, and surrounded by a brilliant staff. The groupe [sic] about him is a very effective one, and is the first marked object that strikes the eye on entering.

According to one review, 'We cannot say whether the Duke of Wellington has not been rather flattered in features; but, assuredly, the wounded Prince of Orange looks most ghastly pale.' [98] One reviewer, noting that the battle's importance had been magnified by the distance of date, was struck especially by the depiction of the charge of Sir Hussey Vivian's 6th (Light) Cavalry Brigade, which reminded him 'of a battle-piece by one of our greatest masters'.[99]

The panorama met with general praise,[100]

Smoke, fire, and dust, are all depicted, the landscape is very good, and the foregrounds are painted with good effect, and thrown in bold advance. The horses and combatants are very spirted, and yet very correct. The whole is in apparent motion, and the treatment throughout is very felicitous. It is one that everyone should see.

97 *Sun*, 22 Mar. 1842.
98 *La Belle Assemblée*, 1 Apl. 1842.
99 *London Saturday Journal*, 16 Apl. 1842.
100 *Weekly True Sun*, 27 Mar. 1842.

It was displayed from March 1842 to February 1843, being viewed by Wellington in June 1842.[101] It was shown again after Wellington's death (14 September 1852) from November 1852 to March 1853, and once more in 1855.[102]

William Heath, who produced military costume prints as well as illustrations of British battles alongside his satirical caricatures, also seems to have painted a panorama of Waterloo that was exhibited at Sadler's Wells.[103] Heath certainly produced a number of panoramic watercolour sketches of Waterloo, which might be preliminary sketches for Barker's Waterloo panorama since a pamphlet in 1816 was published as *Description of the field of battle, and disposition of the troops engaged in the action, fought on the 18th of June, 1815, near Waterloo; illustrative of that great event in the Panorama, Leicester-Square.* It suggested that there would be 'forthcoming prints' by Heath and John Atkinson, and the National Army Museum has many examples of Waterloo prints based on Heath's sketches.[104]

101 *Argus, or Broad-sheet of the Empire*, 25 June 1842.
102 BL, 014601056: *Now exhibiting, the Battle of Waterloo; also Nimroud, part of the city of Nineveh; and the Bernese Alps* (London, 1855); BOD, JJC, Dioramas 2 (8i and 20a), advertisements; Altick, *Shows of London*, 140.
103 *Morning Chronicle*, 10 Aug. 1818; *British Press*, 17 Aug. 1818; Getty Research Institute (hereafter GRI), N7436.52.B4 W3: *Key to Burkitt and Hudson's large coloured engraving of the Battle of Waterloo, from a painting by W. Heath : also particulars of the Battle and disposition of the troops engaged in that action, illustrative of the above engraving* (London: Gilbert, 1817).
104 Julie Melby, 'William Heath (1794/95–1840): "The man wots got the whip hand of them all"', *British Art Journal* 16 (2015/16), 3-9; BL, 014597455 (see fn. 118 above). Prints based on Heath's Waterloo work can be found in NAM, 1971-02-33-446, 446 and 450; 1974-05-69-6.

4

The Burfords

Succeeding Barker at Leicester Square, the Burfords specialised mostly in 'tourist art', such as views of Mont Blanc, Rome, Damascus, Constantinople, and Vesuvius. Robert Burford was a consummate showman, advertising his panoramas through handbills, press previews, and even billboards on the new horse-drawn omnibuses. He was well aware of the potential for exploiting contemporary military events alongside landscapes. Indeed, the juxtaposition of battle panoramas and topographical scenes in the upper and lower galleries at Leicester Square catered for all tastes, suggesting 'that panorama impresarios were not only sophisticated promoters of their artistic wares (placing a more prosaic subject in the same building as an epic one may have heightened audience reaction to the more spectacular of the two paintings), but may also have been designed to accommodate the gendered composition of their audience'.[1]

Burford visited Antwerp 'during the last four days of the siege' of the Dutch garrison by French forces in December 1832, this being part of the French intervention in the Belgian revolution leading to Belgian independence. Burford also drew information from a number of British military observers including Lord Ranelagh and Captain Brandreth. The resulting panorama was exhibited at Leicester Square from March 1833 to January 1834.[2]

Another conflict that attracted interest in Britain was the First Carlist War in Spain (1835-38) through the presence of the British Auxiliary Legion. Raised primarily from British veterans - many Irishmen - of the Napoleonic Wars, it fought under the command of the military radical, Sir George de Lacy Evans, to support Queen Isabela II and Spanish liberals against the conservative followers of the late King's brother, Don Carlos. Approximately, 10,000 strong, the Legion suffered heavy casualties before being disbanded in December 1837. In April 1838 a panorama of San

1 Griffiths, 'Shivers Down Your Spine', pp.18-19.
2 BL, 014578010: *Description of a view of the siege of Antwerp, with part of the city, and surrounding country; now exhibiting at the Panorama, Leicester Square* (London: Brettell, 1833); also EXBD, 70476; GL, A 9.1. NO 7 IN 66; CUL, Pam.5.82.6; BOD, JJC, Dioramas 2 (13) and Entertainments 6(1), advertisements.

Sebastian featuring the Legion's action at Ayete outsides the town on 5 May 1836 and painted by E. Lambert, opened in the Grand Room, Maddox Street off Mayfair's Hanover Square. Sketches and information were provided by Claudius Shaw, a former Royal Marine subaltern with experience in the Peninsular War who had commanded the Legion's artillery. Ayete was the Legion's first major action and it succeeded in pushing back Carlist forces blockading San Sebastian but at the cost of 600-800 casualties.

The space available in Maddox Street was far more limited than that usually required for panoramas but the *Naval and Military Gazette* characterised it as an 'interesting and clever picture', whilst the *Morning Advertiser* believed it would appeal to 'military gentlemen', civilians and 'juveniles' alike. It also praised it as 'being the best if not the only one, we have ever seen that really conveyed the true aspect of a great military engagement, with all the incidents and appointments of a battle-field'. The *Evening Chronicle* felt the portrait of Evans conferring with his officers was particularly striking. By contrast, whilst finding the topography and location of troops accurate, *The Times* felt the canvas had little overall merit and, again, commented on the confines deriving from the limited display space.[3] Lambert was principally a diorama artist of subjects such as the Roman destruction of Jerusalem in 70 AD and the burning down of the old Houses of Parliament in 1834. San Sebastian was his only military subject.

British imperial adventures did not initially attract Burford and some of his canvasses fitted more into the pattern of tourist art than battle panoramas per se. Such was the view of Kabul reflecting the disastrous First Afghan War (1839-42) that appeared alongside the revived Waterloo panorama in 1842.[4] Occupation of Kabul to forestall Russian influence there had resulted in the eventual retreat and almost total loss of the Anglo-Indian army in January 1842. The guide recognised that the city was 'invested with a most painful and melancholy interest, by the fatal termination of the campaign'. Despite 'brilliant sorties' the army had succumbed to 'overpowering masses'. It mattered little whether disaster was due to Afghan treachery, or 'the natural desire of the people to free themselves from the yoke of a foreign enemy'. It was necessary 'for our character and our safety' to exact retribution. Indeed, the reduction of the city to ruins would 'form a fitting monument to the memories of the brave that have fallen'. *The Naval and Military Gazette* noted that the canvas would enable visitors 'to form a correct notion of the operations, if they deserve such a name'.[5]

3 GRI, N7436.52.S7.S3.1838: *Description of the panorama of San Sebastian and the adjoining country, including the action of the 5th May, 1836, between the troops of the Queen of Spain and Don Carlos, from a view taken on the spot by Claudius Shaw ...; painted by Lambert: now exhibiting in Maddox Street, Hanover Square* (London: Brettell, 1838); *Naval and Military Gazette and Weekly Chronicle of the United Service*, 14 Apl. 1838; *Morning Advertiser*, 16 Apl. 1838; *The Times*, 16 Apl. 1838; *Evening Chronicle*, 18 Apl. 1838. For the Legion at Ayete, see Edward Brett, *The British Auxiliary Legion in the First Carlist War, 1835-38* (Dublin: Four Courts Press, 2005), pp.79-90.
4 Altick, *Shows of London*, p.177; BL, 002239119: *Description of a View of the City of Cabul with surrounding country, now exhibiting at the Panorama, Leicester Square [With a plan.]* (London: Nichols, 1842); also GL, PAM 17788; GRI, N7436.52.A3 K33; and CWAC, A 137 (011).
5 *Naval and Military Gazette and Weekly Chronicle of the United Service*, 14 Jan. 1843.

AFFGHANISTAN.—Just OPENED, Panorama, Leicester-square, a comprehensive and interesting VIEW of CABUL, including every object of interest in the city, the Bala Hissar, the River Cabul, with a distant view of the Himalaya Mountains and the Pass of Khurd Cabul, where the British Army was so treacherously destroyed. The whole illustrated by numerous groups of figures descriptive of the manners of the Affghanese. The Views of the Battle of Waterloo and of Jerusalem remain open. 14 June 1842

Advertisement for Burford's Cabul Panorama (1842). [Bodleian Libraries, University of Oxford. John Johnson Collection: Entertainment folder 6(1)]

Similarly, the panorama of Nanking in 1845 was influenced by the First China War (1839-42), which was brought to an end by the Treaty of Nanking (29 August 1842). It merely included 'many portraits of distinguished men who were engaged in the Chinese War, and to some extent partaking of the character of an historical painting'. Soldiers were largely seen encamped on the city walls. The guide admitted that the meeting between the British and Chinese representatives did not take place where shown, and it was intended as a means to include the portraits of the principal figures and depict Chinese costumes.[6]

On the other hand, the First Anglo-Sikh War (1845-46) did not lack spectacle, not least as it featured hard-fought pitched battles against a European-style army as at Ferozeshah (21-22 December 1845), and Aliwal (28January 1846). Unfortunately, the Governor-General of India, Lieutenant General Sir Henry Hardinge, chose to accompany the Commander-in-Chief, Lieutenant General Sir Hugh Gough, in the field. Whilst Gough had military seniority, Hardinge had supreme political authority. The two men's orders and counter-orders hampered the operations generally, whilst Gough's penchant for old-style frontal assault led to unnecessary losses.[7]

Assisted by his principal artist, Henry Courtney Selous (1803-90), who specialised in figures and horses, Robert Burford produced a panorama of the defeat of the Sikhs at the Battle of Sobraon (10 February 1846) that concluded the war. With exaggerated hyperbole and woeful inaccuracy, the guide suggested the 'campaign of the Sutlej unquestionably ranks amongst the most brilliant and complete achievements of modern warfare, and is

6 CUL, Pam.6.84.1: *Description of a View of the City of Nanking, and surrounding; now exhibiting at the Panorama, Leicester Square: painted by the proprietor Robert Burford, assisted by H. C. Selous, from drawings taken on the spot* (London: Brettell, 1845); *The Satirist*, 27 Apl. 1845; Alison Griffiths, 'Le panorama et les origines de la reconstitution cinématographique', *Cinémas* 14 (2003), pp.35-65, at pp.54-56.

7 For a useful summary, see E. R. Crawford, 'The Sikh Wars, 1845-49', in Brian Bond (ed.), *Victorian Military Campaigns* (London: Hutchinson, 1967), pp.31-70.

Henry Courtney Selous (1803-90), self-portrait. [National Portrait Gallery, London]

eminently calculated to exalt and add new lustre to the imperishable renown of British arms'. Sobraon itself was 'one of the most memorable and signal victories ever gained by our armies in the east'. It was shown at Leicester Square from June 1846 to June 1847.[8] Information was derived from 'three officers present in the engagement'.[9] The viewpoint was from within the Sikh entrenchments at the moment they were taken by the British. To the rear of the canvas were depicted the 3rd Dragoons, 9th Lancers, and 4th Bengal Light Cavalry. To the front, the British infantry was seen, [10]

> dashing through the front, charging right and left, and committing great havoc… On all sides, the most determined bravery is conspicuous - hand to hand combats, of the fiercest descriptions - bold rencontres between horse and foot - and the desperate stand of individuals against numbers - present scenes of terrible interest.

8 BL, 01014601036: *Description of a view of the battle of Sobraon, with the defeat of the Sikh army of the Punjab, now exhibiting at the Panorama, Leicester Square* (London: Nichols, 1846); 008238625: *Description of a view of the battle of Sobraon* (London: Nichols, 1846); also YCBA, DP361.B8; GRI, N7436.52.16.
9 *The Art Union* (1846), p.216.
10 *Illustrated London News*, 13 June 1846.

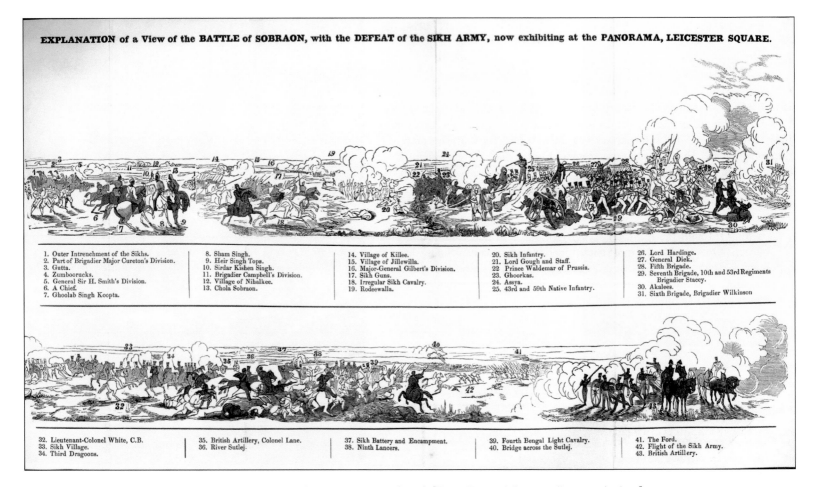

EXPLANATION of a View of the BATTLE of SOBRAON, with the DEFEAT of the SIKH ARMY, now exhibiting at the PANORAMA, LEICESTER SQUARE.

1. Outer Intrenchment of the Sikhs.
2. Part of Brigadier Major Cureton's Division.
3. Gutta.
4. Zumboorucks.
5. General Sir H. Smith's Division.
6. A Chief.
7. Ghoolab Singh Koopta.

8. Sham Singh.
9. Heir Singh Tops.
10. Sirdar Kishen Singh.
11. Brigadier Campbell's Division.
12. Village of Nihalkee.
13. Chola Sobraon.

14. Village of Killee.
15. Village of Jillewilla.
16. Major-General Gilbert's Division.
17. Sikh Guns.
18. Irregular Sikh Cavalry.
19. Rodeewalla.

20. Sikh Infantry.
21. Lord Gough and Staff.
22. Prince Waldemar of Prussia.
23. Ghoorkas.
24. Assya.
25. 43rd and 59th Native Infantry.

26. Lord Hardinge.
27. General Dick.
28. Fifth Brigade.
29. Seventh Brigade, 10th and 53rd Regiments Brigadier Stacey.
30. Akalees.
31. Sixth Brigade, Brigadier Wilkinson

32. Lieutenant-Colonel White, C.B.
33. Sikh Village.
34. Third Dragoons.

35. British Artillery, Colonel Lane.
36. River Sutlej.

37. Sikh Battery and Encampment.
38. Ninth Lancers.

39. Fourth Bengal Light Cavalry.
40. Bridge across the Sutlej.

41. The Ford.
42. Flight of the Sikh Army.
43. British Artillery.

Plan of Burford's Battle of Sobraon Panorama (1846). [Getty Research Institute/Internet Archive]

The 10th and 53rd Foot were especially prominent. The canvas also showed the death of Sir Robert Dick leading the 80th Foot, Brigadier-General Charles Cureton 'executing his feint', Sir Harry Smith's division routing 'several native chiefs' and Sir Joseph Thackwell's cavalry driving the Sikhs across the bridge over the Sutlej. The *Naval and Military Gazette* reported, 'This is one of the pictures that all the town must visit.' [11] For *The Satirist*, the canvas 'instructs while it pleases, and conveys to those more especially who have friends or relations in our gallant army an interest of no ordinary description'. It noted that crowds had been frequenting what represented a 'national tableau'. [12] For *The Athenaeum*, a striking feature was the depiction of the Sikh chieftains 'whose brilliant costume, energetic action, and high-mettled horses are delineated with great spirit'. [13]

In a lengthy descriptive article, *The Times* commended, [14]

a painting well worth seeing, as it illustrates in an admirable manner one of the greatest military achievements of modern days, and explains at one view the difficulties which were surmounted by the valour of the British troops, and the strategy of the generals who commanded.

It found 'no impossible exploits depicted, no theatrical giants, no monstrous perpetrations of romance'. It suggested the uniforms and horses were well drawn and painted, 'whilst the lurid effect of the atmosphere, the clouds of smoke, and gleam of fire and steel, surpass all that in pictures of this class has hitherto effected'.

After some apparent criticism, Burford made it known in the booklet accompanying the Sobraon panorama that his work was not 'a species of scene-painting, coloured in distemper, or other informal matter', but 'painted in the finest oil colour, and varnish that can be procured; and in the same manner as a gallery picture'.[15] As mentioned earlier, Wellington had visited Barker's original Waterloo panorama, and it is known that he visited others subsequently, including Burford's Siege of Antwerp and Sobraon panoramas.[16] It was said that when Wellington visited the Sobraon panorama, 'Contrary to the usual impassiveness of temperament which the Duke exhibited, he became intensely excited, and seemed to chafe against the barriers which restrained him from the field he so distinctly realised.'[17]

11 *Naval and Military Gazette and Weekly Chronicle of the United Service*, 30 May 1846.
12 *The Satirist, or Censor of the Times*, 7 June 1846.
13 *The Athenaeum*, 6 June 1846.
14 *The Times*, 1 June 1846.
15 Harrington, 'Entertaining Battles', pp.64-69.
16 Altick, *Shows of London*, p.222; *Naval and Military Gazette and Weekly Chronicle of the United Service*, 1 June 1833; *Illustrated London News*, 13 June 1846.
17 *Chambers Journal* 13 (1860), pp.34-35.

Extract from the Descriptive Guide of Burford's Sobraon Panorama (1846). [Getty Research Institute/ Internet Archive]

Whilst the Second Anglo-Sikh War (1848-49) led to the annexation of the Sikh kingdom by the East India Company, it was perhaps less attractive as a subject from the heavy losses suffered by British and East India Company forces at Chillianwallah (13 January 1849), although Goojerat (21 February 1849) was a more satisfactory concluding victory. Gough was again Commander-in-Chief and, whilst Hardinge had gone, the former still clashed with the new Governor-General, the Earl of Dalhousie.

As the first conflict with a European power since 1815, the Crimean War (1854-56), however, was the focus of a wide range of popular responses very much akin to the response to Waterloo. The realities of the battles of the Alma (20 September 1854), Balaclava, and Inkerman (5 November 1854), as well as the suffering of troops in the subsequent siege of Sebastopol, were brought home to the British public. Among many innovations in the conduct of the war, it was the first extensively covered by a new national press, notably by William Howard Russell of *The Times*. *The Times* saw its circulation increase by 50 per cent and benefitted by the government's decision in March 1855 to abandon stamp duty on newspapers in the hope of encouraging competition from rivals. In the event, whilst *The Times* had a daily print run of 61,000 in 1855, its rivals could muster no more than 3-6,000. *The Illustrated London News*, meanwhile, reached a weekly circulation of 130,700 by June 1855 and over 200,000 by the end of the year. [18] *The Times* had played a significant role in whipping up public opinion against Russia and took up the cause of administrative reform in the light of Russell's exposure of the 'incompetency, lethargy,

18 Olive Anderson, *A Liberal State at War: English Politics and Economics during the Crimean War* (London: Macmillan, 1967), p.71; Emma Armstrong, 'Art and War Reportage in the Crimean War I: *The Illustrated London News*', in Alastair Massie (ed.), *A Most Desperate Undertaking: The British Army in the Crimea, 1854-56* (London: National Army Museum, 2003), pp.194-202, at pp.200-01.

aristocratic hauteur, official indifference, favour, routine, perverseness, and stupidity' that it claimed 'reign, revel and riot' in the Crimea, at the hospitals in Scutari, and 'how much nearer home we do not venture to say'. [19]

The War Office despatched an official photographer, Richard Nicklin, a civilian, in June 1854 to provide visual proof that Russell's criticisms of the direction of the war were unjustified. Unfortunately, Nicklin and his photographs were lost when his ship, en route for home, went down in the 'Great Storm' in November 1854. Two subalterns tried their hand but their efforts were of poor quality. Thus, another commercial photographer, Roger Fenton, was the first to make an impact, working in the Crimea from March to June 1855 before returning home ill. [20] A gifted amateur, James Robertson, an engraver at the Ottoman Imperial Mint in Constantinople, and George Shaw-Lefevre, later Liberal MP for Reading, then continued the role. [21]

Fenton's images, however, were not exhibited in Britain until October 1855 and Robertson's not until February 1856. Nor did they sell well, the negatives of both men being sold off in 1856. Although there were the coloured sketches of William Simpson, [22] and the black and white representations in *The Illustrated London News*, the public was primarily informed by theatrical and other entertainments. Apart from panoramas, in London alone there would be dioramas in Regent Street, effigies and tableaux of allied generals in Madame Tussaud's, a representation of the Alma at Ashley's Amphitheatre, a Turkish exhibition at Hyde Park Corner, numerous plays on the stage, and displays at the Crystal Palace.[23]

The soldier's new status - no longer oppressor of the domestic poor but hero fighting Tsarist tyranny - was confirmed by the institution of the Victoria Cross for all ranks in January 1856. The perceived heroism of soldiers during the sinking of the troop transport, the *Birkenhead*, off South Africa (24 February 1852) had already begun to portray the army in a new and more favourable light: women and children were placed in the only three lifeboats that could be launched whilst 438 men drowned. The Crimea undoubtedly accelerated changed perceptions in the popular

19 *The Times*, 23 Dec. 1854.
20 Sophie Gordon, *Shadows of War: Roger Fenton's Photographs of the Crimea, 1855* (London: Royal Collections Trust, 2017).
21 Marion Harding, 'Sebastopol after the Siege, 1855-56', in Marion Harding (ed.), *The Victorian Soldier* (London: National Army Museum, 1993), pp.122-27; Kate Wood, 'Photography in the Crimea', in Massie (ed.), *Most Desperate Undertaking*, pp.284-91.
22 Emma Armstrong, 'Art and War Reportage in the Crimean War II: William Simpson, Carlo Bossoli and Recreational Artists of the Crimean War', in Massie (ed.), *Most Desperate Undertaking*, pp.327-35.
23 Harrington, *British Artists and War*, p.136; J. S. Bratton, 'Theatre of War: The Crimea on the London Stage, 1854-55', in David Bradby, Louis James, and Bernard Sharratt (eds), *Performance and Politics in Popular Drama: Aspects of Popular Entertainment in Theatre, Film and Television, 1800-1976* (Cambridge: Cambridge University Press, 1980), pp.119-37; BOD, JJC, Dioramas 1 (74).

representation of the army. The impact in art and literature was especially marked.[24] Nonetheless, the war did not improve the army's image so far as recruiting the other ranks was concerned.

The Crimean War remained central to the work of the army's favourite battle artist, Elizabeth Thompson, Lady Butler (1846-1933), through such works as *The Roll Call* (1874) and *Balaclava* (1876), which featured ordinary soldiers prominently.[25] A Balaclava Commemoration Society was formed in 1877, and survivors of the Charge of the Light Brigade were invited to the Queen's Jubilee in 1897. Street names also began to reflect overseas conflicts with Crimean-inspired names such as Alma Street in Weston-Super-Mare and Balaclava Road in Bristol. Thus, despite being limited in terms of geographical extent, the ways in which diplomatic control was largely maintained, and the mobilisation of resources, the war's impact on British popular culture was substantial.

Burford and Selous co-operated (with the assistance of 'Monsieur Letour') on a panorama of the Battle of the Alma, which was shown from December 1854 to April 1856.[26] The scene was the moment at which the Guards and the Highland Brigade reached the Russian Great Redoubt and 'are charging an immense solid mass of Russian infantry upon the hill-side'.[27] In the foreground, the 'remains of the 7th, 23rd and 33rd Regiments are reforming after being so terribly cut up in their first assault. The batteries of Horse Artillery are in position, or hastening at a gallop to their post. Lord Raglan and his staff are advancing towards the scene of triumph.'[28]

The *Art Journal* commented that the depiction of the terrain based on descriptions by 'the best authorities' showed the outcome a 'marvel' that any troops 'whatever their discipline and courage, could have overcome the resistance offered them by such masses of the enemy, and from batteries

24 Matthew Lalumia, *Realism and Politics in Victorian Art of the Crimean War* (Ann Arbor, MI: UMI Research Press, 1984), Hichberger, *Images of Army*, pp.49-58; Stefanie Markovits, *The Crimean War in the British Imagination* (Cambridge: Cambridge University Press, 2009); Ulrich Keller, *The Ultimate Spectacle: A Visual History of the Crimean War* (London: Routledge, 2001), pp.41-70; Sean Willcock, *Victorian Visions of War & Peace: Aesthetics, Sovereignty and Violence in the British Empire, c.1751-1900* (New Haven, CT: Yale University Press, 2021), pp.29-35; Lara Kriegel, 'Who Blew the Balaclava Bugle: The Charge of the Light Brigade and the Afterlife of the Crimean War', *19: Interdisciplinary Studies in the Long Nineteenth Century* 20 (2015) found at https://doi.org/10.16995/ntn.713.

25 Paul Usherwood and Jenny Spencer-Smith, *Lady Butler: Battle Artists, 1846-1933* (Gloucester: Alan Sutton Publishing for the National Army Museum, 1987), pp.28-43; Harrington, *British Artists and War*, pp.133-59, 233-37; Dorothy Nott, 'Reframing War: British Military Painting, 1854-1918', Unpub. Ph.D., York, 2015, pp.31-78.

26 BL, 014583340 [also in NAL, 200.B.271]: *Description of a view of the Battle of the Alma fought on the 20th Sept. 1854, between the allied armies of England and France, and the Russians; now exhibiting at the Panorama, Leicester Square* (London: Golbourn, 1854).

27 *The Press*, 23 Dec. 1854.

28 *The Era*, 24 Dec. 1854.

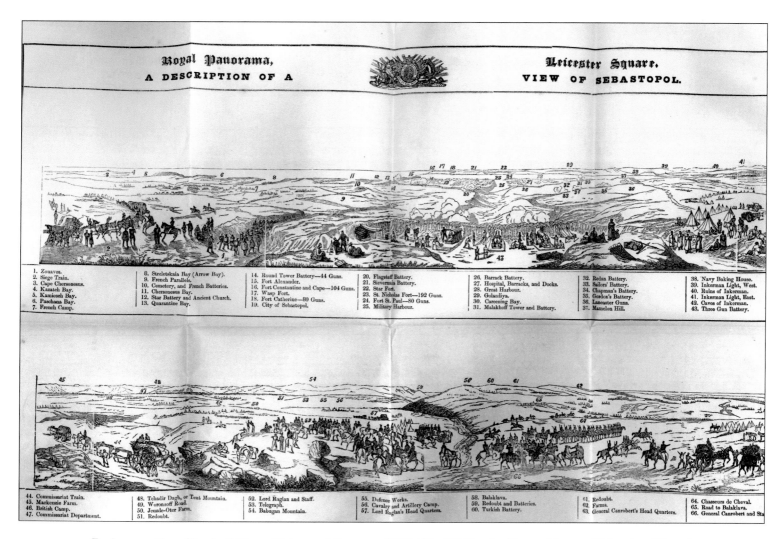

so advantageously placed…'.[29] According to *The Morning Post*, whilst the painting conflated various incidents, it 'realises to the eye all that has been made familiar to the ear for some time past by descriptions from "our correspondents," "our special correspondents," and "communications from other sources."' Thus,[30]

> However graphic that information may have been, it is quite impossible for a civilian to comprehend the enormous strength of the Russian fortified position at Alma until he has seen this admirably exact representation of the spot where the great struggle took place, as well as of the surrounding country, by which he can form an accurate idea of the relative nature of the heights, and a consequent appreciation of the courage by which, under such circumstances, a victory could be obtained.

Reporting the various Christmas attractions in the capital in 1854 for some of the provincial press, a London correspondent noted the exclamation of a young woman viewing the panorama, '"Why," said she, "did the Russians run?" On being told they were compelled to do so by British bayonets, she asked with evident surprise, if the Russians had not bayonets too?' The correspondent had no doubt 'that this excellent representation of the sad realities of war will have the effect of increasing the public sympathy for those actually engaged in the struggle'.[31] In April 1855, the panorama was visited by George, Duke of Cambridge, the Queen's cousin, and soon to become the army's Commander-in-Chief at home. He had been present at the Alma in command of the 1st Division.[32]

Burford and Selous then produced another panorama on the fortifications of Sebastopol as seen from the allied besieging lines with the 'Three-gun Battery' as the focal point. It was shown from May 1855 to February 1856. *The Times* reported,[33]

> The present picture commands on one side the trenches and zigzags, peopled by the besiegers, and leading to a view of Sebastopol, taken before the destruction of the Armenian Church, with the blue sea in the extreme background. In the opposite direction the camps of

29 *Art Journal*, Feb. 1855, 66.
30 *Morning Post*, 25 Dec. 1854.
31 *Stroud Journal*, 30 Dec. 1854; *Poole and Dorset Herald*, 4 Jan, 1855.
32 *Morning Post*, 14 Apl. 1855.
33 *The Times*, 28 May 1855.

Descriptive Guide to Burford's View of Sebastopol Panorama (1856). [Bodleian Libraries, University of Oxford. John Johnson Collection: Diorama folder 3 (77)]

the allies are dotted over a broad undulating country, and a totally different scene is presented. The interest of the subject is increased by the beauty of the execution.

For the *London Daily News*, the scene looked almost too peaceful,[34]

The various troops are represented in a comparative state of repose - here and there some soldiers are cowering to avoid an awkward shell or ball, and some are firing through crevices and loop-holes in the trenches, but otherwise all is serene, and the coveted city wears a smiling *poco-curante* air that is quite provoking.

Punch, too, found the scene one of 'preternatural stillness', although 'a considerable noise is being made by Mrs. Major M'Gab, or some other military lady, who is sure to be present, and to be explaining the positions of the Allies with commanding gestures, in a loud voice'.[35]

 Subsequently, a new panorama by Burford and Selous viewed Sebastopol at the time of the British and French assaults on the main Russian defensive positions of the Redan and the Malakoff (8 September 1855).[36] The first allied assaults on these positions had failed on

34 *London Daily News*, 25 May 1855.
35 *Punch*, 25 Aug. 1855.
36 BL, 014597221: *Description of a view of the city of Sebastopol, and the surrounding fortifications; the attack of the allied armies; the British & French camps, etc. now exhibiting at the Panorama, Leicester Square* (London: Golbourn, 1855); EXBD, 71003, descriptive key; also YCBA, DK 215.7.B87 1855 Copy 1; GRI, N7436.52.I7 A37.

DESCRIPTION
OF
A VIEW
OF
THE CITY OF
SEBASTOPOL,
THE ASSAULTS ON
THE MALAKHOFF AND THE REDAN,
The Retreat of the Russians
TO THE
NORTH SIDE OF THE HARBOUR, &c.

NOW EXHIBITING
AT
THE PANORAMA, LEICESTER SQUARE.

PAINTED BY THE PROPRIETOR,
ROBERT BURFORD,
AND
HENRY C. SELOUS
AND ASSISTANTS,
From Sketches taken by Capt. VERSCHOYLE, *Grenadier Guards,
aided by Photographic Views.*

London:
PRINTED BY W. J. GOLBOURN, 6, PRINCES STREET, LEICESTER SQUARE.
PRICE SIXPENCE.
1856.

18 June 1855 but, although the British failed again to take the Redan on 8 September, the French were successful at the Malakoff, leading to the Russian abandonment of Sebastopol. Information was drawn from Captain Henry William Verschoyle of the Grenadier Guards and use was also made of the photographs of James Robertson, who had photographed the ruins of Sebastopol in September 1855. Verschoyle was himself photographed in the Crimea by Roger Fenton, whilst some of his letters are in the care of the National Army Museum.[37] Private Burry of the Coldstream Guards, who had lost an arm at Inkerman, was employed as an 'assistant explainer' for the Alma and Sebastopol panoramas.[38]

According to the *Art Journal*, the whole scene,[39]

> lies stretched out before the eye of the spectator - who is presumed to be standing on one of the outworks of the Malakoff - in all its terrible vividness: we see the brilliant and successful attacks of the French on this almost impregnable position, our own not less gallant but unfortunate attempt to storm the Redan…

The Times noted that the interest of the spectator was drawn to the French with the British assault 'prudently shrouded in the cloud of battle, but the combined operations of that memorable day are represented with a justness of proportion and effectiveness of illustration which we have seldom seen equalled in pictures of this kind'.[40] The 1856 edition of Burford's description included the various glowing press endorsements including that of *The Times*, which headed the list.[41]

On 26 June 1855 the Queen with Prince Albert, the Princess Royal, and Princess Alice visited the Alma and Sebastopol panoramas, followed by the former Queen of France, Maria Amalia, widow of King Louis Philippe, on the next day.[42] Queen Victoria visited a number of panoramas. Her reaction on this occasion was that they were 'well painted, but not exact'. She was much taken by Private Burry who, 'a fine, tall man with only one arm, having lost the other at Inkerman, was there to explain, acting as showman, & this, I am sure, draws people'.[43] On 18 February 1856 the Queen,

37 RC, RCIN 2500287; NAM 1960-05-88 and 2016-10-23-149.
38 *Sheffield Daily Telegraph*, 28 June 1855.
39 *Art Journal*, Åpl 1856, 126.
40 *The Times*, 21 Feb. 1856.
41 BOD, JJC, Dioramas 3 (77): *Description of a view of the city of Sebastopol, the assaults of the Malakhoff and the Redan, the retreat of the Russians to the North side of the harbour, etc., now exhibiting at the Panorama, Leicester Square* (London: Golbourn, 1856).
42 *Windsor and Eton Express*, 30 June 1855; *Bolton Chronicle*, 7 July 1855.
43 RC, Queen Victoria's Journal, Vol. 39, 356: Entry, 26 June 1855.

Prince Albert, the Prince of Wales, Prince Alfred, the Princess Royal, and Princess Alice made a return visit. The Queen, 'who remained some time, expressed her extreme satisfaction with what she had seen', although she did not pass any comment in her journal other than mentioning the visit.[44]

By contrast, Franz Roubard's Siege of Sebastopol was unveiled in the city in June 1905 for the 50th anniversary of the repulse of the first British and French attack on the city. Its viewpoint was from within the Malakoff. After extensive damage in the Second World War, Roubard's panorama was recreated and re-opened in 1954. Before the 2014 Russian annexation of the Crimea when western visitors could still get there, and to the clear anger of the formidable array of female Russian custodians, Ukrainian guides liked to point out the representation of Joseph Stalin smoking a pipe in a dugout!

Burford's Sebastopol panorama remained on display from February 1856 to March 1857. Various rival panoramas were advertised but did not materialise. Burford took out an advertisement in *The Times* to proclaim his the only one in London or anywhere else 'in consequence of the appearance of announcements at various places, setting forth to the public panoramas which do not exist'.[45]

A painting of the entrance to the Leicester Square rotunda in 1858 by George Shepherd shows the two panoramas currently being shown as 'The Fall of Delhi' and the 'City of Lucknow'.[46] The Indian Mutiny, which erupted at Meerut on 10 May 1857, posed a significant challenge to the rationality and tolerance of Victorian liberal sensitivities.[47] After murdering their officers, mutinous sepoys made their way to Delhi, proclaiming the aged Moghul Emperor, Bahadur Shah II, their leader. Mutiny spread through the summer, British garrisons being cut off in Cawnpore and Lucknow. That at Cawnpore was massacred after its surrender on 26 June, with surviving women and children then murdered on 15 July. Lucknow was finally relieved and its garrison evacuated on 27 November. It took until the summer of 1858 to finally suppress all resistance.

As in the case of the Crimea, the cultural impact was considerable, weeklies such as *Reynolds's Newspaper* and *Lloyd's Weekly Newspaper* attracting a more lower middle-class and working-class readership than the national dailies. Moreover, notwithstanding the disruption in India, much improved telegraph communications meant that news was arriving far more quickly than previously. There was also the prurient nature and morbidity of the mid-Victorian public. European casualties at the Mutiny's outbreak were not as numerous as sometimes supposed, but the butchering of white women and children had a disproportionate and traumatic impact when India had been seen as 'a key site for the realisation of the British ideal of progress,

44 *Morning Chronicle*, 19 Feb. 1856; RC, Queen Victoria's Journal, Vol. 41, 82: Entry, 18 Feb. 1856.
45 Harrington, *British Artists and War*, p.142.
46 BM, Prints and Drawings, 1880,1113.3007. Several publications make the error of ascribing the illustration to Thomas Hosmer Shepherd.
47 John Peck, *War, the Army and Victorian Literature* (Basingstoke: Macmillan, 1998), pp.15-16, 71-93.

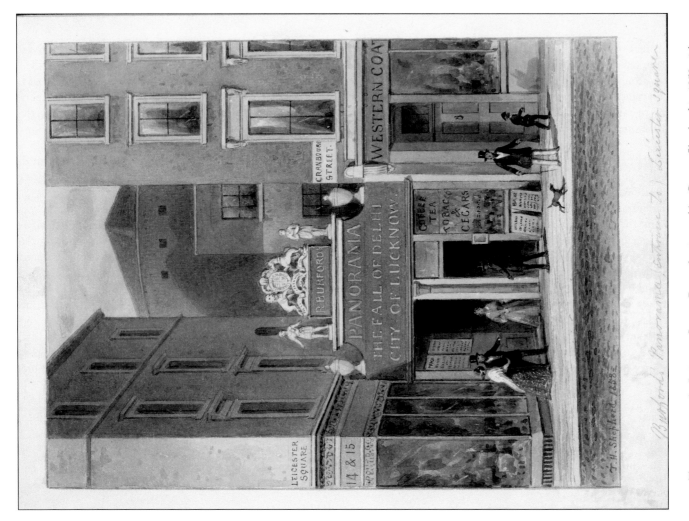

The entrance to the Leicester Square Rotunda pictured by George Shepherd in 1858 with the Fall of Delhi and the City of Lucknow Panoramas being advertised. [British Museum Images/The Trustees of the British Museum]

improvement, and civilisation'.[48] The clamour for revenge was such that it has been argued that the Mutiny represented Britain's 'first national-popular colonial war'.[49]

The two panoramas together were said to 'possess a peculiar interest, from the terrible scenes recently enacted in the cities represented'.[50] The Delhi panorama depicted the 'action between Her Majesty's Troops and the revolted sepoys', and was based on sketches by Captain Robert Smith, RE. The first British assault breached the defences on 14 September 1857 and was marked by the blowing in of the Kashmir Gate, for which Lieutenants Duncan Home and Philip Salkeld (posthumously), Sergeant John Smith and Bugler Robert Hawthorne were all awarded VCs. The 'hero of Deli', the charismatic Brigadier John Nicholson, who led the assault once the breach was made, was mortally wounded in the ensuing fierce street fighting. The panorama, however, settled for a view of fighting taking place outside the Mughal Emperor's Palace. The guidebook admitted that it represented 'one of those terrific encounters… that were of daily, indeed almost hourly occurrence'. Thus, it was a 'faithful and vivid picture of many interesting incidents and sanguinary single-handed encounters, which, although they did not actually take place at the precise time, or on the exact spot, have, with an artist's licence, been introduced to give greater spirit and effect to the scene'. [51]

It was absolutely uncompromising in its representation of the mutineers as opposed to the British and their Sikh and Gurkha allies, who were exacting 'dreadful but just retribution' for 'the most fearful crimes and revolting cruelties that the most atrocious and diabolical natures could conceive'. As the guidebook continued:

In every direction the Sepoys, although fighting with the ferocity of wild beasts, their eyes scowling hatred and fanaticism, are giving way before the cool courage and stern determination of their opponents; the wretches who knew no mercy have none shown to them, and fall by hundreds, mingling their foul blood with that of some of the best and bravest of their foes, who fell in one of the noblest struggles that ever consecrated warfare. Half-distracted women are seen mingling in the fight in the vain hope of saving some beloved husband or relative, and

48 Christopher Herbert, *The War of No Pity: The Indian Mutiny and Victorian Trauma* (Princeton, NJ: Princeton University Press, 2008), p.29. On the cultural impact of the Mutiny on theatre and popular entertainment, see Marty Gould, *Nineteenth-Century Theatre and the Imperial Encounter* (Abingdon: Routledge, 2011), pp.161-87.
49 Graham Dawson, *Soldier Heroes: British Adventure, Empire and the Imagining of Masculinities* (London: Routledge, 1994), p.81.
50 *Sharpe's London Magazine*, July 1858.
51 GL, A 9.1 NO 9 IN 66: *Description of a view of Delhi, with an action between Her Majesty's troops and the revolted sepoys: Now exhibiting at the Panorama, Leicester Square* (London: Golbourn, 1858); also YCBA, DS486.D3 B87 1858; GRI, N7436.52.I7 A37.

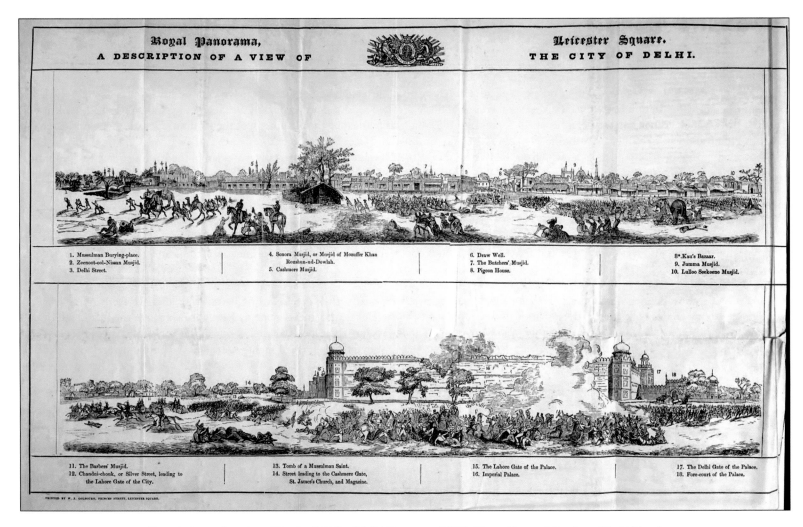

1. Mussulman Burying-place.
2. Zeenoot-ool-Nissan Musjid.
3. Delhi Street.

4. Sonora Musjid, or Musjid of Mozuffer Khan Roushun-ud-Dowlah.
5. Cashmere Musjid.

6. Draw Well.
7. The Butchers' Musjid.
8. Pigeon House.

8*. Kau's Bazaar.
9. Jumma Musjid.
10. Lulloo Seekeene Musjid.

11. The Barbers' Musjid.
12. Chandni-chouk, or Silver Street, leading to the Lahore Gate of the City.

13. Tomb of a Mussulman Saint.
14. Street leading to the Cashmere Gate, St. James's Church, and Magazine.

15. The Lahore Gate of the Palace.
16. Imperial Palace.

17. The Delhi Gate of the Palace.
18. Fore-court of the Palace.

PRINTED BY W. J. GOLBOURN, PRINCES STREET, LEICESTER SQUARE.

Descriptive explanation of Burford's Fall of Delhi Panorama (1858). [Getty Research Institute/Hathi Trust]

affrighted children are seen running wildly here and there, but unmolested, for they were everywhere respected and saved; the British soldier fought to the death against the ravisher and the murdered, but even in the heat of revenge, respected women and children.

As described in the *Art Journal*, 'English soldiers, Sikhs, Ghoorkhas, Sepoys, native men, women and children, elephants, artillery, in large masses or in small groups, are seen fighting or fleeing along the esplanade on the south-west of the palace, looking towards the city'.[52] *The Times* also reviewed the panorama, noting that there was 'necessarily less of the picturesque character in this work than in most of those exhibited' at Leicester Square. However, 'the opportunity of showing the architectural wonders of the place has not been lost, and rising above the scene of tumult and desolation appear the minarets and cupolas of the beautiful mosques for which Delhi is renowned'.[53] It was displayed from January 1858 to February 1859.

The view of Lucknow was based on sketches by Bland Hood Galland of the East India Company, this panorama being shown from March 1858 to May 1859.[54] According to the *Art Journal*, the view of Lucknow from the Residency before the siege 'offers to the spectator nothing that he can associate with the horrors which have been perpetuated within the city'.[55] Also commenting, *The Times* found the more peaceful scene 'rather fortunate than otherwise, for the picture of Delhi is an animated battle-piece, and the spectator, satiated with the scene of turmoil that it offers his gaze, will repose himself agreeably in contemplating another Indian city bright with every accessory of peaceful splendour'. Nonetheless, the approach taken by Sir Colin Campbell in the final relief of the defenders was readily apparent from the depictions of the buildings 'and thus a link is formed between the unsullied beauties of a former day and the events that kept the public mind in a state of agitation during the latter half of last year'.[56]

Burford's advertising handbills included press endorsements, led by that of *The Times*. Thus, *Bell's Weekly Messenger* proclaimed it 'the most finished specimen of artistic excellence that has for a long time past been given to the public, even by Mr. Burford himself'.[57]

One of the last of the Burford panoramas at Leicester Square - again a collaboration with Selous - was a view of Canton after its bombardment and capture (1 January 1858) in the Third China War (1856-60). It was taken from photographs supplied by the Royal Engineers, courtesy of the

52 *Art Journal*, Mar. 1858, p.94.
53 *The Times*, 25 Jan. 1858.
54 Hyde and Wilcox, Panoramania, p.64; NAL, 200.B.271, *Description of a view of the city of Lucknow, taken from the residency: now exhibiting at the Panorama, Leicester Square* (London, 1858); also EXBD, 71003.
55 *Art Journal*, May 1858.
56 *The Times*, 27 Mar. 1858.
57 BOD, JJC, Dioramas 4 (16), handbill, 19 June 1856.

Secretary of State for War, General Jonathan Peel, and the Inspector-General of Fortifications, Sir John Fox Burgoyne. The view point was 'Mann's Battery' on one of the highest points within the walls on the north of the city.[58]

Bell's Weekly Messenger made the point evident in the case of so many panoramas that few Europeans knew anything of the city, which had been *terra incognita* before British and French troops occupied it and had since been closed once more,[59]

> Now, however, persons of every country and clime can tread its narrow alleys - streets they cannot be called - and become acquainted with the internal arrangements of a people said to be civilised, but who most assuredly are yet many centuries behind the western portions of the world on the road to actual progress.

It praised scenes that were revealed 'with all the force of stereoscopic and photographic sharpness', suggesting Burford had not lost his touch after almost 30 years in the business.

In that time, Robert Burford had capitalised upon the growth of empire and the concomitant colonial campaigns, but the Leicester Square rotunda closed before the accelerated expansion of British possessions after 1870 and the burgeoning of the culture of popular imperialism. Prior to the revival of the 360° panorama in the 1880s, exploitation of popular imperialism would be left to the moving panorama.

58 Harrington, *British Artists at War*, 176; *Art Journal*, Apl 1859, 126; *London Daily News*, 7 Mar. 1859.
59 *Bell's Weekly Messenger*, 5 Mar. 1859.

5

The Moving Panorama and Panorama Al-fresco

Interest in panoramas had waned by the early 1860s with two exceptions. What were characterised as moving panoramas and as dioramas retained their appeal throughout the nineteenth century. Moving panoramas - a term first used around 1805, although they had appeared as early as 1797 - were linear canvasses displayed between revolving spools.

The term diorama will convey to many, small-scale scenes using model soldiers such as 'The Kings' Armies through the Ages' series of 15 scenes of British battles by Otto Gottstein (and assistants including Denny Stokes) ranging from Caesar's landing in 55 BC to D-Day (6 June 1944) that were exhibited at the former Royal United Service Museum in the Banqueting Hall in Whitehall from 1937 until it closed in 1962.[1] Alternatively, dioramas can also mean the large-scale curved paintings (less than 180°) with modelled foregrounds that remain a feature of many military museums in Russia, China, North Korea, and elsewhere.

In the nineteenth century, however, dioramas - first developed in France in the 1820s - had a different meaning. They were introduced to London in a building in one of the Nash terraces in Regent's Park by Louis Daguerre in 1823. Dioramas usually seated the audience in a slowly rotating amphitheatre. Changing scenes were lit in such a way as to give the illusion of depth with the use of various colour screens and shutters adding to

1 *The Kings' Armies Through the Ages* (London: Royal United Service Museum, n. d. [1937]). Five went to the Glenbow Museum in Calgary, one of which is still displayed there. One is displayed at the Regimental Museum of the Staffordshire Regiment, one at the Eastbourne Redoubt Museum, one at the Thurrock Museum, and part of one at the Hastings Museum. One formerly displayed at the old Rotunda Museum of the Royal Artillery at Woolwich has since disappeared, as has one formerly held by the Royal Military School of Music at Kneller Hall. The author has a hazy recollection of at least one displayed at the Castle Museum in York in the late 1960s.

the effect of a canvas painted on both sides of finely woven cloth with some parts unpainted and thereby transparent. The *Penny Magazine* described a diorama in September 1842:[2]

> The arrangement is somewhat as follows:- Let the reader conceive a circular room or rotunda, about forty feet in diameter, with two square openings or windows communicating with two rooms. At the farther end of each room, opposite the opening, is a very large picture, and the ceiling is provided with windows or lights susceptible of much change in arrangement. Within the rotunda is a smaller rotunda capable of rotating horizontally around its centre; it is nearly equal in diameter to the outer one, but has only one opening instead of two. The ground of the inner rotunda is occupied by tiers of gradually rising seats for the spectators; and no light can gain admission but that which passes through the single aperture or window. The consequence of this arrangement is, that when the opening in the inner rotunda coincides with one of those in the outer one, the spectator can see the picture at the farthest end of the open room; but when the inner rotunda is so far turned as to bring its aperture away from both those in the outer rotunda, all is in darkness. Hence the spectator is allowed to see one picture, and then to see the other picture, by the platform on which he stands or sits being made to rotate.

Panoramas may have attracted most those of 'the same social class who visited the annual art exhibitions of the Royal Academy, attended opera, subscribed to the illustrated papers, and purchased paintings and prints'.[3] The audience for moving panoramas was different. There was certainly still, in part, the educational aspect to panoramas noted previously. Moving panoramas and dioramas were part of a wider entertainment experience that might include lecture, song, and comedic performances. It was very much in the tradition of touring theatrical troupes, fairground attractions and, later, the 'dissolving views' of magic lantern shows. Especially in the provinces, such entertainments suggested more of a mass audience. A caricature by Charles Williams, 'The Moving Panorama or Spring Gardens Rout', published by Fores in June 1823, satirised the motley crowd of the aristocratic, the fashionable, and others attempting to enter the Great Room at Spring Gardens to see Messrs. Marshalls' moving panorama of the coronation of King George IV, and showing little interest in a rival moving panorama of a tour along the banks of the Clyde.[4] Moving panoramas

2 'On Cosmoramas, Dioramas and Panoramas', *The Penny Magazine* 11 (1842), pp.363-64: issue of 17 Sept. 1842.
3 Harrington, 'Entertaining Battles', pp.64-69.
4 LMA, SC/PZ/WE/02/0271.

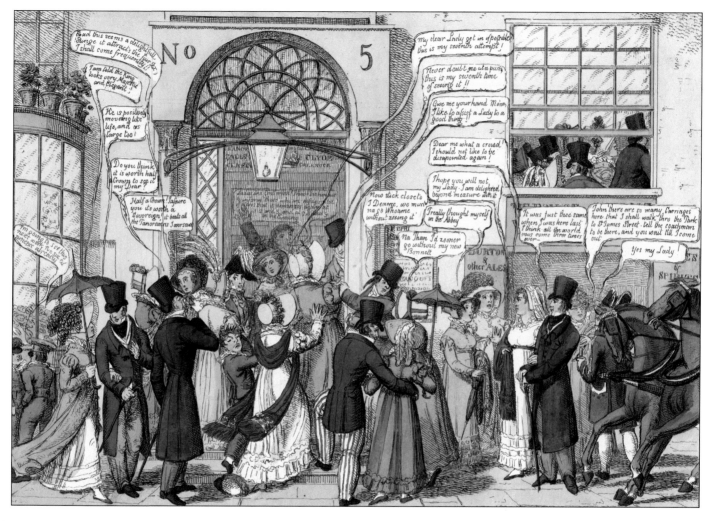

'The Moving Panorama or Spring Gardens Rout', Cartoon by Charles Williams (1823). [London Metropolitan Archives, City of London: SC/PZ/WE/02/0271]

GREAT ROOM, SPRING GARDENS.

DESCRIPTION

OF

MARSHALL'S GRAND HISTORICAL PERISTREPHIC

PANORAMAS,

BATTLE OF GENAPPE,

ST. HELENA,

AND THE

MOST INTERESTING EVENTS THAT HAVE OCCURRED TO

BONAPARTE,

FROM HIS DEFEAT

At the Battle of Waterloo,

Until the Termination of his Earthly Career at ST. HELENA;

AND THE MEMORABLE

BATTLE OF TRAFALGAR,

THE FIGURES THE SIZE OF LIFE;

The Ships of War on the largest Scale ever delineated on Canvas.

DAY EXHIBITIONS to commence at 12, 1, 2, 3, & 4 o'Clock;
EVENING EXHIBITIONS, at 7 and Half-past 8 o'Clock.

LONDON:

PRINTED BY W. ROBARTS, 16, SHOE-LANE, FLEET-STREET.

1825.

Descriptive Guide to Marshalls' Moving Panorama of the Battle of Genappe, St Helena, the career of Napoleon, and the Battle of Trafalgar (1825). [Lennox-Boyd Panoramas Collection, Special Collections and Archives, University of Kent]

were certainly much easier to move around than 360° panoramas and could be displayed almost anywhere, panorama entrepreneurs approaching towns and communities, arranging schedules, and agreeing terms.[5]

One commentator on seeing Messrs. Marshalls' moving panorama of the battles of Ligny (16 June 1815), Quatre Bras (also 16 June 1815) and Waterloo suggested it attracted the same audience as a peep-show. They were 'adapted to amuse and satisfy the tastes of that class of persons alone who frequent the aforenamed halfpenny exhibitions'. They should be confined, he thought, 'to the fairs, to which by right of demerit they belong'.[6]

It also needs to be emphasised that the artists responsible for moving panoramas and dioramas did not undertake the research or travel employed for the production of panoramas. Whereas panoramas were painted in oils, moving panoramas were in cheaper water-based distempers favoured by theatrical scene painters. By the 1880s, it is likely that they were based largely on the illustrations from the periodicals, but their battle scenes were likely to be far more impressionistic than those in panoramas. There would be an even greater emphasis upon the dramatic, and upon the received image of any particular action.

Another visitor to Messrs. Marshalls' moving panorama of Ligny, Quatre Bras and Waterloo when shown at Spring Gardens in the 1820s noted,[7]

5 Peter Harrington, 'The Anatomy of a Moving Panorama: John James Story's Ocean and Overland Journey Round the World', *International Panorama Council Journal* 4 (2020), pp.59-65.
6 Erkki Huhtamo, 'Penetrating the Peristrephic: An Unwritten Chapter in the History of the Panorama', *Early Popular Visual Culture* 6 (2008), pp.219-38, at p.230.
7 Huhtamo, 'Penetrating the Peristrephic', p.227.

Scenes representing the principal events were, in succession, and apparently on the same canvas, made to glide across the field of view, so designed that the real motion of the picture gave to the spectator the feeling of the events being only then in progress, and with the accompaniments of clear narration and suitable music, they produced on those who viewed them the most complete illusion.

Yet another commented on being attracted to enter the same show by 'the Peristrephic music shaking the tiles off the neighbouring houses' and then seeing the 'charges of cavalry and discharges of infantry, great guns, thunderbombs, flying artillery, lying troops, and dying soldiers'.[8] Similarly, a German prince, Hermann von Pückler-Muskau, visiting Marshalls' moving panorama of the Battle of Navarino in Dublin in August 1828 recorded, 'A man describes aloud the objects represented, and the distant thunder of cannon, military music, and the noise of battle, increase the illusion.' The 'slight undulation of that part which represents the waves and the ships' added further so that 'the imitation almost reaches reality'. It is assumed that the image of the waves was separated from the main canvas with some kind of rotating mechanical device behind it used to suggest movement.[9]

A description 'behind the scenes' when one of the leading moving panorama shows - Hamilton's Excursions - was at Leeds in 1896 is worth quoting at length,[10]

There is not much mystery behind the scenes. Anyone can imagine it. A gigantic frame-work with upright cylinders at each end round which the scenes are wound and unwound; rows of countless gas jets now glowing with blinding brightness and now subdued to tiny beads of light; a number of silent machinists, stationed at their posts on the stage or perched aloft on the framework; drums, "rain boxes," and other stage contrivances to imitate military and atmospherical convulsions; the music of the orchestra mingling with the slightly perceptible rustle of the shifting canvas; and the luminous glow of the lighted hall seen through the dark red drapery which forms the proscenium... On each side of the stage there are six upright revolving cylinders, some wrapped round with the painted cloths and others with a kind of gauze. The movement of the gauze in front of the picture imparts to it a certain atmospherical illusion. At the top of each cylinder is a kind of horizontal capstan, the handles of which are turned by men who are experts at their business and require a special training... At the top of the canvas is seen a stout band of webbing with a row of little balls or buttons. It is the business of the men who turn the capstan to see that these buttons slide into a groove so that the picture may be borne along in suspension. It is also their business to fix hooks here and there into the webbing

8 Ibid, p.228.
9 Erkki Huhtamo, *Illusions in Motion: Media Archaeology of the Moving Panorama and Related Spectacles* (Cambridge, MA: MIT Press, 2013), pp.69-70.
10 *Yorkshire Evening Post*, 28 November 1896.

at the top of the canvas, so as to keep it tightly wrapped round the cylinder and held taut from side to side. As the picture passes along a manipulator is giving it out at one side while another is receiving it at the other side. Some of the pictures are 28 ft. by 16 ft., while others are 36 ft. by 20 ft… The explanation of the dioramic change, when one picture instantly disappears and another takes its place, is simple enough. In that case the picture is a double one; the canvas is painted on both sides, each with a different view. The first picture shown is that on front of the canvas, with all the lights on in front. Then the lights are lowered in front and put full on at the back, and the picture painted on the back is forced through by the light. All this requires delicate calculation on the part of the artists... The pictures are, of course, painted in distemper; if painted in oils there would be confusing lights and shadows… Whilst behind the scenes, I noted that the panorama had once or twice ceased to move, and there was a pause in the glowing description of the *cicerone*…On those occasions, variety artists, who had been waiting their "turns", slipped out from the wings into the sight of the audience, and earned loud applause by their performance.

By this time, moving panoramas were larger than in earlier years and now required a special train of five large trucks. The frame alone would cost in the region of £1,000, a first rate tableau by a leading artist costing around £400. Yet, they were still cheaper than static panoramas. They were also exceedingly popular. When Marshalls' Ligny, Quatre Bras and Waterloo was shown on a tour of the West Country taking in Bath, Bristol, Exeter and Plymouth between September 1822 and August 1823, over 22,000 visitors were recorded at both Bath and Bristol. Tickets cost 2s.0d for a box and 1s.0d in the gallery. Some moving panoramas were purely regional in their circulation such as 'Scenes of the War in Afghanistan' by a local Plymouth artist, Samuel Cook, which was shown there as well as at Truro, Helston, Penzance, Exeter, and Tiverton in 1843-44.[11] At Tombland Fair in Norwich in April 1844 there were no less than four rival moving panoramas on show, one of Waterloo and three of the First Afghan War.[12]

Family firms tended to dominate such as George Danson & Sons, Messrs. Hamilton, Messrs. Marshalls, and Messrs. Poole. They used multiple sites throughout the country, their productions travelling from one to another with different shows on offer simultaneously. Marshalls' 'Grand Marine Peristrephic Panorama of the Bombardment of Algiers', for example, was shown at 16 different venues between 1819 and 1827.[13] Hamiltons

11 John Plunkett, 'Moving Panoramas c. 1800 to 1840: The Spaces of Nineteenth-Century Picture-Going', *19: Interdisciplinary Studies in the Long Nineteenth Century* 17 (2013) found at https//doi.org/10.16995/ntn.674.
12 *Norfolk Chronicle*, 6 Apl. 1844.
13 Ralph Hyde, *Dictionary of Panoramists of the English-speaking World*, (2015) p.74. Found at https://www.bdcmuseum.org.uk/uploads/uploads/biographical_dictionary_of_panoramists2.pdf. See YCBA, DT 291 B75 1818 for the descriptive key.

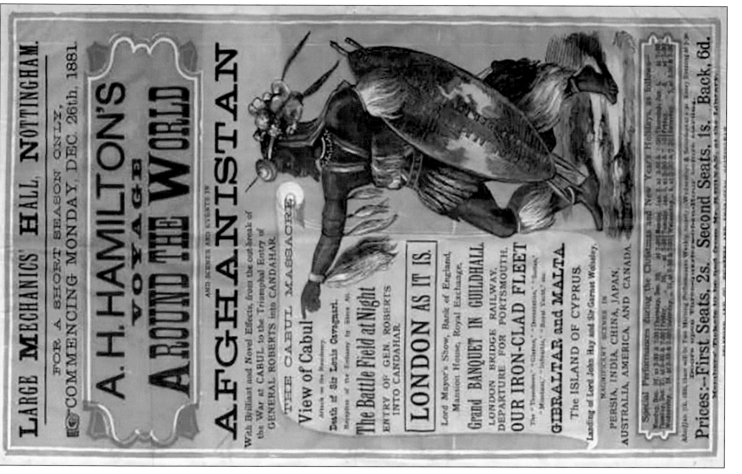

Advertisement for Hamilton's Voyage around the World at Nottingham, featuring the Second Afghan War (1881). [The Bill Douglas Cinema Museum, University of Exeter]

were based in Manchester and had a 13- week annual residence at the Free Trade Hall, whilst commonly presenting shows at the same time at Birmingham, Dublin, Leeds, Liverpool, 'and one or two Scottish towns'.[14]

Dioramas were not necessarily topical in subject. Moving panoramas, however, would often depict contemporary military scenes as part of a wider theme of journeys such as the inclusion of the Poona Light Horse in 'London to Hong Kong in Two Hours' displayed by the Lamb brothers in 1860.[15] Thus, whilst military actions were well suited for moving panoramas, they might form only some of the scenes in any given entertainment. From the early shows of perhaps 10 or 12 scenes on one roll displayed in 30-60 minutes, shows now commonly lasted two hours. Indeed, typically, moving panoramas were journeys such as the highly popular American import, John Banvard's trip down the Mississippi, which was exhibited in London in 1851 and was estimated to have been seen by five million people worldwide.[16]

To give an example, in November 1888, 'Under Two Flags', presented by William Hamilton at the North London Colosseum, began with an Atlantic voyage from Liverpool to New York. It was followed by crossing the prairie 'where the train is attacked by Indians, and rescued by cowboys'. It continued across the Pacific to Canton, Burma, and Afghanistan, where 'we are shown Generals [Sir Frederick] Roberts and [Sir Samuel] Brown [Browne] receiving the submission of the native chiefs' in the Second Afghan War (1878-80). Then it was on to the Middle East including Jerusalem and Constantinople, the battle of Abu Klea in the Sudan (17 January 1885), the slave trade 'on the dark continent', and 'General [Charles] Gordon's night halt in the desert'. Stops were made at Milan, Rome, Venice, Switzerland, and Paris, before the 'traveller' came home to Dover. Supporting performers included the 'Three Cobras' and 'Professor' Devril and his performing dogs.[17] Similarly, Charles Poole's 'New Myriorama Trips Abroad' in 1886 - an extensive world tour - included the bombardment of Alexandria (11-13 July 1882) that had immediately preceded Sir Garnet Wolseley's campaign to occupy Egypt, Wolseley's victorious return to Charing Cross Station, and the Queen's review of the returning troops.[18]

Rolled linear narratives sold in tubes were also popular. Such souvenir reproductions, for example, survive for William Ludlow's 'Bengal Troops on a Line of March' (c. 1835), and Frederic Layard's 'Line of March of a Bengal Regiment of Infantry', (c. 1845).[19]

14 *Yorkshire Post*, 28 Nov. 1896.
15 BOD, JJC, Dioramas 1 (38A); Ralph Hyde, 'London to Hong Kong in Two Hours: A Victorian Moving Panorama', in *More Than Meets the Eye*, pp.84-87. It came up for auction at Sotheby's in December 2018: see *Daily Telegraph*, 7 Dec. 2018.
16 John Hanners, 'The Great Three-Mile Painting: John Banvard's Mississippi Panorama', *Journal of American Culture* 4 (1981), pp.28-42.
17 *The Era*, 17 Nov. 1888.
18 Huhtamo, *Illusions of Motion*, p.291.
19 ASKB, ocm31310142, ocm56384824.

Handbill for Laidlaw's Moving Panorama of Waterloo at Brighton (1831). [National Fairground Archive, Special Collections and Archives, University of Sheffield]

On other occasions, however, military events could form the central focus of major moving panoramas. James Howe, who may have been linked to the Marshalls, showed a moving panorama of Waterloo at York Place in Edinburgh in June 1816, to which six new scenes were added to depict the action at Quatre Bras. It was shown subsequently in Clyde Place, Glasgow.[20] Similarly, O. J. Richardson exhibited a panorama of Waterloo in Peterborough in 1817, the 1s.0d admission being reduced to 6d for children and 'the labouring classes'.[21] It also seems to have been exhibited in Birmingham. Given that it was characterised as a 'portable panorama' then, it was clearly a moving panorama. Another moving panorama of Waterloo by William Turner appeared in Birmingham in 1817.[22]

Yet another moving Waterloo panorama, with ten scenes, was shown at Glasgow in 1821, whilst in 1831, J. B. Laidlaw, who was associated with Messrs. Marshall but also developed a number of panoramas of his own, displayed a moving panorama of Waterloo of eleven scenes at Brighton covering 16,000 sq. ft. of canvas. Previously exhibited at Spring Gardens, it encompassed Ligny, Quatre Bras, and the pursuit of the French after the battle, and was accompanied by a military band. It included the deaths of the Duke of Brunswick and Sir

20 *Caledonian Mercury*, 8 June 1816; A. D. Cameron, *The Man who Loved to Draw Horses: James Howe 1780-1836* (Aberdeen: Aberdeen University Press 1986), pp.27-32; Huhtamo, *Illusions in Motion*, pp.66-67; EXBD, 100197/100198: *The Grand Panorama of the Battle of Le Quatre Bras*.

21 *Stamford Mercury*, 6 June 1817; NLS, Crawford.FR. 861: *Description of the Battle of Waterloo Illustrative of the Representation of that Great Event in the Portable Panorama, Planned, Erected, and Painted Expressly for the Purpose of Exhibition in the Country* (London: Haws, 1816).

22 Trevor Fawcett, *The Rise of English Provincial Art: Artists, Patrons, and Institutions outside London, 1800-1830* (Oxford: Clarendon Press, 1974), p.154.

Thomas Picton, and the capture of the French Eagles of the 45th Regiment (by Sergeant Charles Ewart of the Scots Greys) and 105th Regiment (by Captain Alexander Kennedy Clark of the Royal Dragoons), although suggesting erroneously that both were captured in the same charge. Laidlaw's panorama was reported as being 'a restless magnet with the military, and their friends cannot but be influenced by their example'.[23]

No relation to the Barkers in London, M. Barker and Co.'s 'Grand Revolving Dioramic Panorama' - combing a Greek defeat of the Turks in the Greek War of Independence (1821-29), and Waterloo - was shown in Dublin in December 1824. Emphasis was laid on it being the only moving panorama to depict the French retreat from the field, and wounded officers and men in Waterloo village on the following morning. As with other moving panoramas, a band was present to add to the experience. Supposedly 10,000 figures were depicted on 16,000 sq. feet of canvas.[24] At the same show, similar moving panoramas included the storming of Seringapatam and the Battle of Ligny.

It is not apparent which Turkish defeat was depicted and, indeed, the arrival of Egyptian forces in the Peloponnese in 1825 would soon seriously impact on Greek resistance. The first four scenes were devoted to the Greek War, with the remaining four scenes showing Ligny and Waterloo, the flight of Napoleon and the retreat of the French army, the capture of Napoleon's carriage at Genappe, and the village of Waterloo the morning after the battle.[25] It was shown subsequently in Bristol, Leeds, Liverpool, Norwich, Nottingham, Salisbury, Torbay, Weymouth, and in the Channel Islands.[26]

Earle's 'Grand Moving Peristrephic Panorama of the Siege of Hull in 1643' opened at the Olympic Circus in Hull in March 1829. Its eight scenes depicted the unsuccessful Royalist siege of Hull (2 September-12 October 1643) in the First English Civil War (1642-46). Shown were actions at Beverley, Anlaby, Hessle, and Kirk Ella; the destruction of Paul Church and of Royalist siege batteries by bombardment from the Parliamentary fleet; Royalist assaults; and the Royalist bombardment of the city. It claimed to show 2,000 figures, 200 of them life-size, on 3,000 sq. feet of canvas. The work of local artists, it had been two years in the making. It was also shown at the Music Hall in Albion Street, Leeds. By April, attendances in Hull had fallen off despite the free admission of children from two workhouses, and the intention to offer similar free entry to pupils from the

23 National Fairground Archive, 178T1.197; R. E. Foster, *Wellington and Waterloo: The Duke, the Battle and Posterity, 1815-2015* (Stroud: Spellmount, 2014), pp.113-14.
24 *Dublin Evening Mail*, 1 Dec. 1824.
25 *Leeds Intelligencer*, 25 Mar. 1824.
26 BL, 0146555043: *Last Week. Napoleon panorama, now exhibiting in the Exchange Rooms, Nottingham, will positively close on Saturday, January 11, 1823, owing to other engagements. M. Barker and Co. (from London) most respectfully inform the inhabitants and gentry of Nottingham and its vicinity, that they have brought here and fitted up at a great expense their original and only correct grand historical Peristrephic panorama of the Battle of Genappe, St Helena! And the funeral procession of Buonaparte.* (Nottingham: Stretton, 1823); also EXBD, 69645.

Advertisement for Gompertz's Diorama of the Indian Mutiny at St James's Hall (1858). [Bodleian Libraries, University of Oxford. John Johnson Collection: Entertainment folder 7 (3A)]

Lancasterian School. It was announced that testament to the accuracy of the painting was the discovery of cannon balls and tools on the site of the Half Moon Battery depicted on the canvas.[27]

Some years later, in September and October 1856, a scenery painter named Lancaster had equal success attracting large crowds in Hull and Driffield with his moving panorama of the 'Late Crimean War', which was advertised as being under the patronage of Lord Lovaine (later the 6th Duke of Northumberland), the Conservative MP for North Northumberland from 1852-65; Lieutenant General Sir Harry Smith; and the man who had led the Charge of the Heavy Brigade, Major General (later General) the Hon. Sir James Yorke Scarlett. Pupils of the Hull Ragged and Industrial Schools were admitted free. Of the accompanying band, it was suggested that 'the performances of the infant drummer are surprising'.[28]

James Wyld's 'Great Globe', located in Leicester Square between 1851 and 1862, displayed moving panoramas on such themes as the Indian Mutiny and the Third China War in the space underneath the giant hollow sphere in which the earth's continents and oceans were depicted in relief.[29]

One moving panorama by the showman, Moses Gompertz (c. 1812-93) depicted the Mutiny. It included scenes of Delhi, the defence and relief of Lucknow, and blowing mutineers from guns at Peshawar.[30] A lecturer explained each scene, with a 'saxtuba' band performing between each. However, it was heavily criticised for including a 'revolting' scene of the massacre at Cawnpore.[31] It was 'too painful for an exhibition designed for popular entertainment', and 'calculated to excite emotions which it is not desirable to awaken'.[32] 'Professor' Groves, who operated a mechanical theatre with automaton figures known as an 'ediophusikon', also presented a 'new and magnificent colossal diorama of Turkey and India' at Shipley and Bradford in 1858. This included the 'Great War in India' with scenes of Meerut, Agra, Peshawar, Cawnpore, and 'the bombardment and fall of Delhi'.[33]

Earlier, Gompertz had exhibited panoramas of the First Anglo-Sikh War, the First Afghan War, and the Crimea. His 'Panorama of the Invasion of British India by the Seikh [sic] Army of the Punjaub', with 14 scenes including the Battles of Ferozeshah and Aliwal, was shown at Exeter in May 1849 and at Norwich in January 1853. It was advertised as 'showing on all sides the most determined bravery, hand-to-hand combats of the

27 *Hull Advertiser and Exchange Gazette*, 30 Jan. 1829; *Hull Packet*, 31 Mar. and 21 and 28 Apl. 1829; *Leeds Patriot and Yorkshire Advertiser*, 4 July 1829.
28 *Hull Packet*, 5 and 20 Sept., and 10 Oct. 1856; *Hull Advertiser and Exchange Gazette*, 20 Sept. 1856.
29 Oettermann, *Panorama*, p.90.
30 *Leamington Spa Courier*, 23 Jan. 1858; BOD, JJC, Entertainments 7 (39), advertisement.
31 *Illustrated London News*, 8 May 1858; Altick, *Shows of London*, p.481.
32 *Cheltenham Looker-On*, 13 Mar. 1858.
33 YCBA, C20171; *Bradford Observer*, 2 Dec. 1858.

fiercest description, bold rencontres between horse and foot, the desperate stand of the British against numbers, while suffering under the exhausting influence of hunger and thirst'. It might be noted that this was an almost identical press description of Burford's Sobraon panorama.

For good measure it was suggested that when shown at garrison towns, it had drawn visits from 'numerous heroes' from the 9th, 31st and 62nd Foot, all of whom had 'given their valuable testimony as to the extreme accuracy of the views depicted'. Accompanied by a band, there were five morning and eight evening shows with first class seats at 2s.0d, second class at 1s.0d and half price admission for juveniles under 12, and for schools. The show also included scenes of the Great Fire of London showing the city before and after the fire, and the Crypt of the Holy Sepulchre at Jerusalem. [34]

Of Gompertz's 'Colossal Panorama illustrating the War with Russia', then appearing at Clifton, *Punch* commented,[35]

The war is not confined to the Crimea but it has been carried into the very heart of England, and has even found its way to Clifton, whose walls bear the marks of some tremendous broadsides, which have been poured into the place, with the hope of taking it by storm, and laying siege to the pockets of the inhabitants... It appears from Gompertz's printed declaration of war, that he has for twenty years been engaged in hostilities - on canvas - with the enemies of this country; for "stimulated by the general appreciation of his war with China, on a prior occasion, that of the Cabul passes," he has, it seems, gone to war with Russia on a scale of magnitude and an extent of canvas far exceeding his former achievements.

The scenes included Constantinople, the Bosphorus, Scutari, and the Black Sea by moonlight.[36]

Even Robert Burford tried his hand at a moving panorama, the 'Grand Historical Moving Military Panorama of the War in the East, Baltic and Black Sea' touring the provinces in 1855 and 1856, including Bridport, Chelmsford, and Lancaster.[37] Seeing an advertisement for the panorama in Shrewsbury, one periodical correspondent wondered if that at Leicester Square had disappeared. He was happy to discover it 'just where it was - not only in the columns of advertisements, but in Leicester Square also'. Success was wished 'to the artist through whose enterprise the denizens of rural

34 *Exeter Flying Post*, 10 May 1849; EXBD, 63580, extract from *Norfolk Annals*, 1852-53.
35 *Punch*, 16 Dec. 1854.
36 EXBD, 63578, handbill.
37 *Lancaster Guardian*, 1 Sept. 1855; *Bridport News*, 21 June 1856; *Essex Standard*, 12 Dec. 1856.

towns, as well as those of the metropolis, will learn to know the landmarks of that fatal region which will henceforth claim a prominent place in the annals of our times and country'.[38]

The surviving moving panorama at Brown University, Providence, Rhode Island celebrating the exploits of the Italian nationalist, Garibaldi, created by John Story of Nottingham, is believed to have been purchased by Burford in 1863 and taken to the United States. Story was a journeyman panorama artist and created a number of moving panoramas including such subjects as Trafalgar, the Afghan Wars, and the Zulu War (1879). Story's best known moving panorama was an 'Ocean and Overland Journey around the World', which was toured extensively throughout England between 1864 and 1885.[39]

Inspired to try and emulate Banvard's success with the Mississippi moving panorama, Thomas Grieve (1799-1882) and William Telbin (1813-73) exhibited dioramas of the Crimean War in the Gallery of Illustration at 14 Regent Street, the lease of which they took on in 1850. They were assisted by the watercolourist John Absalom and the leading animal artist, John Herring. Scenes included the Alma, Sebastopol, Balaclava, and, later, Tchernaya (16 August 1855), at which French, Sardinian, and Ottoman forces had clashed with the Russians.[40] They also had the major hand in the 'Grand National and Historical Diorama of the Campaigns of Wellington' at the Gallery of Illustration from 1851-53, which Queen Victoria visited on 26 April 1852. She found the scenes in India and the Peninsula 'the best, really beautifully painted; - Waterloo, the worst'.[41] When Wellington died in September 1852, the display was speedily converted with additional scenes of the Duke's life added on 17 November, including his lying in state, funeral procession, and funeral service.[42] Similarly, Grieve and Telbin's moving panorama of the 'Route of the Overland Mail to India', which Prince Albert had visited with four of the royal children in 1850, was changed to include Sebastopol, and then converted into showing the army's route to the 'Seat of War' in the Crimea.[43] The well-known lecturer, journalist, prolific author, and military crammer, Joaquin Hayward Stocqueler

38 *The Ladies' Cabinet of Music, Fashion and Romance*, 1 Nov. 1855.

39 Ralph Hyde, '"The Campaigns of Garibaldi": A Look at a Surviving Panorama', in Koller (ed.), *Panorama in Old World and New*, pp.46-51; Peter Harrington, 'Garibaldi's Panoramic Exploits', *MHQ: The Quarterly Journal of Military History*, 20 (2008), pp.82-87; Idem, 'Anatomy of a Moving Panorama', pp.59-65.

40 *Art Journal*, Jan. 1855, 33; Oct. 1855; *Naval and Military Gazette*, 16 Dec. 1854; 22 Sept. 1855.

41 RC, Queen Victoria's Journals, Vol. 33, 205: Entry, 26 Apl. 1852; BL, 001268283: *A Guide to the Diorama of the Campaigns of the Duke of Wellington* (Heavitree: Ford, 1852); Royal United Services Institute for Defence Studies, Rare Books 15; BOD JJC, Dioramas 5 (19), *The Campaigns of Wellington in India, the Peninsula, Belgium and France* (London, 1852).

42 Altick, *Shows of London*, pp.208, 479.

43 BL, 002229625: *The Route of the Overland Mail to India, from Southampton to Calcutta* (London: Gallery of Illustration, 1850); 002229631: *The Seat of War: A Descriptive Guide to the Diorama illustrating the Danube, and Black Sea; and route of the troops to the East* (London: Gallery of Illustration, 1854); RC, Queen

Advertisement for Grieve and Telbin's Diorama of the Events of the War with Russia at the Gallery of Illustration (1854). [Bodleian Libraries, University of Oxford. John Johnson Collection: Diorama folder 5 (16)]

(1801-86), was on hand to explain events given the often perfunctory nature of the added topography.[44] He had also been employed to lecture on the Overland Route to India and Wellington's campaigns, and had provided scripts for military shows at Astley's Amphitheatre.

Originally an NCO in one of the East India Company's European artillery regiments, Stocqueler purchased his discharge in 1824 and became a journalist. He edited *The Englishman* in Calcutta from 1833 to 1843 and then the *United Service Gazette* in Britain from 1847 to 1857. He was also a promoter of the short-lived Cavalry College at Richmond. Stocqueler was initially averse to lending his talents to the Gallery of Illustration as he felt it 'partook very much of the character of a showman's description'. Persuaded that the lecturing art had been brought into disrepute at other shows, he relented and adopted what proved to be an immensely successful 'conversational style'. He found that 'old warriors' flocked to see the diorama of Wellington's campaigns 'to look upon the success of their exploits, and show their friends "how fields were won"'. Wellington attended one morning performance, commenting on each scene. Asked by Stocqueler if he had ever actually uttered the words, 'Up Guards and At Them', at Waterloo, the Duke replied, 'No; I couldn't have been such a d....d fool. I was too far away from them to be heard.' Stocqueler tried to persuade Grieve and Telbin to produce a diorama of India but they thought it unlikely to be commercially

Victoria's Journals, Vol. 29, 141: Entry, 20 May 1850.
44 Altick, *Shows of London*, p.480.

viable and, when he produced one himself, this was proven all too correct.[45] Often in financial difficulties and using the pseudonym of Siddons, he moved eventually to the United States.

George Augustus Sala, the author and journalist, commented that Grieve and Telbin and one of their moving diorama rivals, William Beverly, would transport the audience to the seat of war 'while the urbane Mr. Stocqueler, or the voluble Mr. Kenney, will talk like agreeable books, and save us the trouble of reading and travelling, and yet teach us more than we might gain by either'.[46] Beverley and Charles Kenney, however, were associated with travel rather than military dioramas.

The Grieve and Telbin Crimea canvas ended up as part of a Dublin pantomime show.[47] In 1856, the singer and actress, Priscilla Horton, began to perform at the Gallery of Illustration. Her performances in conjunction with her husband, Thomas German Reed, became so popular that Grieve and Telbin gave up producing moving panoramas there. As the *Daily News* put it in June 1859,[48]

> Since Messrs Grieve and Telbin have given up painting panoramas of historical events or travelled interest, and since Mr Stocqueler
> - undoubtedly the clearest, pleasantest, and most succinct lecturer of the day - has confined himself to the superintendence of young
> gentlemen's military education, the public has come to look upon the Gallery of Illustration as the special home of Mr and Mrs German
> Reed, and to regard them as the sole persons with any right to be there.

Taking Burford's panorama of Sebastopol and the dioramas in the Gallery of Illustration together, the *Naval and Military Gazette* pronounced that they[49]

45 J. H. Stocqueler, *Memoirs of a Journalist* (London: The Times of India, 1873), pp.185-88; Richard Stevenson, 'The Cavalry College at Richmond', *Soldiers of the Queen* 145 (2011), pp.18-24.
46 [G. A. Sala], 'Some Amenities of War', *Household Words* IX (15 July 1854), p.520-24, at p.523.
47 Huhtamo, *Illusions in Motion*, p.200.
48 *Daily News*, 21 June 1859.
49 *Naval and Military Gazette and Weekly Chronicle of the United Service*, 25 Aug. 1855.

give such truthful and vivid delineations of the town, the fortifications, and the works of the Allies, that we do not wonder they are so much frequented. These exhibitions very much aid the descriptions we read in the newspapers, and enable us better to understand the positon of our troops.

Of the four main family firms most associated with moving panoramas, George Danson & Sons were apparently responsible for the Waterloo scene the Queen had criticised in the diorama of Wellington's campaigns at the Gallery of Illustration, whilst Grieve and Telbin did the remainder.[50]

Dansons also designed what were termed modelled panoramas or panoramas al-fresco - essentially, large set scenes or tableaux - as well as moving panoramas, dioramas, and pyrotechnic entertainments for the Royal Surrey Zoological Gardens in Walworth, which was located between Kennington Park Road and Walworth Road. They also did so annually for John Jennison's Belle Vue Gardens in Manchester. The Royal Surrey Zoological Gardens opened in 1831, Belle Vue in 1836, and the similar Cremorne Gardens in Chelsea in 1845, all heirs in many respects to fashionable eighteenth century pleasure gardens such as the Vauxhall Gardens and Ranelagh Gardens, although now aimed at a far wider and far less exclusive audience.

Cremorne Gardens, which closed in 1877, presented at least one 'stereorama' by Grieve and Telbin in 1860 depicting the route to Italy via the St Gotthard Pass. Combining 'the peculiarities of the theatrical set scene with those of the panorama', amid a notoriously wet season for outdoor events it 'was a novelty that could be witnessed amid the storms of 1860 as comfortably as Mr. Burford's pictures in Leicester-square…'[51] Clearly, this was a moving panorama and indoor attraction. Cremorne, however, did not generally feature panorama al-fresco, although a 'battleship' was blown up at a 'naval fete' in 1851 and the taking of Sebastopol featured in 1855 with the participation of military bands and 500 Grenadier Guardsmen.

By contrast, the extravaganzas at the Royal Surrey and Belle Vue combined free-standing architectural and topographical models, large scale translucent picture flats illuminated from behind that could be easily replaced with others, spectacular fireworks, and actors. At Royal Surrey, for example, the Spanish failure to take Gibraltar in the 'Great Siege' (1779-83) featured in 1847, one account reporting the 'droll effect produced by a squadron of ducks who, in the hottest part of the siege, followed their leader across the lake perfectly unmoved by the riot around them, to their roosting place'.[52] Badajoz was the subject of the 1849 show. The short-lived satirical weekly journal, The Puppet-Show, for all the pyrotechnics, was

50 Hyde, *Dictionary*, p.131.
51 *Sun*, 6 Oct. 1860.
52 Huhtamo, *Illusions in Motion*, p.327.

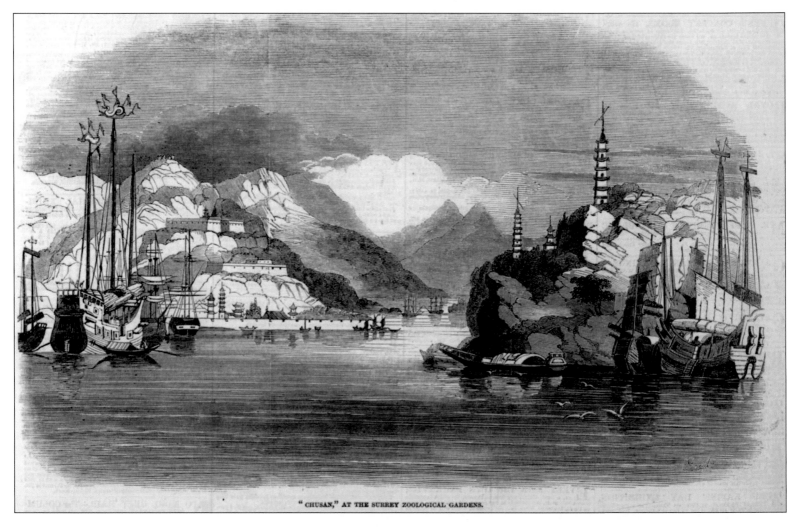

" CHUSAN," AT THE SURREY ZOOLOGICAL GARDENS.

Danson's Panorama Al-fresco of the Bombardment of Chusan at the Royal Surrey Gardens from *The Illustrated London News*, 28 May 1853.

unimpressed by a 'ridiculously meagre' assault on a cardboard bastion defended by cardboard Frenchmen, 'dead' attackers soon getting up to join their colleagues in the climb of the walls.[53] Similarly, *Punch* mercilessly lampooned just ten soldiers storming the city, one of whom 'died' repeatedly,[54]

> There is a grand explosion - the whole air is hissing hot; - the trees are crimson; - the water is the colour of Tomata [*sic*] sauce, - there is a mighty flash of red fire: - Badajoz is taken. The devoted ten rush once more into the breach, which is burning like a furnace; a figure with a wooden sword, cocked hat, and nose is pushed forward on rollers, - three cheers rend the sky - it is the Duke of Wellington!

The capture of Chusan (1 October 1841) during the First China War was featured in 1853 and the capture of Sebastopol in 1855 with military invalids taking part.[55]

Royal Surrey Gardens closed in 1862, but the Belle Vue shows, which had started in 1852, continued more or less until 1956 albeit with less emphasis over the years on imperial triumphs. Among the many pyrotechnical extravaganzas at Belle Vue were the fall of Seringapatam (1853); the siege of Sebastopol (1855); the siege of Gibraltar (1857); the storming of Delhi (1858); the defence of Lucknow (1863); the fall of Magdala (13 April 1868) in the Abyssinian expedition (1869); Sir Garnet Wolseley's capture of Kumase (4 February 1874) in the Second Ashanti (Asante) War (1875); Wolseley's victory at Tel-el-Kebir (13 September 1882) completing the occupation of Egypt (1883); the fall of Khartoum (26 January 1885) and Charles Gordon's death (1885); Inkerman (1891); the Alma (1896); the 'Indian Frontier War' of 1897 (1898); the Battle of Omdurman (2 September 1898) at the culmination of the reconquest of the Sudan (1899); and the Boer siege of Ladysmith (2 November 1899 to 28 February 1900) in the South African War (1900).[56] The impact could be significant, the display in 1855, for example, bringing cries of alarm 'from females as an occasional stuffed soldier was hurled over the battlements'.[57]

The Tel-el-Kebir extravaganza in 1883 proved particularly popular, supposedly attracting 'countless thousands'. It featured 500 performers and closed with illuminated portraits of Wolseley and the Commander-in-Chief of the Mediterranean Fleet, Admiral Sir Beauchamp Seymour, created

53 *The Puppet-Show* 2 vols. (London: 1849), II (June 1849), pp.221-22
54 *Punch*, 9 June 1849; *Illustrated London News*, 26 May 1849.
55 BOD, JJC, Entertainments 2(31 and 38), advertisements; *Illustrated London News*, 28 May, 1853; Keller, *Ultimate Spectacle*, p.66.
56 David Mayer, 'The World on Fire: Pyrodramas at Belle Vue Gardens, Manchester, c. 1850-1950', in John Mackenzie (ed.), *Popular Imperialism and the Military* (Manchester: Manchester University Press, 1992), pp.179-97.
57 Ibid, p.187.

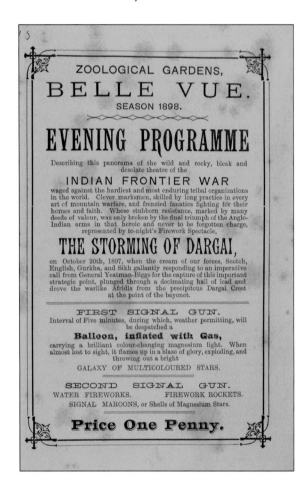

Programme of the Panorama Al-fresco of the Indian Frontier War at Belle Vue, Manchester (1898). [Chetham's Library, Manchester]

Lord Alcester for his part in the bombardment of Alexandria and the naval operations in support of Wolseley. On 30 September 1883, however, much of the 'magnificent scenic representation', in front of which the actors performed, was destroyed by a fire that broke out after the park was closed. Damage was initially estimated at £20-30,000. Fortunately it did not spread to the fireworks manufactory, and it was possible to repair and replace enough of the scenery for the show to continue.[58]

The Alma was portrayed oddly in 1896 as 'England's Greatest Crimean Success', the backdrop painted by Messrs. Caney and Perkins of the Royal Opera House and Drury Lane Theatre. The British victory was immediately followed by a view of the Winter Palace at St Petersburg and then views of 'England's United Empire' before culminating in a 'Bouquet of Rockets and Coloured Stars'. Two years later, the 'Indian Frontier War' gave some praise to the tribesmen's 'stubborn resistance marked by many deeds of valour', which was 'only broken by the final triumph of the Anglo-Indian arms in that heroic and never to be forgotten charge' at Dargai (20 October 1897). It ended with 'homage to Piper Findlater, VC, The Hero of Dargai', who had continued to play to encourage the advance of the Gordon Highlanders despite being wounded. The performance then concluded with a tableau of Government House, Calcutta, a 'most elaborate moving Firework Device of Hindoo Serpent Charmers and the Temple of Fountains of Golden Fire', and then the ubiquitous 'Bouquet of Rockets and Coloured Stars'.[59]

58 *The Graphic*, 6 Oct. 1883; *Manchester Evening News*, 2 Oct. 1883.
59 Chetham's Library, Belle Vue Collection, F.4.4.3 (14 and 15).

Rather similarly, James Pain provided semi-circular and semi-pyrotechnical presentations of battles for Alexandra Palace and for Aston Lower Ground in Birmingham such as the 1588 defeat of the Spanish Armada (1881), and the bombardment of Alexandria (1882).[60] Raikes Hall Gardens at Blackpool had a similar series of panorama al-fresco provided by Benjamin Firth & Sons including the bombardment of Alexandria (1883), Abu Klea (1886), Seringapatam (1888), the bombardment of Canton (1889), Sebastopol (1890), and Balaclava (1891).[61]

Messrs. Marshalls established their first rotunda in Edinburgh in 1818, using it for both static and moving panoramas, but also had premises in Old Bond Street in London, and exhibited at Spring Gardens from 1823 to 1826. Apparently advised by Lord FitzRoy Somerset, Wellington's military secretary, and Colonel Francis Ponsonby and with information from the 'Adjutant-General's Office at Paris', their 'Grand Historical Peristrephic Panorama', with seven, then nine, and later twelve scenes and covering 400' of canvas, included Ligny, Quatre Bras and Waterloo. It was shown in Birmingham, Brighton, Bristol, Dublin, Dumfries, Edinburgh, Exeter, Glasgow, Hull, Ipswich, Leicester, Leeds, Liverpool, Manchester, Newcastle, Norwich, Nottingham, Plymouth, Sheffield, and at Spring Gardens between 1816 and 1829.[62] In April 1824, 1,000 pupils of the Royal Military Asylum were marched with their band to view the show in Spring Gardens under the patronage of the Duke of York. Waterloo veterans were admitted gratis.[63] William Heath was associated with the Marshalls, notably for a panorama of Navarino in 1828. He also produced a print for the second issue of the short-lived illustrated fortnightly magazine, *The Glasgow Looking Glass* (later *The Northern Looking Glass*), of which he was editor and illustrator, on 25 June 1825 showing 'The Grand Panorama of Waterloo' on display at a rotunda in Glasgow's Buchanan Street, which suggests he had a hand in its illustration. [64]

60 Hyde, *Dictionary*, p.337.
61 Ibid, pp.169-70.
62 BL, 019961685: *Battles of Ligny and Waterloo. Description of Messrs .Marshall's grand historical peristrephic painting of the ever-memorable battles of Ligny and Waterloo* (Dublin: Jyrrell, 1816); 017685785: *Battles of Ligny and Waterloo: Description of Messrs. Marshall's grand historical peristrephic painting of the ever-memorable Battles of Ligny, and Waterloo, etc.* (Manchester: Wilson, 1817); also NAL, GC/ROL 47.Z.1107; GRI, N7436.52.B4 L5; NLS, Crawford.FR.68 ; BL, 002168154: *Description of the grand historical peristrephic spectacle, now exhibiting of the Battles of Ligny and Waterloo, etc. Painted by Messrs. Marshall* (Birmingham, 1817); 014654496: *For a short time only. Will open on Whit-Monday next, the 31st instant, 1819, in the Exchange Assembly Rooms, Market Place, Nottingham, Messrs. Marshall's grand Peristrephic panorama, (from London) of the ever memorable Battles of Ligny, Quatre Bras, and Waterloo, fought on the 16th & 18th days of June, 1815, between the French and allied armies; painted on an extensive scale, under the direction of Lord Fitzroy Somerset* (Nottingham: Stretton, 1819).
63 *Public Ledger and Daily Advertiser*, 12 Apl. 1824; *Morning Advertiser*, 5 June 1824.
64 Melby, 'William Heath', p.12; University of Glasgow Library, Special Collections, Bh14-x.8.

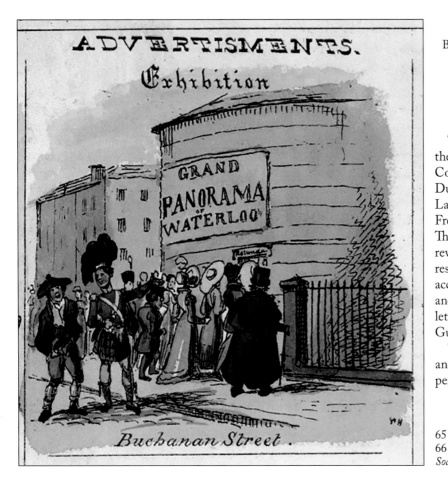

Marshalls' Rotunda showing the 'Grand Panorama of Waterloo' in Buchanan Street, Glasgow, from William Heath's *The Glasgow Looking Glass*, 25 June 1825. [University of Glasgow Archives and Special Collections: Bh14-x.8.]

The original seven scenes depicted Napoleon and his staff viewing the French army, Ligny with the 'perilous situation' of the Prussian Commander-in-Chief, Blücher, Quatre Bras and the death of the Duke of Brunswick, the French position at Waterloo, the attack on La Haye Saint, the death of Sir Thomas Picton together with the French cavalry attack on the British squares, and French prisoners. The first two scenes added were Wellington and the allied staff reviewing troops near Brussels, and the climatic British charge resulting in 'the complete Overthrow of the French Army'. [65] The accompanying descriptive booklet included lines from Pope's *Iliad* and Dryden's *Aenied* as well as accounts of the battle taken from letters by an officer of the 95th Rifles and a private of the 2nd Life Guards. [66]

The show was accompanied by a military band at Spring Gardens and also in New Tavern, Dublin, where there were five daily performances, the two in the evening being 'brilliantly illuminated'.

65 *Hull Packet*, 16 Sept. 1817.
66 Gavin Musgrave, 'The Dublin Waterloo Panorama', *Journal of the Society for Army Historical Research* 99 (2021), pp.396-400.

Entrance was 1s.8d. A bagpiper was subsequently introduced for a new scene showing the 42nd Highlanders. [67] Regimental bagpipers were also used at Edinburgh in 1820 and the 80th Foot supplied additional bandsmen, being part of a process by which regiments attempted to use the memory of Waterloo to appeal to the public's support. [68] The additional scenes were said to be [69]

> so striking, that, without personally viewing them, every description must fall far short of the real merit they possess: the grouping of the Allied Staff is truly grand; each of the heroes who bore a distinguished part in the conflict, many of whom fell gloriously on the field; the Horses and Figures are spirited, and judiciously placed.

There was some regret that the period of its exhibition in Dublin was a matter of a few months for,[70]

> If we consider the immensity of its size, the number and variety of the figures which it represents, the graceful and accurate manner in which they are disposed of, the brilliancy of its colouring and beauty of its effect - this picture may be classed, without hesitation, amongst the best executed specimens of modern historic painting; and no eulogy or argument is necessary to establish the greatness of the subject.

In fact, the moving panorama had proved so popular that it was retained in Dublin at the Pavilion on Eden Quay until December 1818, by which time it had been visited by Grand Duke Michael of Russia.[71] When it was shown at the Exchange in Manchester, the charge was sounded by the trumpeter who had done so for the 1st (Household) Cavalry Brigade at Waterloo.[72]

A slightly different panorama with scenes covering Napoleon's death and Trafalgar was then toured again through Birmingham, Bristol, Edinburgh, and returned to Spring Gardens in London. The descriptive booklet devoted 14 pages and four scenes to Trafalgar; two pages and one scene to Genappe, which was characterised as part of the Prussian pursuit of the French on 18 June; two pages and one scene to Napoleon captive on

67 *Saunders's News-Letter*, 9 Feb. 1818; *Dublin Evening Post*, 25 Apl. 1818.
68 Milkes, 'A Battle's Legacy', pp.371-72.
69 *Dublin Evening Post*, 12 Feb. 1818.
70 *Saunders's News-Letter, 2 Sept. 1818.*
71 *Dublin Evening Post*, 22 Dec. 1818.
72 Harrington, *British Artists and War*, p.111.

HMS *Bellerophon* in Portsmouth harbour after his surrender; and eight pages and six scenes to St Helena, including Napoleon's funeral and grave.[73] Oddly, there was now no scene of Waterloo, presumably as it was believed an audience would want something different. This version appears to have been shown in Edinburgh in 1820, 1824, 1826, and 1840.

At Glasgow, veterans were admitted free in 1825 to celebrate the battle's tenth anniversary and asked to wear their medals, the Waterloo Medal having been issued from April 1816 onwards for all participants.[74] When the show re-appeared at Edinburgh in 1840, veterans were again admitted free on 18 June.[75] It appears also to have gone eventually to the United States.[76] Messrs. Marshalls also displayed a panorama of the bombardment of Algiers at the Exchange Rooms in Nottingham.[77]

Charles Marshall (1806-90) - no relation - opened his Kineorama in Pall Mall in 1841, featuring the Sutlej campaign of the First Anglo-Sikh War told in sixteen scenes, each 36' x 22'.[78] Charles Marshall also exhibited a view of Delhi at the Auction Mart close to the Bank of England in 1857.[79] His 'Grand Moving Panorama of the Mutiny in India' - covering some 20,000 sq. ft. of canvas - began with the route followed by British troops to India from Southampton to Calcutta. It then proceeded through Meerut, the departure of the mutineers to Delhi, the events at Agra, and to the fall of Delhi. In the way of such entertainments it concluded with an entirely unconnected diorama of Jerusalem at the time of Christ, and its subsequent destruction by the Romans under Titus (70 AD). The descriptive lecture was supplemented by a female singer.[80]

Messrs. Hamiltons, founded in 1848, toured with their 'Panstereorama' and 'Excursions Home and Abroad'. Exhibitions were devoted to the Crimean War, the Indian Mutiny, the Zulu War, and the Second Afghan War. Locations used in London included Great St James's Hall in Regent

73 Hyde, *Dictionary*, pp.303-07; Harrington, *British Artists and War*, p.111; BL, 017420774/000917754: *Description of the Peristrephic Panorama, now exhibiting, illustrative of the principal events that have occurred to Bonaparte, commencing with the Battle of Waterloo and ending with his funeral procession at St Helena* (Exeter: Cullum, 1822); BOD, JJC, Dioramas 5 (40): *Description of Marshall's Grand historical Peristrephic Panoramas of Genappe, St. Helena, and the most interesting events that have occurred to Bonaparte, from his defeat at the Battle of Waterloo, until the termination of his earthly career at St. Helena; and the memorable Battle of Trafalgar; the figures the size of life; the ships of war on the largest scale ever delineated on canvas* (London: Robarts, 1825); also UKTC, Lennox-Boyd Panoramas, 53, and GRI, N7436.52.E9, but this published by Whiting, 1825.
74 Philip Shaw, *Waterloo and the Romantic Imagination* (Basingstoke: Palgrave Macmillan, 2002), p.84.
75 *Witness*, 17 June 1840.
76 Altick, *Shows of London*, p.429.
77 BL, 014655018.
78 Hyde, *Dictionary*, p.302.
79 Harrington, *British Artists and War*, p.162.
80 *West Middlesex Herald*, 2 Jan. 1858.

Street, the Egyptian Hall in Piccadilly, and the Royal Agricultural Hall in Islington. Hamiltons' Amphitheatre in Holborn, for example, showed a scene of Isandlwana (22 January 1879), coupled with a 'quadruple war dance by Zulu warriors', in March 1879. Scenes of the deaths of Lieutenants Melvill and Coghill at Fugitives' Drift after Melvill carried the Queen's Colour of the 1/24th Foot from the field of Isandlwana were added in April 1879, and the show toured through the provinces from June.[81] In addition, the show included scenes from the Second Afghan War including the storming of Ali Masjid, the fortress regarded as key to the Khyber Pass, by Sir Sam Browne VC's field force (21 November 1878). Notwithstanding the focus on war, the supporting performers included the 'Human Tripod', and a minstrel troupe.[82]

Hamiltons' employed a number of artists. One was William Dugan (1841-c.1900), the first artist to produce a painting of the defence of Rorke's Drift (22-23 January 1879) against the Zulu. Based in Southsea, Dugan's canvas was exhibited at the Yorkshire Fine Art Institute in Leeds in May 1879, but then purchased by Hamiltons' Panstereorama for display in Birmingham, Exeter, and Torquay. Dugan assisted another artist, Thomas Gray, in further scenes of the Battles of Kassassin (28 August 1882), Tel-el-Kebir, and Abu Klea, as well as Balaclava, Waterloo, and scenes from the Second Afghan War.[83]

William Jones, one of the eleven Rorke's Drift VCs, was employed to speak in conjunction with the exhibition of the Rorke's Drift painting at Exeter and Torquay, just as Joseph Doughton, formerly of the 13th Light Dragoons, who had been wounded at Balaclava, had been on hand to explain aspects of the Hamiltons' moving panorama of the Crimean War at Birmingham in 1855.[84] Jones was still appearing with Hamiltons into the 1880s, his account of Rorke's Drift at Dundee juxtaposed with two female singers, a comic vocalist, and a 'negro sketch'.[85] Subsequently, Jones joined Buffalo Bill's Wild West Show in 1887, but was reduced to pawning his VC, and died in poverty in 1913.

Messrs. Poole came on the scene in around 1863-64, although Poole's 'Myriorama' was not a term used for their moving panoramas until 1883. The overland route to India was one of their most popular displays. Anthony Young was a business partner of both Charles and George Poole, with

81 Ian F. W. Beckett, *Rorke's Drift and Isandlwana* (Oxford: Oxford University Press, 2019), p.106.
82 *Illustrated London News*, 8 Mar. 1879.
83 Hyde, *Dictionary*, 200-01; Beckett, *Rorke's Drift and Isandlwana*, p.114; Harrington, *British Artists and War*, p.188. Dugan's painting of Rorke's Drift is now in the Royal Welsh Museum at Brecon.
84 Hyde, *Dictionary*, p.146.
85 *Dundee Evening Telegraph*, 9 Jan. 1883; *Burnley Express*, 8 Aug. 1885; *Nottingham Evening Post*, 5 Oct. 1886.

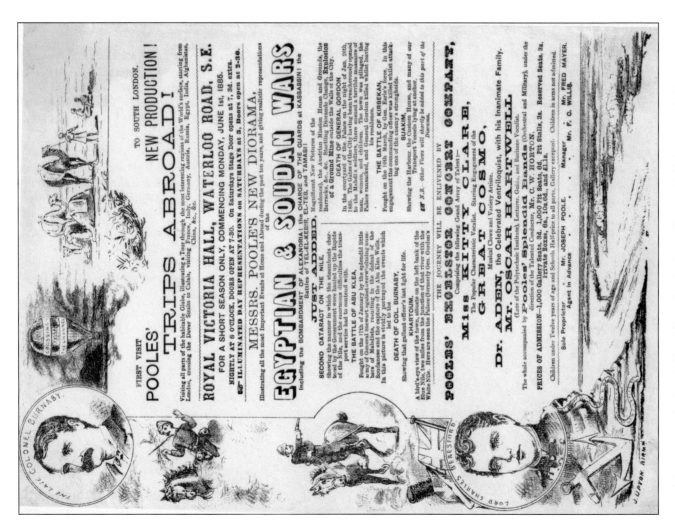

Advertisement for Poole's Trips Abroad at the Royal Victoria Hall, featuring the Egyptian and Sudan Wars (1885). [Bodleian Libraries, University of Oxford. John Johnson Collection: Cinema folder 2 (21)]

several dioramas and moving panoramas touring under the auspices of Poole & Young.[86] The latter, for example, presented a 'dioramic excursion' on the Zulu War including scenes of Isandlwana and Rorke's Drift at Bristol in July 1879, and at Exeter in October.[87]

Poole's Zulu scenes still formed part of a wider 'journey'. Thus, when shown at Southampton, the trip from London included some of the 'notable places' involved in the Russo-Turkish War (1877-78) before getting to South Africa. Once there, however, the audience was presented,[88]

> with some of the most realistic views we have ever witnessed of the fighting there, the dioramic effect being a special feature of the exhibition, bringing before the spectator, with vivid reality, the flight of shells, the firing of cannon and explosions, which suggest the barbarism of war in all its features. By models introducing the battalions of troops and warships, the views are made more than ordinarily attractive and picturesque; and an excellent band performs appropriate selections to aid the imagination in realising the passing scenes.

There was also a ventriloquist, a female songstress, and a performer of character songs. Similarly, a presentation on the wars in Egypt and the Sudan at the Royal Victoria Hall in June 1885 included a vocalist, ventriloquist, and 'musical clown'.[89]

Henry Poole presented the Egyptian campaign on Jersey in 1886 and the defeat of the Armada at Cheltenham in 1893. At Folkestone in 1897 Joseph Poole showed the abortive Jameson Raid (29 December 1895 to 2 January 1896), by which Cecil Rhodes had hoped to overthrow Afrikaner control of the Transvaal, and the resulting Matabele (Ndebele) Revolt (1896) encouraged by the removal of those British South Africa Company forces that had been captured by the Boers. In co-operation with Imrie Kiralfy's 'Greater Britain: Savage South Africa' show, which was put on at Olympia and elsewhere, Poole also presented Omdurman, and the early South African War battles of Elandslaagte (21 October 1899) and Glencoe (20 October 1899). Kiralfy's shows, created by Frank Fillis, combined 'thrilling circus spectacle, ethnography laced with savage exoticism, and grandiose and superficially convincing enactment'.[90] Charles William Poole featured Glencoe and the siege of Mafeking at Cheltenham in 1900.[91]

86 Hudson Powell, *Poole's Myriorama; A Story of Travelling Panorama Showmen* (Bradford on Avon: ELSP, 2002).
87 Beckett, *Rorke's Drift and Isandlwana*, p.106.
88 *Hampshire Independent*, 17 Sept. 1879.
89 BOD, JJC, Dioramas 6 (12).
90 Ben Shepherd, 'Showbiz Imperialism: The Case of Peter Lobengula', in John Mackenzie (ed.), *Imperialism and Popular Culture* (Manchester: Manchester University Press, 1986), pp.94-112, at p.98.
91 Hyde, *Dictionary*, pp.365, 367, 370; Harrington, *British Artists and War*, p.294.

Cheltenham had also hosted B. J. Malden's dioramic presentations on the death of Charles Gordon in 1885, and on the Third Burma War (1885-86) in 1887.[92]

What is striking is how far the most recent events were presented as entertainment. The criticism of the 'blind, brutal, British public's bestial thirst for blood' put into the mouth of Rudyard Kipling's protagonist, Dick Heldar, a war correspondent, in his novel, *The Light That Failed* (1891) based in part on the Suakin expeditions against Mahdists in the Eastern Sudan (1884-85), is perhaps apposite.[93] Even more than 360° panoramas, moving panoramas were able to present a sense of 'moral ideology' contributing to a national narrative of expansion in the depiction of civilisation struggling against savagery and overcoming even nature itself.[94]

It was part, however, of that wider celebration of empire that emerged in the context of the more militarised society resulting from the increasing transmission of nationalist and imperialist themes in popular culture after 1870. Patterns of consumption were transformed by new methods of production, distribution, marketing and advertising, the latter making full use of imperial images. Society was fully exposed to a modern mass media. The first cheap mass half-penny daily newspaper, the *Daily Mail*, would be launched in 1896. The press (not least the reports of the war correspondents or 'specials'); art; music hall; sheet music; theatre and melodrama; poetry; popular literature (especially for children such as the novels of George Henty and boys' comics); commemorative bric-a-brac of all kinds; postcards; cigarette cards; toy soldiers; and a range of entertainments including military spectacle all contributed. The working class was not immunised from imperial propaganda as some historians like to suggest. After the Reform and Redistribution Act (1884), 60 per cent of adult males enjoyed the franchise and, as a result of the Education Act (1870), there was almost full literacy among 20-24 year olds by 1899.[95] Like zoological and ethnological exhibitions, museum displays, and all manner of theatrical and other visual shows and spectacles to which the Victorians in particular were wedded, panoramas and moving panoramas were 'sister sites for the

92 Hyde, *Dictionary*, pp.297-98.
93 Rudyard Kipling, *The Light That Failed* Paperback edn. (Harmondsworth: Penguin, 1970), p.51.
94 John Bell, 'The Sioux War Panorama and American Mythic History', *Theatre Journal* 48 (1996), pp.279-99.
95 John Mackenzie, *Propaganda and Empire: The Manipulation of British Public Opinion, 1880-1960* (Manchester: Manchester University Press, 1984), pp. 6, 19, 22, 24, 27-28, 49, 63, 70, 204-05; Edward Spiers, *The Late Victorian Army, 1868-1902* (Manchester: Manchester University Press, 1992), pp.180-203; Berny Sebé, *Heroic Imperialists in Africa: The Promotion of British and French Colonial Heroes, 1870-1939* (Manchester: Manchester University Press, 2013), pp.46-47, 57, 68-73, 116-24; Kenneth D. Brown, 'Modelling for War: Toy Soldiers in Late Victorian and Edwardian Britain', *Journal of Social History* 24 (1990), pp.237-54; Stephen Attridge, 'The Soldier in Late Victorian Society: Images and Ambiguities', Unpub. Ph.D., Warwick, 1993, pp.25-60.

viewing of the wider world, sharing a common set of visual techniques in their quest to reproduce the imperial periphery for the entertainment and instruction of metropolitan audiences'.[96]

The purveyors of moving panoramas plied their trade using a stable of British artists, but it is striking that every one of the new 360° panoramas appearing in Britain in the 1880s and 1890s was a product of a foreign artist. Nationalism and imperialism may have been prime factors in the expansion of panorama enterprises after 1870 but commercialism knew no national boundaries.

96 Gould, *Nineteenth-Century Theatre and Imperial Encounter*, p.15.

6

The Last Phase

The revival of interest in the 360° panorama in the 1880s began in France and Germany, inspired by the Franco-Prussian War (1870-71).[1] The French wished to commemorate heroic resistance as a means of rekindling national pride, and the Germans to commemorate their triumph in establishing a new unified Germany. It has been argued that panoramas of the Franco-Prussian War promoted national ideology in a bloodless way that preserved almost a pre-Napoleonic vision of heroic war.[2]

It is certainly the case that the continental experience of warfare in the mid-nineteenth century, as evidenced by the limited nature and short duration of the German Wars of Unification (1864-71) with swift Prussian and German victories over Denmark, Austria, and France, fell far short of the totality of the French Revolutionary and Napoleonic Wars. Nonetheless, artistic interpretation of the latter had been just as traditional as that of earlier conflicts, be it the work of French artists such as Antoine-Jean Gros (1771-1835), Louis-François Lejeune (1775-1848), and Horace Vernet (1789-1863), or British artists such as Denis Dighton (1792-1827) and George 'Waterloo' Jones (1786-1869). In traditional battle art, there was little difference between the work of those who celebrated the French Second Empire such as Édouard Detaille (1848-1912) and Alphonse de Neuville (1835-85), and those British artists who celebrated colonial conflict such as Thomas Jones Barker (1815-82 - no relation to the panorama Barkers),

1 François Robichon, 'Emotion et sentiment des les panoramas militaire après 1870', *Revue Suisse d'art et d'archéologie* 42 (1985), pp.281-87. See also the discussion of Anton von Werner's Panorama of the Battle of Sedan (1883) in Grau, *Virtual Art*, pp.90-139.
2 Kathrin Maurer, 'The Paradox of Total Immersion: Watching War in Nineteenth Century Panoramas', in Anders Engberg-Pedersen and Kathrin Maurer (eds), *Visualizing War: Emotions, Technologies, Communities* (Abingdon: Routledge, 2018), pp.78-94, at p.89. Like Grau, Maurer also focusses on von Werner's Sedan panorama.

Richard Caton Woodville (1856-1927), or William Barnes Wollen (1857-1936). Lady Butler was much more reflective of the realities of war but, in any case, most British battle artists now increasingly focused on smaller incidents and the individual rather than larger, more distant scenes.[3]

Other Europeans also chose to depict aspects of their national stories in panoramas, notably minorities within the Austro-Hungarian Empire. French and Belgian companies were particularly active in creating and exhibiting panoramas in Europe and further afield, often using studios in Germany. In the United States, the memory of the American Civil War also resulted in new panoramas. Most art emanating from the avowedly 'modern' American Civil War, however, was less in the mould of 'history painting'. The latter had been always less pronounced in North America, the war being recorded more in the American tradition of landscape and genre paintings.[4]

The revival in Britain re-introduced the public to an art form that had come to be associated only with the moving panorama since the 1860s. As the *Glasgow Evening Post* noted when the 360° panorama of the battle of Bannockburn was shown in the city in June 1888, it 'will come as a surprise to those whose ideas of a panorama have been based on the roller-winding, and slow-music description we are so familiar with under that name'.[5]

In Britain, the revival of interest in panoramas featured initially a number of imported French paintings relating to the Franco-Prussian War such as 'The Siege of Paris' (19 September 1870 to 28 January 1871) by Félix Philippoteaux (1815-84), and 'The Batte of Rezonville' (also known as Mars-la-Tour, 16 August 1870) by Édouard Detaille and Alphonse de Neuville at Crystal Palace. The latter was cut up and sold off in 1896 but occasional fragments still appear for sale. Philippoteaux's 'Siege of Paris' was on display on and off until 1896.[6] Military art had enjoyed a higher status in France but had been 'simultaneously admired, despised and condemned' in Britain.[7] Unsurprisingly, therefore, not all imports found favour with the British public, the most successful French import being the panorama of Niagara by Paul Philippoteaux (1846-1923), the son of Félix. Its popularity led to the renaming of the National Panorama in Westminster as Niagara Hall. Nevertheless, there were also British battle panoramas, albeit not painted

3 Hornstein, 'Episodes in Political Illusion', pp.158-232; Frédéric Lacaille, 'Napoléon et Louis-Philippe: 'L'Empire dans Les Galeries Historiques de Versailles', in *Napoléon: Images de la Légende* (Paris: Somogy, 2017), pp.40- 46; Susan Siegfried, 'Naked History: The Rhetoric of Military Painting in Post-revolutionary France', *The Art Bulletin* 75 (1993), pp.235-58; Harrington, *British Artists and War*, pp.107-32, 233-48; Usherwood and Spencer-Smith, *Lady Butler*, pp.69-73; Hichberger, *Images of Army*, pp.81-84.
4 Eleanor Jones Harvey, *The Civil War in American Art* (Washington: Smithsonian American Art Museum, 2012), 1-p.15. It is noticeable that there is no discussion of panoramas of the war.
5 *Glasgow Evening Post*, 7 June 1888.
6 BOD, JJC, London Play Places 3 (81) and (82); London Playbills CP (25); Dioramas 1(41) and (42).
7 Hichberger, *Images of Army*, p.5.

Théophile Poilpot (1848-1915) from Félix Potin, *Album 510 Célébrités Contemporaines* (2ème collection), Trade Card, c. 1908.

in Britain, which formed part of the wider celebration of imperial endeavour already evident in the circulation of moving panoramas, dioramas, and similar entertainments.

The new Royal London Panorama's first offering in 1881 was 'The Charge at Balaclava', created in France by Théophile Poilpot (1848-1915) and Stephan Jacob (b. 1846). Slightly smaller than other contemporary panoramas at 15,000 sq. feet, it featured the charge viewed from the rear, the dead Captain Louis Nolan being dragged by his horse to the side of the advance. The impetuous Nolan had brought the fatal message ordering the move forward and was killed almost at once riding across the front of the Light Brigade, possibly in an attempt to change the direction. Lord Cardigan was shown at the head of the brigade, along with Captain William Morris of the 17th Lancers, and Lord George Paget of the 4th (The Queen's Own) Light Dragoons.

Although Poilpot had visited the Crimea, the landscape was somewhat indistinctly shown. The 42 page guide proclaimed the 'glories and horrors of the Crimean War are so enthralling, and its memories so dear to English minds that the story never grows old'. It suggested the charge of the Light Brigade shed 'a lasting splendour over the whole campaign' and its 'heroic fight', 'fatal order', and 'fearless execution' would 'ever thrill the blood of England's sons'. Sold for 6d, the guide described the war's causes and course as well as Balaclava itself with various extracts from the reports of W. H. Russell.[8]

8 EXBD, 17414; also BOD, JJC, Dioramas 3 (83) *Souvenir of the Royal London Panorama, Leicester Square. Charge of Balaclava* (London, 1881); 3 (78-82), advertisements; CWAC, A 138 (007).

Poilpot employed specialists in descriptive mathematics - so-called *perspecteurs* - who used various optical techniques to correct perspective on his canvasses.[9] Open daily from 1100 to 2300 hours with a 1s.0d admission price, Balaclava was sensationally lit by 2,700 electric lamps. It was also the first panorama in Britain to have a *faux terrain*, which caused much comment. Realism was conveyed by the foreground with its 'dismounted cannons, broken baggage waggons, dead horses, and dead and mangled men, so closely imitating the real horrors of war in many instances that the spectator shudders to look at them'. Adding to the effect were 'real earth and stones, with living grass and shrubs'. It was visited by the aged Lord Lucan, who had commanded the Cavalry Division, and other participants such as Sir George Wombwell, who had ridden with the 17th Lancers, as well as by the Duke of Connaught, Prince Leopold, Princess Beatrice, and W. H. Russell.[10]

Punch had some fun with a cartoon showing an aged visitor, 'Pa', who had dropped his hat on the *faux terrain*, climbed over to retrieve it, and had been mistaken for a mannequin of Russell.[11] Likewise, *Judy* had a drunk falling over the barrier and mistaking a corpse on the foreground for a fellow drunk.[12] There was almost a disaster when straw in an ambulance wagon on the *faux terrain* caught fire. A veteran taken prisoner by the Russians, Sergeant Henry of the 11th Hussars, was employed to answer questions and relate his experiences.[13]

Disliking the 'staccato accents of the military *cicerone*' explaining the action, the 'extra-special' observer dispatched by *Fun* suggested the addition of a band 'with plenty of trombone and big drum', booming and whizzing shells 'by those theatrical expedients which are so well known to the stage manager', frequent trumpet calls, periodic cheers from 'strong-lunged' men, piano-organs played backwards to simulate the cries of the wounded, a dog trained to drag the corpse of his

Programme for Poilpot's Charge of the Light Brigade Panorama (1881). [Bodleian Libraries, University of Oxford. John Johnson Collection: Diorama folder 3 (70)]

9 Fruitema and Zoetmulder (eds), *Panorama Phenomenon*, p.45.
10 *The Era*, 2 April 1881; *Globe*, 28 Mar. 1881; *The Graphic*, 2 Apl., and 21 May 1881.
11 *Punch*, 1 June 1881.
12 *Judy*, 28 Dec. 1881.
13 Hyde and Wilcox, *Panoramania*, p.174; Altick, *Shows of London*, p.506.

AT THE "PANORAMA."

Spectators (delighted). "BEAUTIFULLY PAINTED, ISN'T IT! LOOK THERE! WHO IS IT? WHY, IT'S THE—OF COURSE—WHAT'S-HIS-NAME—THE *TIMES* CORRESPONDENT!!"

[*Pa's new Hat had fallen down, and he would go and get it!*

Cartoon from *Punch*,
11 June 1881.

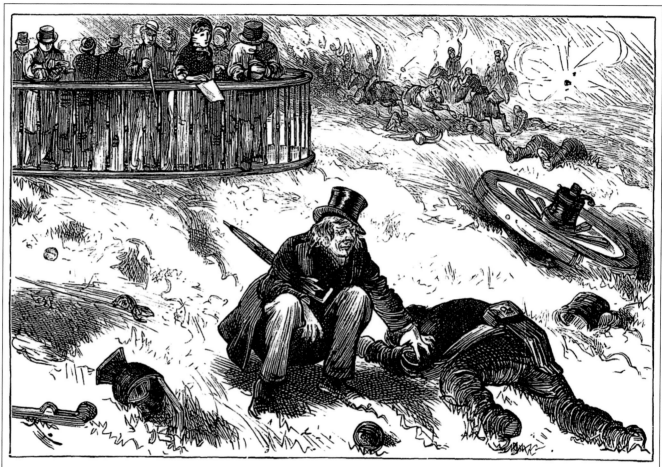

HIS LAST VISIT TO THE PANORAMA.

He had been Dining, and had got over the Rail and tumbled across the Corpse of one of the Six Hundred, and, says he, "Hic!" he says. "He's worse 'an I am," he says. "He mush a-been at it a' day!"

Cartoon from Judy,
28 December 1881.

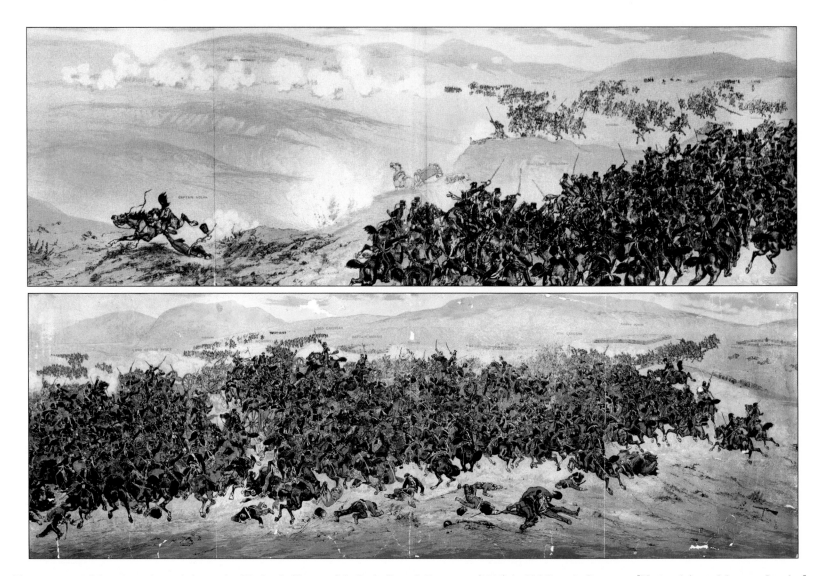

The two parts of the colour chromolithograph of Poilpot's Charge of the Light Brigade Panorama (1881), by Val Rosa & Company. [National Army Museum, London]

master, a 'low comedian' to play a corpse and, for public holidays, a comic Russian prisoner to play opposite him.[14] Full colour chromolithograph facsimiles survive.[15] The panorama was not successful since the Royal London Panorama closed in 1882, becoming a theatre and, later, a music hall.[16]

Later in the year, a panorama of the disastrous charge of French Cuirassiers against the Prussians at Reichsoffen (also known as the Battle of Wörth and the Battle of Froeschwiller, 6 August 1870) by Poilpot and Jacob opened in Paris. They also co-operated on a panorama of the Battle of Buzenval during the Prussian siege of Paris (21 October 1871) in 1882, and another of the storming the Bastille (14 July 1789) in 1885.[17] Like Paul Philippoteaux, Poilpot also worked in the United States, producing panoramas of the ironclad naval duel between the CSS *Merrimack* and the USS *Monitor* (8-9 March 1862), the Battle of Shiloh (6-7 April 1862), and the Second Battle of Manassas/Bull Run (29-30 August 1862). Best known for his four panoramas of Gettysburg (1-3 July 1863), Paul Philippoteaux also produced a panorama of Waterloo shown in Chicago, Boston and Los Angeles before being exhibited at Melbourne and Adelaide in Australia.[18]

Intriguingly, there was a previously unnoticed panorama of Abu Klea by Stephan Jacob in 1888. The London Metropolitan Archives include consideration of legal proceedings by the Metropolitan Board of Works against conversions of buildings in High Road, Knightsbridge for a 'Panorama of Abu Klea'. This was a development at Humphreys' Iron Hall behind Albert Gate, the location of Messrs. J. C. Humphreys' Albert Gate Ironworks. Humphreys made all manner of prefabricated iron buildings including even churches. Opened as an exhibition hall in 1880, Humphrey's Iron Hall was best known for the celebrated 'Japanese Village' between January 1885 and June 1887, which partly inspired W. S. Gilbert whilst he was creating *The Mikado* with Sir Arthur Sullivan although Gilbert had conceived the piece and written the first act before the exhibition opened. In January 1888 the District Surveyor for South Kensington, Alfred Williams, began proceedings against Humphreys for some of the uses of the iron buildings on the site. On 14 July he proposed to take further action against Humphreys for linking two temporary structures supposedly for sale between Brompton Road and Knightsbridge Road to create a public exhibition room for the Abu Klea panorama in contravention of the Metropolitan Building Amendment Act of 1882. He requested legal assistance from the Metropolitan Board of Works' Building Act Committee, but this was not approved.[19] The plan of the building Williams submitted makes it clear it was a 180° panorama.

14 *Fun*, 20 Apl. 1881.
15 NAM, 2004-01-114 and 1976-07-3; Westminster City Library, A138 (Leicester Square 007), handbill.
16 Oettermann, *Panorama*, p.140.
17 Ibid, p.167.
18 Leroy, *Panorama de la Bataille de Waterloo*, pp.102-03.
19 LMA, MBW/BA/38436.

Planning application for Stephan Jacob's Aby Klea Panorama (1888). [London Metropolitan Archives, City of London: MBW/BA/38436]

Balaclava having largely failed to make money, presumably a more recent battle was thought to be a better attraction. As it happened, on 27 July 1888 Wolseley unveiled the new memorial in St Paul's to Sir Herbert Stewart, who had commanded the Desert Column at Abu Klea but then been mortally wounded at Metemmeh three days later on 19 January 1885. Advertisements for a 'War Exhibition' featuring Jacob's painting of Abu Klea - 'the greatest pictorial representation of the Soudan War' - together with 'realistic effects' were carried from June to September 1888 in the London press. It opened on 7 July 1888 but was not advertised after 7 September. 'Stephen [sic] Jacob of Paris' was billed as the artist of the Balaclava, Bastille, Reichsoffen and Buzenval panoramas although Poilpot had been the lead artist in each case. One advertisement indicates the Abu Klea panorama featured the 'last moments' of the popular hero, Colonel Fred Burnaby, commanding the Heavy Camel Regiment of the Desert Column, killed when the Mahdists broke into the British square, Abu Klea being one of only two such instances. Admission was just 6d and the exhibition was open from 1000 to 2200 hours daily: it was started that all West-End omnibuses passed the entrance.[20]

20 *Morning Post*, 13 July, 15 Aug. and 7 Sept. 1888; *London Evening Standard*, 12 June and 13 July 1888; *The Times*, 27 July 1888; *Globe*, 12 July 1888.

Strangely, none of the newspapers advertising the canvas appraised it, the only appreciation being that in the *Saturday Review*, which gave the artist's name as Ernest Jacob although identifying him correctly with the Balaclava, Bastille and Reichsoffen panoramas. It found the canvas just as vivid but the illusion not as complete due to the restricted space available, the focus being on the square with a 'mere handful of our men contending with masses of the enemy'. The moment was that at which the 4th Viscount St Vincent, adjutant of the Heavy Camel Regiment, had just received his death wound and the mounted Burnaby was in combat with those who had penetrated the square's corner. Lord Charles Beresford commanding the Naval Brigade was on the ground by his jammed Gardner machine gun. Stewart, the intelligence officer, Sir Charles Wilson, and Frank Rhodes, brother of Cecil Rhodes, were visible in the centre of the square. Others were less recognisable but the general effect was 'striking' and demonstrated the heroism of the British soldiers.[21]

The Alexandra Palace rotunda - a 'huge circular structure in wood in the grounds' - also opened in 1881 with 'The Siege of Sebastopol' created by the French military panoramic artist, Jean-Charles Langlois (1789-1870) with a team of 32 assistants. Commissioned in the French army in 1807, Langlois had seen action at Wagram (17 July 1809), in Spain, and at Waterloo, where he was wounded whilst serving with the Imperial Guard. He reached the rank of colonel. His military service continued until his retirement in 1849 including participation in the French intervention in Spain in 1823, which was intended to help to restore the authority of the ultra-conservative King Ferdinand VII, and the occupation of Algeria in 1830. However, he also combined military service with art, in which he began training in 1815. His first panorama in 1831 was of Navarino and he went on to produce panoramas of the taking of Algiers (3-4 July 1830), and the battles of the Pyramids (21 July 1798), Eylau (7-8 February 1807), and Borodino (7 September 1812).

The production of large scale battle paintings became an increasing feature of the July Monarchy of King Louis Philippe (1830-48) as evidenced by the Gallery of Battles inaugurated at the Palace of Versailles in June 1837 with the majority of its paintings created especially for it between 1834 and 1845. Intended to associate the regime with past military glories, the paintings also had a 'compensatory function as a means of filling the gap left by absence of large-scale international conflict'.[22] Langlois' motivation was commercial in intent but his panoramas also served to extend the limits of conventional French battle art by creating a much more powerful illusion of reality. For his Navarino panorama he had acquired the *Scipion*, one of the French ships of the line involved, and used some of it as part of the display. Instead of a stairway, visitors passed through the hull past vivid modelled dioramas of men in action to emerge on the deck surrounded by the scene of battle.[23] He was the first to develop the idea of the *faux terrain*.

21 *Saturday Review of Politics, Literature, Science and Art*, 14 July 1888.
22 Hornstein, 'Episodes in Political Illusion', p.173.
23 Ibid., pp.204-208.

In September 1855 Langlois was tasked by Emperor Napoleon III with painting a panorama of the siege of Sebastopol primarily for propaganda purposes. An enthusiastic photographer, Langlois arrived in the Crimea in November 1855 with a photographic assistant, Léon Méhédin, having decided to use photographs for the first time to record the landscape. He also used some of the photographs of James Robertson.[24] The focus of the canvas would be from within the Malakoff on 8 September 1855, Langlois being astonished by finding such a complete destruction of the Russian fortifications.[25] A series of 14 photographs survive in the Musée d'Orsay in Paris corresponding to the background of the panorama. [26] Other photographs taken by Langlois and Méhédin exist in other collections in Paris, Rouen, and Los Angeles. In fact, Langlois and Méhédin quarrelled, with Langlois taking possession of the 'military' images needed for his panorama, and the latter taking the 'picturesque' images. [27] Langlois again used photographs for his last panorama of the Battle of Solferino (24 June 1859) in the Franco-Austrian War. On his death in 1870 Langlois bequeathed much of his work to the town of Caen, and the Musée des Beaux-Arts not only has four studies in oil of the original Sebastopol panorama, each 71 x 113 cm, but also a photograph of a detail and what appears to be a fragment of an earlier study for the panorama without any figures.[28]

Langlois returned to France in May 1856, the Sebastopol panorama opening in a new purpose-built rotunda on the Champs -Élysées in August 1860, the entrance fee two francs in the week and 50 centimes on Sundays and holidays. It remained on display in Paris until 1865 but, subsequently, it was displayed in Brussels in 1880. Curiously, the authors of the catalogue of the major exhibition on Langlois' panoramas held in the Musée des Beaux-Arts at Caen in 2005 could find no trace of the canvas after its appearance in Brussels.[29]

Said to be the largest yet exhibited in Britain with 200,000 sq. feet of canvas, the Sebastopol panorama was variously said to be between 120' and 130' in diameter and between 40' and 45' high, and had required 3½ tons of paint. As suggested earlier, the view was that of an observer in the Malakoff at 'the very hottest of the struggle which occurred just as the Russian resistance was finally being overborne'. The unsuccessful British

24 François Robichon and André Rouillé (eds), *Jean-Charles Langlois: La Photographie, La Peinture, La Guerre - Correspondance inédite de Crimée, 1855-56* (Nîmes: Éditions Jacqueline Chambon, 1992), pp.23-25.
25 Ibid, pp.189-90.
26 Luc Desmarquest, 'Le colonel Langlois et la photographie', in *Jean Charles Langlois 1789-1870: Le Spectacle de l'histoire* (Caen: Musée des Beaux-Arts, 2005), pp.25-33; Idem, 'Jean-Charles Langlois, panoramiste et photographe', *Bulletin de la SABIX* 52 (2013), pp.53-58. Paris, Musée d'Orsay: PHO 1982, pp.16-29 for the photographs.
27 Robichon and Rouillé (eds), *Langlois*, pp.24-26, 293-302.
28 'Panorama de la Prise de Sébastopol', in *Langlois*, pp.147-61. Caen, Musée des Beaux-Arts: 2005.1.31-35 for the oil studies; 205.1.34 for the earlier study without figures; and BIN 001 BUR for the photograph.
29 Ibid, p.149.

Study in oils for Langlois' Siege of Sebastopol Panorama (1860). [Musée des Beaux-Arts, Caen/The Picture Art Collection/Alamy Stock Photo]

attack on the Redan 'is seen being carried on in the distance, to the right and to the left. In front extends Sebastopol and its harbour and behind is seen the *débris* of the earthworks and trenches constructed by the Allies in advancing upon the Russian fortress.' Seen with opera glasses, it appeared 'carefully finished in its details'.[30]

Given that the canvas was French in conception and manufacture, there were some complaints, as in the *Weekly Despatch*, that the British did not take centre stage beyond Lord Raglan and the French commander, Pélissier, being shown meeting on the 'Kornilov heights'. Several reports of the canvas suggested Pélissier and Raglan were depicted yet this seems erroneous. Pélissier and other allied staff officers did appear on the canvas observing the attack, but from the Kamtchatka Redoubt, also known as the Mamelon Vert, which had been taken by the French in the earlier June assault.[31] Raglan, however, had died unexpectedly on 28 June 1855 from a combination of what was characterised as choleraic diarrhoea and exhaustion.[32] As with many panoramas, Langlois combined several different incidents including the planting of the French flag by a sergeant, and the explosion of the Russian magazine. He also took the opportunity to include portraits of Pélissier and other senior officers in order to provide a better understanding of the occasion. He had drawn on the account of at least one wounded officer.[33]

As one report put it, whilst worth seeing, 'undue prominence is given in all the most brilliant situations to our friends across the Channel, and Englishmen will no doubt vote it a big historical fib'.[34] Nevertheless, the *London Evening Standard* was struck by the vivid impact,[35]

> Although a belt of flame seems to frame in the whole picture, still there are breaks here and there in those lurid lights, telling of the bursting mines and belching of cannon, through which long lines - seeming miles - of perspective are portrayed with wonderful skill and effect, showing at times the waters where our ships are busy in the work of bombardment, and, at other times, long reaches of country.

The Era was struck by small details that caught the eye:

30 *The Times*, 19 Sept. 1881.
31 *Weekly Despatch*, 18 Sept. 1881; *London Evening Standard*, 16 Sept. 1881; *Islington Gazette*, 26 Sept. 1881
32 Mike Hinton, 'Field Marshal Lord Raglan: His Final Illness and Unanticipated Demise', *Soldiers of the Queen* 179 (2020), pp.39-54.
33 *Langlois*, p.149; Robichon and Rouillé (eds), *Langlois*, pp.29-34.
34 *Barnet Press*, 17 Sept. 1881.
35 *London Evening Standard*, 16 Sept. 1881.

Thus, at one point there are three or four Zouaves, who, outrunning their comrades, have mounted some of the broken stonework of the fort, and are defiantly planting the cherished tricolour; at another, a *vivandière* is about to succour a wounded soldier when her attention is momentarily distracted by the confusion prevailing below between the victors, and their prisoners.

As it also pointed out, the panorama was again lit by electric light and had a *faux terrain*, [36]

For some space in front on either hand up to the huge boulders, and pile upon pile of sandbags forming portions of the outer works, is strewn *débris* significant of the struggle. In various spots are guns of the old "Brown Bess" type, broken planks, posts, etc.; but this feature is not overdone; indeed, the illusion might justifiably be furthered by something more realistic than the ordinary barrier which now separates the spectator from the picture.

In this case the muskets were wrong, for neither the British nor French used smooth-bore flintlock muskets. The British army had not employed the 'Brown Bess' since the 1840s, percussion rifled muskets having been issued in 1851. The 'Rifle Musket, Pattern 1851' had been superseded by the 'Pattern Enfield Rifle' in 1853. The British rifle muskets used the cylindrical Minié bullet with conical hollow developed by the French captain, Claude-Etienne Minié in 1846. The French similarly used the 'Pattern 1851 Minié Rifle'. Even most Russians were armed with at least percussion muskets, although some reserve units still had flintlocks.

A fierce storm struck Britain on 14 October 1881. Off Eyemouth in Scotland, for example, 189 fishermen were lost. At Alexandra Palace, it caused severe tears to the Sebastopol canvas from smashed glass and exterior boards blown into the building.[37] It was soon repaired and was still on display in 1887 when it was advertised for sale or hire. It was stated that it had originally cost £12,000 and, on average, had taken £80 on weekdays and £150 on Sundays whilst on display at Alexandra Palace. Only a temporary wooden rotunda would be required and it would be well suited to a venue in Scotland and Ireland that had not experienced the display of such a large panorama. In the event, no potential owners came forward and the panorama was put up for public auction by the Anglo-Continental Contract Association on 31 May 1888.[38] Its fate, thereafter, is unknown.

36 *The Era*, 17 Sept. 1881.
37 *Evening Mail*, 17 Oct. 1881; *Islington Gazette*, 17 Oct. 1881; *The Times*, 17 Oct. 1881.
38 *The Era*, 5 Feb. 1887, and 26 May 1888; *The Times*, 31 May 1887; *The Sportsman*, 22 May 1888.

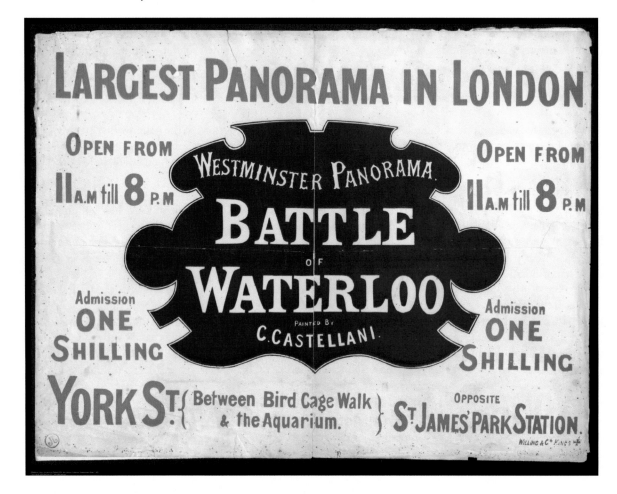

Advertisement for Charles Jules Castellani's Waterloo Panorama (1881). [Bodleian Libraries, University of Oxford. John Johnson Collection: Entertainment folder 7 (42)]

The Westminster Panorama opened in 1881 with a Belgian production, 'The Battle of Waterloo' by Charles Jules Castellani (1838-1913), commissioned by a wealthy stockbroker Victor Jourdain, who formed with his brother, Louis, the Société General des Panoramas. A close friend of Poilpot and Jacob, Castellani became a principal shareholder in the company. The Waterloo panorama had previously been shown in Anvers, and at the Brussels Exhibition.[39] It was so successful that the cost of production was recovered in only four and a half months, Castellani's 800 shares increasing in value on the French stock market from 100 francs each to 1,600 francs.[40] The Société des Panoramas d'Angleterrre was established on 30 April 1880 to exhibit Belgian canvasses in London with the expectation of substantial revenues coming from the Waterloo panorama of at least 3,000 francs daily.[41]

Castellani's Waterloo was also claimed to be the largest panorama in England, with 20,000 sq. feet of canvas, and again lit by electric light.[42] Admission, as to the other panoramas being shown at the time, was still only 1s.0d, in effect making panoramas far cheaper than in the early nineteenth century given the general inflation of price value. The focus was Ney's attack on the British centre at around 5.00 p.m., its repulse by Sir Thomas Picton's division, and Picton's death. The *faux terrain* included real standing corn 'which waves in the foreground', whilst the sounds of the bands from nearby Wellington Barracks acted as 'an economical orchestra'.[43] Castellani, son of an Italian father but brought up by his French mother became a naturalised Frenchman in 1874 but he had served as a captain of *francs-tireurs* in the defence of Paris and had been wounded and captured by the Prussians. He believed that only the arrival of the Prussians had saved Wellington's army.[44]

As with other panoramas, many different incidents were depicted including the advance of the Imperial Guard, the resistance of the Brunswick and Nassau contingents, and the arrival of the Prussians. In addition, 'Napoleon stands in the centre of his famous square, Wellington under the shade of his legendary tree, each chief being surrounded by his staff, and all the most celebrated captains of both hosts have their appointed stations in the brightly coloured scene.'[45] Yet, the panorama did not eschew the horrors: 'Yonder, in the terrible contrast to all the excitements of glory, we perceive the price that has to be paid for it in the sacrifice of brave men who lie dying and dead in a pool of blood, men and horses grouped together

39 *The Graphic*, 13 Dec. 1879; Grau, *Virtual Art*, p.103.
40 Charles Castellani, *Confidences d'un Panoramiste: Aventures et Souvenirs* (Paris: Dreyfus and D'Alsace, 1899), pp.227-29.
41 Leroy, *Panorama de la Bataille de Waterloo*, p.45.
42 *London Evening Standard*, 18 Aug. 1881; *The Globe*, 21 Oct. 1881; *Bell's Life in London and Sporting Chronicle*, 4 June 1881. BOD, JJC, Entertainments 7 (42) for advertisement.
43 *Winsford and Middlewich Guardian*, 28 May 1881.
44 Castellani, *Confidences*, pp.237-38.
45 *Morning Post*, 6 June 1881.

Charles Castellani (1838-1913). [Public Domain]

in melancholy confusion...' A description of the battle written by Major Arthur Griffiths, a Crimean veteran and prolific author best known for sensationalist works on prisons and crime novels, was available to the spectators and 'vividly described the tremendous catastrophe'.[46]

The *London Daily News* also commented on the realism as in the case of one 'sorry' horse standing alone 'on the brink of the ghastly pool bewildered and stupefied by his freedom'. Another striking group included a Highland piper, 'but it is difficult to say which are the more remarkable, the living Guardsmen, or the dead Cuirassiers'.[47]

Castellani's canvas did not enjoy his anticipated success in London as he believed that it came too close to depicting the moment when the French might have won the battle but there is no real sense of this in the press reports. The *Penny Illustrated Paper*, for example, which carried a sketch based on a portion of the canvas, praised it as 'marvellously realistic' and a 'superb tableau'.[48] Castellani's Waterloo was shown subsequently in Rotterdam in 1884 and sold at auction two years later.[49] Another Belgian version of Waterloo by a team headed by Charles Verlat (1824-90) was also painted in 1881 and exhibited at Anvers in 1885 and at Barcelona in 1888. Three fragments featuring the French cavalry charge survive in the National Art Museum of Catalonia.[50]

46 *The Era*, 4 June 1881.
47 *London Daily News*, 2 June 1881.
48 Leroy, *Panorama de la Bataille de Waterloo*, p.98; *Penny Illustrated Paper*, 4 June 1881.
49 Leroy, *Panorama de la Bataille de Waterloo*, p.98.
50 Neus Moyano, 'Tres fragments del panorama de Waterloo de Charles Verlat (1824-1890)', *Butlletí Museu Nacional d'Art de Catalunya* 11 (2010), pp.127-37; Idem, 'El panorama de Waterloo a Barcelona (1888-1890)', *L'Avenç* 4 (2008), pp.42-49; Leroy, *Panorama de la Bataille de Waterloo*, pp.98-101.

It was said that Castellani's Waterloo would be followed by another for the Jourdain brothers, namely 'The Battle of Ulundi', the final action of the Zulu War (4 July 1879), but this was only seemingly exhibited in Brussels following the display there of Castellani's Waterloo. According to *The Era*, the viewpoint of Castellani's Ulundi was from one of the surrounding hills looking towards the British square with the Zulu advancing on it from the rising ground. The moment was just as the British square was opening to allow the cavalry and mounted irregulars to be unleashed to pursue the retreating Zulu. Lord Chelmsford was surrounded by his staff with the war correspondent, Archibald Forbes, riding up 'to receive his instructions as to carrying the news of the victory to Cape Town'. In his so-called 'Ride of Death', Forbes rode 110 miles in 20 hours to the telegraph office at Landsman's Drift, outpacing the official messenger. Castellani painted his canvasses without assistants at a studio in a former locomotive works in the Brussels suburb of Molenbeek, but he did have sketches made for him in Zululand, and also had the landscape photographed.[51]

Castellani also drew on the account of the battle by Melton Prior, the war correspondent of the *Illustrated London News*, who visited him in his Brussels studio. Castellani, who eulogised Zulu heroism in the face of concentrated British firepower, was appalled by the 'horrible butchery' of wounded Zulu by the native auxiliaries of the British. Prior's apparent view that not enough Zulu had been killed reminded him uncomfortably of what some of the French middle classes had said about the suppression of the Paris Commune in 1871.[52] Ulundi was obviously intended to cater for British audiences. It is not clear from Castellani's memoirs why it was not transferred to London but financial mismanagement and over-extension of projects led to the company operating Castellani's own rotunda in Brussels filing for bankruptcy in 1882.[53]

A year earlier, the French artist, Adolphe Yvon (1817-93), had produced a panorama of Ulundi for Emperor Franz Joseph of Austria-Hungary as a gift from his wife, Empress Elizabeth. The emperor was Colonel-in-Chief of the King's Dragoon Guards, which regiment had been present at Ulundi. Yvon had been an official artist in the Crimea and was best known for large-scale French Second Empire scenes such as the taking of the Malakoff, and the Franco-Austrian battles of Magenta (4 June 1859) and Solferino, although he also produced a large allegorical painting, 'The Genius of America'. Yvon had been in the Crimea at the same time as Langlois, who criticised the former's 80' x 40' painting of the taking of the Malakoff as flat and as far less realistic than his own panorama in capturing the totality of the event. Critics saw it as attempting to mimic the illusion of a panorama but failing to do so by being far too overcrowded with figures in such a compressed compositional space. It was not critically successful, therefore, but proved very popular in print form.[54]

51 *The Era*, 21 May 1881; Hyde and Wilcox, *Panoramania*, pp.174-75.
52 Castellani, *Confidences*, pp.249-51.
53 Leroy, *Panorama de la Bataille de Waterloo*, p.57.
54 Hornstein, 'Episodes in Political Illusion', pp.296-317.

Adolphe Yvon (1817-93) by Mayer & Pierson. [National Portrait Gallery, London]

Yvon's Ulundi was announced as being under preparation in the British press in July 1880, artists under his direction working to magnify his depiction ten-fold through photographs projected on the canvas by electric light. It was intended to be 130' in diameter and to come with a *faux terrain*.[55] It was anticipated it would open in May 1881 in a new rotunda in Oxford Street and would be sent to London 'rolled round a huge *solé*, like the trunk of a giant tree'.[56] The view was from the centre of the British square just before the advance of the British cavalry. It showed also 'friendly Zulu' guarding the cattle and baggage wagons 'while infantry are firing in every direction'.[57] It may have been displayed in Brussels, but it may be that there was some confusion in the press between the Castellani and Yvon versions, especially as Castellani had worked in Yvon's studio as a young man. However, a 180° canvas, 4.5' x 22.2' is displayed flat in the National Army Museum, making the battle smoke appear to rise in different directions.[58] In 1965 it was acquired by the National Army Museum from the Parker Gallery, but its previous provenance is unknown since the latter has changed hands and any original records lost. Presumably it was a study for the intended panorama: a section depicting Lord Chelmsford and his staff and part of the charge of the 17th Lancers with Ulundi in flames in the background was cut from the canvas at some stage and appeared at auction some 15-20 years ago in South Africa. It

55 *Yorkshire Post and Leeds Intelligencer*, 29 July 1880; *Aberdeen Free Press*, 29 July 1880; *Bradford Observer*, 31 July 1880; *Lancaster Gazette*, 28 July 1880; *Graphic*, 31 July 1880.
56 *Liverpool Weekly Courier*, 22 Jan. 1881.
57 *The Graphic*, 31 July 1880.
58 NAM 1965-09-46.

Study of Yvon's Battle of Ulundi Panorama (1881). [National Army Museum, London]

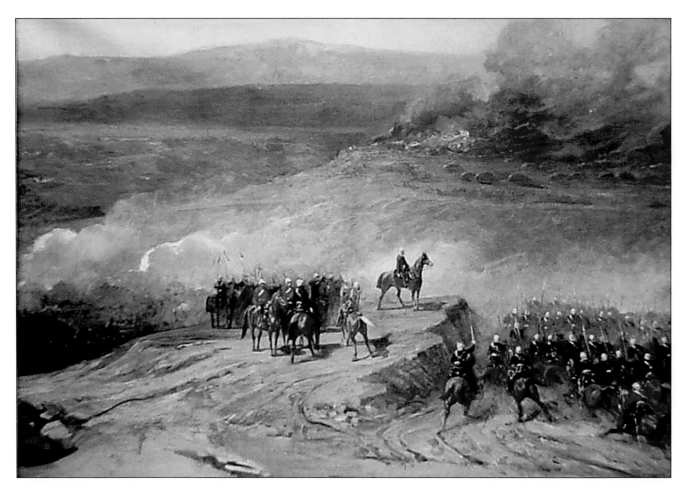

Missing Portion of Yvon's study for the Ulundi Panorama showing Lord Chelmsford and his staff (1881). [Public Domain]

might be noted that there is almost as large a painting in the National Army Museum providing a panoramic view but not intended to be displayed curved. This the 'March of Frances, Lord Moira (later Marquess of Hastings)' to Hardwar in December 1814, is attributed to Colonel Joseph 'Carlo' Doyle circa 1815 and is 2.9' x 16.7'.[59]

The other new London rotundas were showing relatively historical works but the Crystal Palace broke ranks in April 1884 with 'The Battle of Tel-el-Kebir'.[60] It was a satisfying swift and complete victory to celebrate in near retrospect. Moreover, it was a pitched battle when so many engagements in 'small wars' lacked scale. Wolseley's daring night march across the desert and dawn assault had destroyed Ahmed Arabi's army in under an hour for the loss of just 57 British dead compared to over 2,000 Egyptians.[61]

The canvas was produced in Belgium by the celebrated French panorama artist, Paul Philippoteaux, responsible for the surviving panorama at Gettysburg and that of Jerusalem at the time of the Crucifixion at Ste-Anne-de-Beaupré, Quebec. Philippoteaux had already contributed a panorama of the siege of Paris to Crystal Palace as well as the Niagara panorama already mentioned. The chosen focus was,[62]

that at which Arabi's first line of defences have been stormed, and the Highlanders are rushing on to the second line. Arabi's tent is seen just deserted by its occupants, the instruments of the band are scattered about, and a fierce fight is going on between Arabi's guards and some English soldiers. Outside the lines is seen Lord Wolseley and his staff. The desert stretches to the horizon in all directions, and the idea of space and distance is conveyed with unusual skill.

Another report emphasised the many dramatic incidents shown,[63]

We see the panic-stricken Egyptians and their advancing and triumphant foes. The dead and dying are huddled together in many ghastly heaps. Here and there, fighting with the energy of despair, are little groups rallying and vainly trying to resist the onslaught of the Black

59 NAM 1954-12-21-1-1.
60 EXBD, 96438, Crystal Palace programmes; *Norwood News*, 3 May 1884.
61 For a concise summary, see Rob Johnson, 'Egypt and the Sudan, 1881-85', in Stephen Miller (ed.), *Queen Victoria's Wars: British Military Campaigns, 1857-1902* (Cambridge: Cambridge University Press, 2021), pp.187-219.
62 *The Graphic*, 3 May 1884.
63 *South London Press*, 10 May 1884.

Robin Hood and Maid 'Mary Ann' at the Panorama of Tel-el-Kebir

Robin Hood and Maid 'Mary Ann' visiting Paul Philippoteaux's Tel-el-Kebir Panorama (1884), from *The Graphic*, 11 September 1886.

Watch and other Highlanders, who swarm over the earthworks, and, with exultant shouts, carry all before them…The atmospheric effects and the perspective are very fine. The realistic accessories are manipulated with great skill, and, judged as a work of art, the panorama is sure to attract much attention. Those who would recall a battle which was planned with wonderful military sagacity, and in which was displayed all the cool courage, dash, and intrepidity of the British soldier, have only to go down to Sydenham, and they - if they have any imagination at all - can afterwards almost believe they have taken part in the historical fight at Tel-el-Kebir.

In September 1886 *The Graphic* produced a somewhat bizarre illustration of Robin Hood and 'Maid Mary Ann' visiting the Tel-el-Kebir panorama, still on display at Crystal Palace, during the 'Foresters' Fête' of the Ancient Order of Foresters, although noting that few of the 'Merry Men' had done so. It suggested the latter would have done so if the entrance fee had been 6d rather than 1s.0d.[64] Philippoteaux's Tel-el-Kebir was still on display in 1887.[65]

Renamed the National Panorama in 1882, one of the first panoramas shown at the former Westminster Panorama in July 1883 was another version of 'The Battle of Tel-el-Kebir', this by Olivier Pichat (1820-1912), of which a series of five photographs survive in the Anne S. K. Brown Military Collection at Brown University, Providence, Rhode

THE WAR IN EGYPT.
GRAND PANORAMA
By OLIVIER PICHAT.
21, YORK ST., WESTMINSTER,
NEARLY OPPOSITE ST. JAMES'S PARK STATION, DISTRICT RAILWAY.
Views of the Delta and the Desert.
Capture of Arabi Pasha's Camp, &c.
Portraits of Commanding Officers and Staff,
Gen. Lord Wolseley, H.R.H. Duke of Connaught,
Gen. Graham, &c.
OPEN DAILY from 9 a.m. till 7 p.m.
ADMISSION ONE SHILLING.
Soldiers and Children Half-Price.

Advertisement for Olivier Pichat's Tel-el-Kebir Panorama (1883). [Bodleian Libraries, University of Oxford: John Johnson Collection: Diorama folder 4 (56)]

64 *The Graphic*, 11 Sept. 1886.
65 *Morning Post*, 25 Feb. 1887.

Island. Featuring a realistic *faux terrain*, it included 'good portraits of the general [Wolseley] and his staff, and the Ironclad train, the Indian cavalry, the flying Arabs and victorious Britons...'.[66] There is also a photocopy of a sixth photograph, which appears to show the Household Cavalry's earlier action at Kassassin.

The Prince of Wales; the Prince of Saxe-Meiningen; the Duke of Connaught, who had commanded the Guards Brigade at the battle; the Duke of Teck, who had been one of Wolseley's ADCs; Lieutenant-General Sir George Willis, who had commanded the 1st Division; and other officers who had been present all visited the panorama before it opened to the public on 5 July 1883. So, too, did the former Khedive of Egypt, Isma'il Pasha, who had been replaced by his son, Tewfik in 1879. Isma'il's extravagance had led to Egypt falling under greater European financial and political control, fuelling the nationalist movement and the army revolt against Tewfik that prompted British intervention. Connaught and Teck were both represented on the canvas. Rather like Burford in the past, the proprietors of the National Panorama printed a flyer with favourable press reviews. Open daily from 0900 to 1900, admission was 1s.0d, but soldiers and children were admitted half-price.

It was suggested that the disposition of the troops and the topographical detail reflected some licence on Pichat's part but, as a whole, it presented a 'singularly vivid impression'. The viewpoint was within the Egyptian earthworks 'in which a few Arabs are still showing fight, and the bodies of the dead and wounded lie on the solid earth of the foreground'. To the left the Egyptian troops were fleeing, some swimming across the Sweetwater Canal and others crossing the canal bridge 'as a confused rabble, whose retreat the Bengal Lancers on the opposite bank of the canal are dashing forward to cut off'.[67] Pichat had spent 14 days in the vicinity of the battlefield.[68]

Later still, the National Panorama displayed a Trafalgar canvas, this time by Ernst Philipp Fleischer (1850-1927), a professor at the Munich Art Academy, which was also shown at the Royal Naval Exhibition in 1891, as well as in Edinburgh and Manchester.[69] Fleischer also painted a version of Waterloo for the Grand National Panorama in London's Ashley Place, which was opened by the 3rd Duke of Wellington in 1890 and ran until Easter 1891. Acquired by George Alexander, it had been sold to the National Panorama Company, of which he was a director, for £34,000. One

66 Harrington, *British Artists at War*, pp.214-15; *The Graphic*, 14 July 1883; ASKB, b8100809-S7; BOD, JJC, Dioramas 4 (56 and 57a), advertisements; CWAC, E138 (001) is an advertisement for the visitor's guide, 29 Dec. 1883.

67 *The Times*, 5 and 26 July1883; *Daily Telegraph and Courier*, 3 July 1883.

68 *The Era*, 12 Apl. 1884.

69 EXBD, 100261/100267 - respectively the programme and an advertisement; GRI, N7436.52.T7: *Descriptive guide of the great panorama picture The battle of Trafalgar and the death of Nelson* (Manchester, 1888).

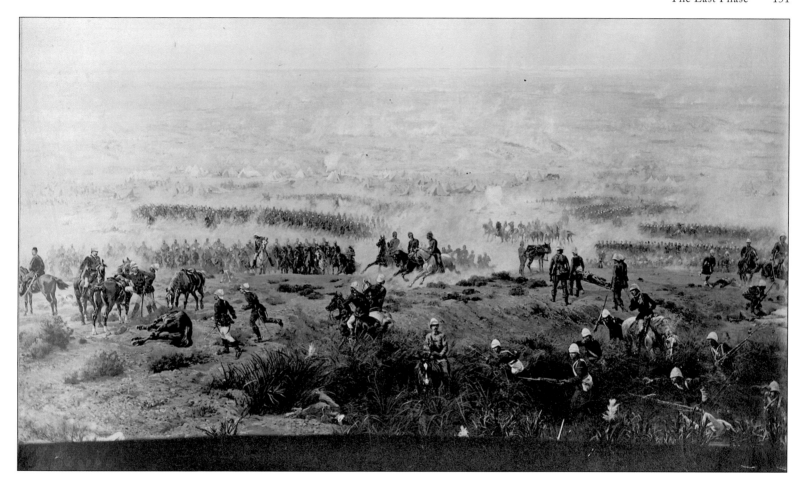

Contemporary photographs of Pichat's Tel-el-Kebir Panorama (1883). [Anne S. K. Brown Military Collection, Brown University Library]

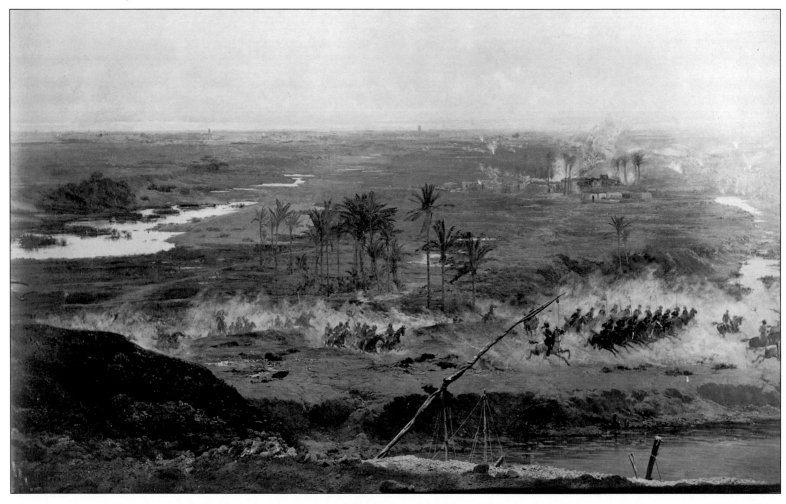

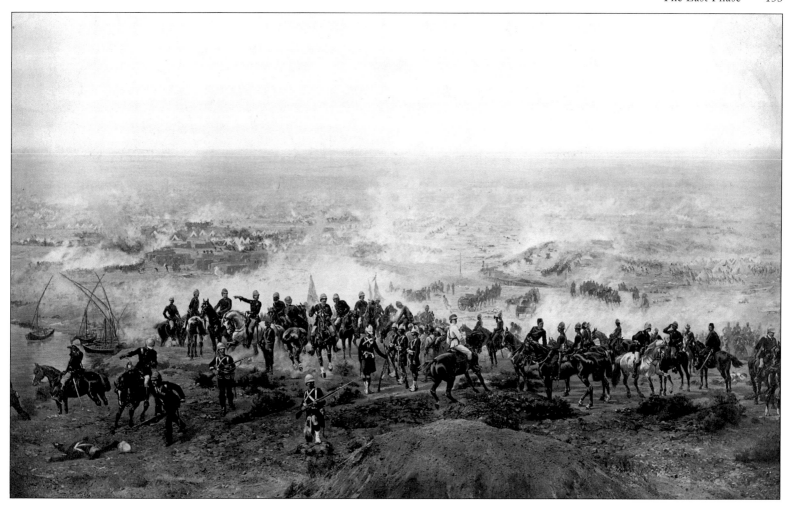

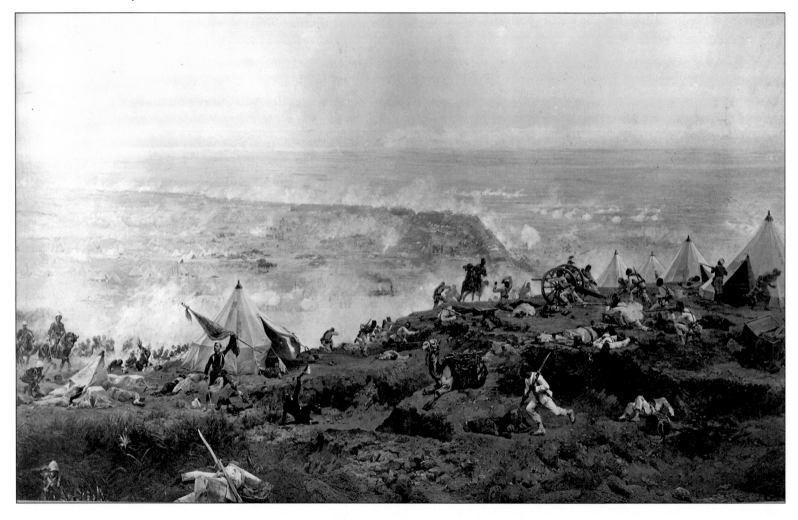

Ernst Philipp Fleischer (1850-1927). [Landeshauptstadt München Stadtarchiv]

visitor was Princess Beatrice.[70]A supposed 94-year old Waterloo veteran, James Davey answered questions from visitors.[71]

According to an advertising handbill that took an article on him from *Tit-Bits* on 3 August 1889, Davey, born at Carharrack near Redruth in Cornwall and now living in Truro, had been a member of the Falmouth Volunteer Corps and had then enlisted in the 23rd Foot. The top of one of his fingers had been shot off at Quatre Bras. The bullet then 'knocked out four of the front teeth of the man behind me, and passing through his brain, killed him instantly, so that I had a narrow escape'. He also claimed he would still walk 40 miles a day to visit his wife in the workhouse, as well as surviving by 'selling little books, or getting little presents from kind friends' as he had no pension from his military service and could no longer work in the Cornish copper mines.[72] Davey mentioned receiving a lump sum by which, presumably, he meant the £2.11s.4d prize money awarded each private. Pensions were certainly not guaranteed even for those qualifying with over 14 years' service.

70 Hyde, *Dictionary*, 16; *The Graphic*, 22 Mar. 1890.
71 Hyde and Wilcox, *Panoramania*, p.176.
72 BOD, JJC, Dioramas 1 (4), handbill, March 1890; also EXBD, 69534. CWAC, 942.132/ A14A7546, A14A7547, A14A7548, A14A7549, and A14A7550 comprise the title page and illustrations of Blücher, Ney, Napoleon and Wellington from the guide to Fleischer's Waterloo panorama.

A WATERLOO VETERAN'S PEDESTRIANISM.

HE WALKS TWENTY MILES A DAY, ALTHOUGH 94½ YEARS OLD.

Reprinted from "The Birs," of August 3rd, 1889.

The performances of Blondin, the hero of Niagara, on the tight rope, show wonderful muscular power for a man 65 years old. The endurance of "Old Campana," whose age is the same, and who recently covered 365 miles in a six-days go-as-you-please race in San Francisco, struck me at the time as being very remarkable, although it seemed every moment that the old man must drop down never to rise again.

But these feats of comparatively aged men are scarcely as extraordinary as the every-day performances of a Waterloo veteran whom I met a few days ago tramping along one of the country roads in Cornwall. This man, who is no less than 94½ years old, is James Davey, of 39, Union-street, Truro, Cornwall, and the facts which he related to me are known by persons residing in the vicinity of his home to be strictly true. As he trudged along steadily beneath a scorching sun, I overtook him, and asked him questions respecting his interesting career.

"I was born," said he, as he wiped the perspiration from his sunburnt forehead, "on January 1st, 1795, and I must be the oldest man alive who fought in the Battle of Waterloo. My birth-place was at Carharrack, a little village in Cornwall, where I lived up to the time the great war broke out. I was then a member of the Falmouth Volunteer Corps, and like many another young man, being fired with a desire to fight the French, I volunteered for the war, and joined the 23rd Welsh Fusiliers.

"You see where the top of one of my fingers has been cut off? Well, that was done by a bullet at Quatre Bras, on June 16th, 1815. The same bullet, after striking me, knocked out four of the front teeth of a man behind me, and passing through his brain, killed him instantly, so that I had a narrow escape. I saw all the fighting I wanted, during the eighteen months that the war lasted.

"When I went into battle I felt a little nervous and excited, until some of the men began to fall around me, and then it was cut and slash. Bayonets and guns dispatched many a man, but the bloodiest work was the hand-to-hand fight with sabres. Nine charges were made in one day, and the last but one which commenced at Quatre Bras ended on the plains of Waterloo, two or three leagues away. I could not stop to tie up my wound, but slashed away and killed scores of brave fellows during that awful day.

"Many of the officers died in their ball clothes, for there was a ball at Brussels the night before, and they had no time to change their attire. The soldiers of one of the horse regiments had to mount with one sleeve hanging, in their haste, and so they fought with their bare shirt sleeves in sight. The regiment afterwards continued to wear a third sleeve hanging in memory of this incident, and I suppose the custom still prevails.

"Is it a fact," I asked, "that in spite of your age you can still walk long distances without fatigue?"

"Well, if you call 40 miles in a day a long distance," he replied, "I must say yes, for I frequently go over that ground."

"What! a man of 94 walk 40 miles in a day. People will never believe that."

"It's true, though. My daily tramp is at least 20 miles, and, as I have already walked twelve miles this morning, I shall exceed that distance by the time I return home to-night. I enjoy the fresh air and a little healthy exercise as much as I ever did; but it is mainly because I am compelled to earn a living still that I go about selling little books, or getting little presents from kind friends who have assisted me for many years.

"You see, when I left the Army at the end of the War, I received a lump sum of £200, as the Iron Duke believed in paying us off in full at once. Then for 70 years afterwards I worked in the Consols and other famous Cornish mines, but it was hard work at times to get a living for my family, so, having no pension, I am now dependent on charity. My children are all dead, and my wife is in the Truro Workhouse, as she is partially imbecile, and when she is at home runs out and loses herself. She is well treated there, and by making my calls I can furnish her with a little extra tea and sugar on visiting days."

"What are your habits as regards eating, drinking, etc.?" I inquired, as he seemed in appearance, and from the clearness of his intellect, to be 30 years younger than he really was.

"I eat a great deal of bread and butter," he said. "I like the butter in May month, because the herbs are at their best, and as the cows chew the herbs I get the benefit in the latter, or the new milk which also does me good. Herb beer is my favourite drink, as I do not touch intoxicating liquors now. I eat plenty of cabbage and other vegetables, but very little animal food. Meal is also part of my diet, and oranges, and other fruits when I can afford them.

"I was once a heavy smoker, sometimes consuming as much as seven ounces of tobacco in a week; but, three years ago, after a terrible struggle, I managed to conquer the habit, and also my liking for intoxicating liquors—in which, however, I had never indulged to excess. I had to pray twenty times before I felt that I was no longer a slave to tobacco; but after offering up three prayers I felt the master of intoxicants.

"I was converted to religion in 1814 at Gwennap Pit (the famous amphitheatre where John Wesley, the founder of Methodism, often harangued the multitude), under the preaching of 'Thundering Aimes,' so called because of his powerful ministrations. There was a great revival on that occasion, and over 2,000 persons were converted before leaving the Pit. The revival extended throughout the country, and lasted nine months."

The interesting old veteran, who bids fair to be at least a centenarian, if not a rival to Old Parr, then threw his bundle of broken meats over his shoulder, and again trudged cheerfully over the dusty roads.

JAMES DAVEY may be seen and interviewed daily at THE PANORAMA OF THE BATTLE OF WATERLOO, Ashley Place, Victoria Street, (Two minutes' walk from Victoria Station.) *March 1890*

Handbill describing the exploits of the supposed Waterloo veteran, James Davey, who acted as a guide to Fleischer's Waterloo Panorama (189). [The Bill Douglas Cinema Museum, University of Exeter]

Nor would a minor wound have merited an award from the Waterloo Subscription Fund catering for widows, orphans and the seriously disabled, which finally closed in 1886.[73]

Davey's story was taken up in the Cornish press, the *Tit-Bits* article re-appearing in the *Royal Cornwall Gazette* in October 1889. As a result of the publicity, Davey was taken on by the panorama to sell programmes and tell his story whilst garbed as a soldier of the 23rd would have appeared at Waterloo. Catching up with him, the *Royal Cornwall Gazette* reported that Davey 'shows you where, over to the left of Hougoumont, he and the rest of the 23rd Welsh Fusiliers were supporting the Guards and skewering Napoleon's Old Guard on bayonets like small birds for a grill'. It was said that the officers of the regiment were taking up a subscription as Davey had no pension.[74] It was also suggested that Davey was the battle's last other rank survivor.[75]

A number of men named James Davey were born in Cornwall around 1796, but it was a common enough name in the county. The only James Davey shown on the Waterloo Medal Roll, however, is a private in the Light Company of the 2nd Grenadier Guards. It is generally thought that the last two surviving British other rank veterans were Samuel Gibson of the 27th Foot, who died in December 1891, and Maurice Shea of the 73rd Foot, who was later commissioned as a lieutenant in the British Auxiliary Legion during the First Carlist War and died in February 1892. The last veteran from the British army as a whole was an ensign in the King's German Legion, Ferdinand Scharnhorst, who died in July 1893.[76] It seems highly likely, therefore, that Davey's story was fraudulent.

This was not unusual. The supposed 100-year 'Waterloo Veteran', Corporal Jeremiah Brown, who recounted his experiences at Philippoteaux's Waterloo panorama in Melbourne in Australia in 1893, turned out to have been born only in 1811, and not to have entered the army until 1829. He was expelled from a veterans' home, arrested, and jailed for vagrancy after the show closed, dying in Geelong Gaol in 1894.[77] It might be noted that Australia mirrored Britain in the projection of military endeavour through panoramas - particularly moving and modelled al-fresco panoramas - as during the Crimean War, Mutiny, and Zulu War, but also taking in the Third New Zealand War (1863-66), Third China War, American Civil War, Franco-Prussian War, Russo-Turkish War, and the Russo-Japanese War (1904-05). William Thompson's 'Colossal Mirror of the Zulu War' made

73 Milkes, 'A Battle's Legacy', pp.107, 128-33, 149-205.
74 *Royal Cornwall Gazette*, 3 Oct. 1889; 6 Mar., and 10 Apl. 1890; *Reynolds' Newspaper*, 16 Mar. 1890.
75 *Morning Post*, 19 Mar. 1890.
76 *Kildare Chronicle*, 26 Dec. 1891; *Irish Examiner*, 12 Mar. 1892; *The Annual Register: A Review of Public Events at Home and Abroad for the Year 1893* (London: Longmans, Green & Co., 1894), p.173.
77 *The Argus*, 20 Feb. 1893; Craig Wilcox, *Red Coat Dreaming: How Colonial Australia Embraced the British Army* (Port Melbourne, VIC: Cambridge University Press, 2009), p.33.

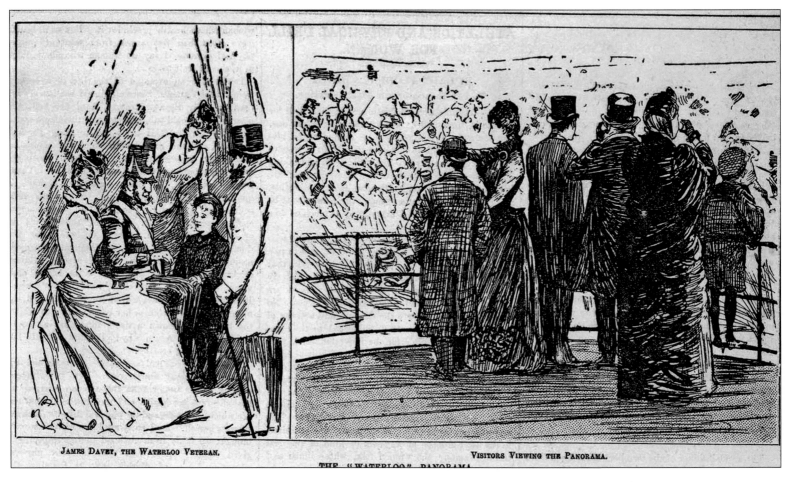

James Davey talking to visitors at Fleischer's Waterloo Panorama from *The Daily Graphic*, 27 May 1890.

use of 8,000 mechanically operated figures although on at least one occasion at Adelaide they 'stuck fast and refused to proceed on the warpath'. The 360° panoramas exhibited in Australia in the 1880s were mostly copies of battle panoramas shown in the United States or, as in the case of Philippoteaux's Waterloo panorama, imported from the United States.[78]

Fleischer's Waterloo panorama was 121' in diameter, 50' high, and 380' in circumference. The focus yet again was on 'that crisis in European history when the Duke of Wellington gave the signal for the advance of the Allies, and when Napoleon was about to stake all upon the last desperate effort of the Imperial Guard'.[79] Ney had 'the French Guard about him', Maitland was at the head of the British infantry, Napoleon was with more of the Imperial Guard, Highlanders were 'locked in battle with the French Cuirassiers', the Prussians were advancing, and Wellington was with his staff.[80]

For one reporter,[81]

Realism runs close up to historical fact without touching upon the gruesome. Art describes death and the agony of it without going beyond the actuality of lost swords and unlimbered cannon. As a field of battle, the scene is remarkable. The perspective admits of every historical detail of the famous fight being vividly painted, and the atmospheric adjuncts, the broken and riven and passing thunderstorm, with shafts of sunlight, lights, and shadows, bathing the field of valour alternately in glory and gloom, touch off with the instincts of nature, a memorable and unrivalled spectacle of its kind.

Another thought it 'more excellent than any which has been seen in a similar composition, and less illusory than other endeavours after similar effects'.[82] An accompanying exhibition of Waterloo relics was opened in January 1889. According to the *United Service Magazine*, which devoted an accompanying article to the battle by the editor and Professor of Military Art and History at the Staff College (1885-92), Colonel Frederick Maurice, 'the crowds of all classes which continually visit it show the deep interest still felt in the great battle by all Englishmen'.[83] *The Times* was

78 Mimi Colligan, *Canvas Documentaries: Panoramic Entertainments in Nineteenth-Century Australia and New Zealand* (Melbourne, VIC: Melbourne University Press, 2002), pp.48-50, 72, 76-82, 86, 89-94, 131, 142, 151-53, 160-61, 163-69, 175-82, 185-86, 204-05; Beckett, *Rorke's Drift and Isandlwana*, p.119.
79 *London Evening Standard*, 25 Dec. 1888.
80 *The Stage*, 3 Jan. 1889.
81 *Aberdeen Press and Journal*, 25 Dec. 1889.
82 *Western Morning News*, 26 Dec. 1889.
83 Hofschröer, *Wellington's Smallest Victory*, p.22; *United Service Magazine*, Apl. 1890; *Volunteer Service Gazette and Military Gazette*, 26 Apl. 1890.

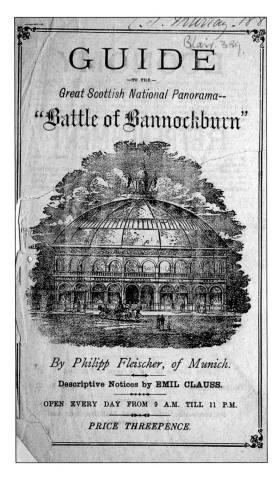

Guidebook to Fleischer's Bannockburn Panorama (1898). [Bodleian Libraries, University of Oxford. John Johnson Collection: Diorama folder 6 (23)]

especially appreciative of the *faux terrain* so that 'nothing short of actual contact could determine the precise point at which these stage properties, as it were, give way to the painted canvas'. It lamented, however, the absence of a plan to guide visitors, although praising the 'clear exposition' by Edward Ansell, who provided a 'lucid' commentary, which was obviously intended to contrast with Davey's more anecdotal account.[84]

Reporting the attendance of a 'golden harvest' of 'thousands of holiday makers' at the panorama in May 1890, the *Daily Graphic* commented that Wellington 'has just given whatever was the actual and historical equivalent of the legendary order, "Up Guards and at 'em."' Hougoumont was in ruins and La Haye Sainte in flames. However, it also noted that visitors were provided each afternoon and evening with 'an admirable vocal and instrumental concert by Mrs. Hunt's Ladies' Orchestra, assisted by Miss Elsa Gwynne'. Davey 'retails thrilling reminiscences to all comers, and fights his battles o'er again in fancy'.[85] Generally, Ashley Place was intended to rival continental-style *kursaal* as an entertainment complex. In addition to the exhibition of relics, there was a reading room, and a full programme of entertainments. In December 1890, alongside the Waterloo panorama, it also featured the Japanese juggler, 'Sintorrasson', and children's Christmas parties with a conjuror, 'Hercat', with a free toy for every juvenile ticket sold.[86]

Although often described as a French Chevalier in the press, Fleischer was born in Breslau and trained in Dresden and Munich. He was a prolific panorama artist, who took great pains to

84 *The Times*, 25 Dec. 1889, and 17 Dec. 1890.
85 *Daily Graphic*, 27 May 1890.
86 *The Times*, 17 Dec. 1890.

get the details correct. As well as Trafalgar, two more panoramas by Fleischer - both painted in Munich - were purchased by the Bavarian hotelier and naturalised British subject, Albert Thiem, and exhibited at rotundas he owned in Edinburgh, Glasgow, and Manchester. Fleischer's Waterloo and Trafalgar panoramas are not extant, but parts of 'The Battle of Bannockburn (1888) and 'The Battle of Omdurman' (1900) survive at the Hotel Hydro in Peebles. Whilst what remains of the Bannockburn panorama is pasted up flat in the Dining Room, the few surviving visible fragments of the Omdurman panorama are in the rear of a storage area that was once part of the Ball Room.

Fleischer's Bannockburn (23-24 June 1314) was originally 35' x 335' and intended for the new Great National Panorama in Sauchiehall Street, Glasgow before going to Thiem's other rotunda in Deansgate, Manchester. Fleischer made sketches of the field of Bannockburn in the autumn of 1887 as well as researching in museums and libraries, consulting historians, and making numerous drawings of arms and armour.[87] A correspondent in Germany reported after seeing the one-tenth size colour sketch of the panorama in November 1888 that the battle was observed from behind Robert the Bruce's position with the English cavalry charging the Scottish infantry in the foreground, some tumbling into the pits and traps set for them: 'Everywhere groups of soldiers and officers are engaged in violent hand-to-hand combat - claymores, Lochaber axes, and Scottish spears making sad havoc in the ranks of the English foe, horses and warriors reeling and writhing on the bloody turf.'[88]

In January 1888 it was reported that Luitpold, the Prince Regent of Bavaria, had visited Fleischer's studio to view the work on the panorama and had asked various questions on the city of Glasgow, which he had visited some years previously: 'The cleverly painted vegetation of the ferny foreground seemed to awaken in the old sportsman pleasant recollections of Scottish grouse and partridge.'[89] Luitpold acted successively as regent to his nephews, Kings Ludwig II and Otto, both of whom proved mentally incapable of ruling.

In opening the attraction in Glasgow on 7 June 1888, the chairman of the Scottish Panorama Company, Robert Cox, remarked that 'it was because of the striking part which the battle of Bannockburn had played in the history of the world that it had been thought the best subject to choose for a panorama in this country'. His somewhat bizarre (and ahistorical) reasoning was that the battle had taught the English to respect the Scots and the resulting 'peace' had been felt throughout the globe as the two nations 'were then set free to go forth to conquer in every quarter of the globe'.[90] A gelatine and glue manufacturer, Cox would later be Unionist MP for Edinburgh South from 1895 until his death in 1899.

87 *Falkirk Herald*, 28 Sept. 1887; *Glasgow Evening Citizen*, 22 Oct. 1887.
88 *Glasgow Evening Citizen*, 12 November 1887; *The Scotsman*, 21 January 1888.
89 *The Scotsman*, 21 Jan. 1888.
90 *Edinburgh Evening News*, 8 June 1888; *The Scotsman*, 8 June 1888.

Contemporary photographs of Fleischer's Bannockburn Panorama (1888). [Yale Center for British Art, Paul Mellon Fund]

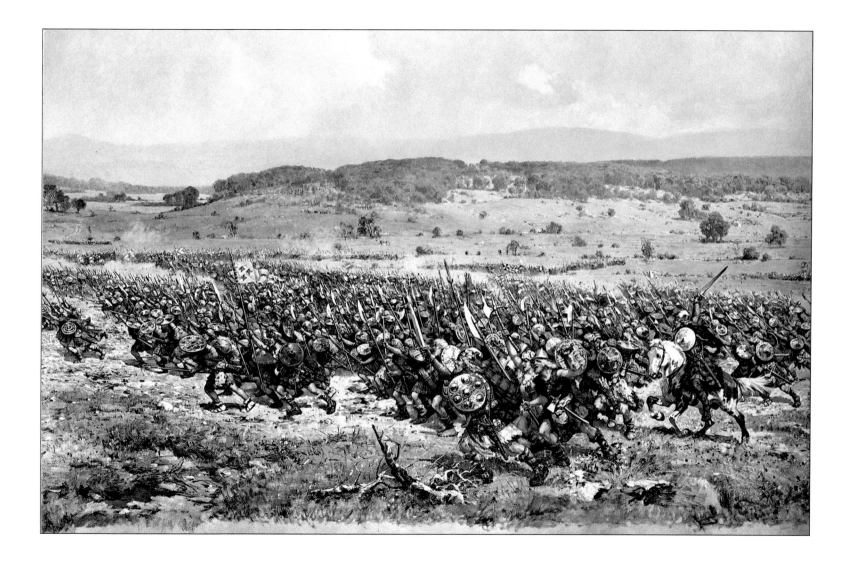

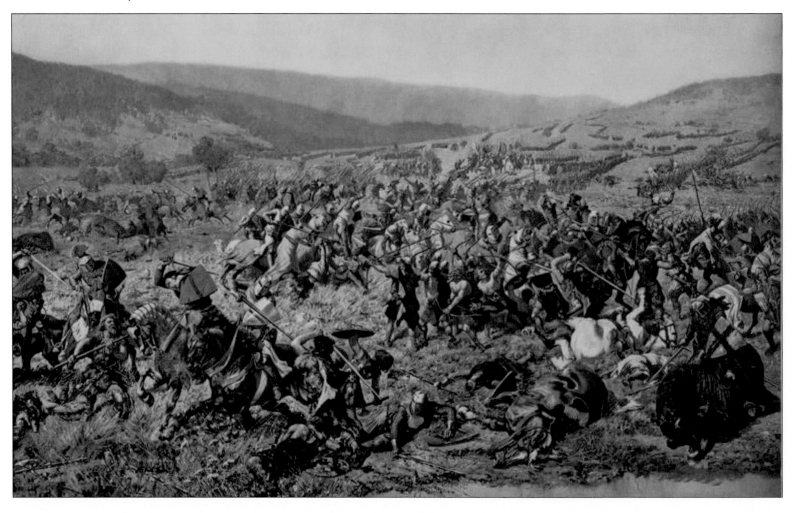

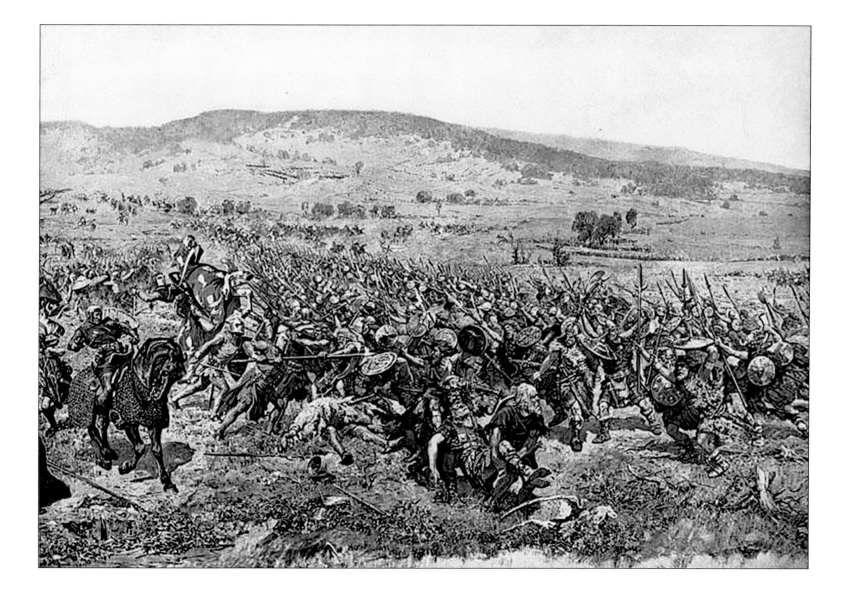

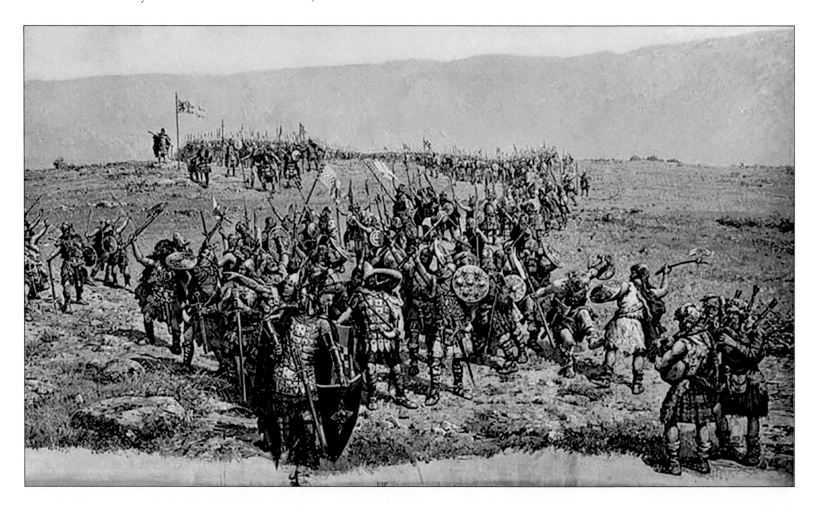

Parts of Fleischer's Bannockburn Panorama (1888) at the Hotel Hydro, Peebles. [Author]

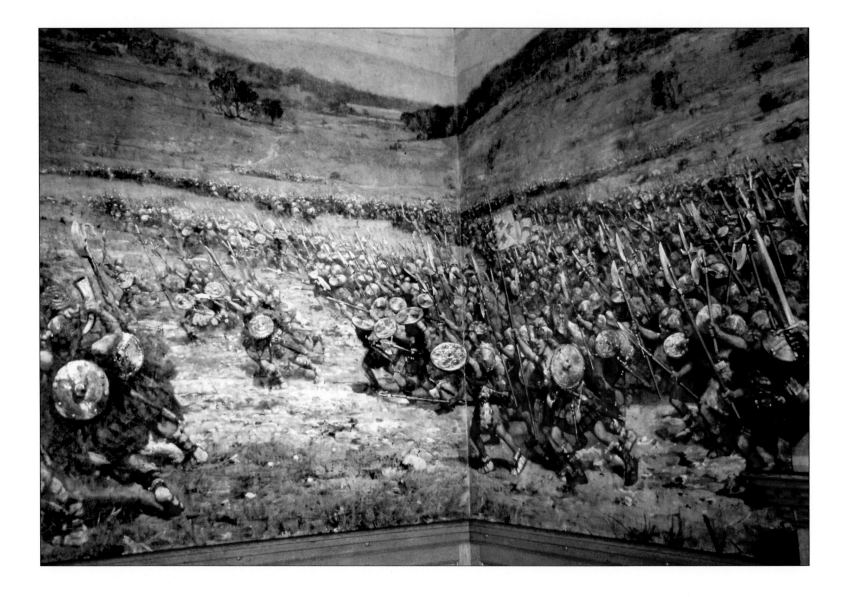

Bannockburn attracted 'immense crowds'. Some 1,115 visitors were recorded on the first day it was open to the public on 8 June. Some 24,580 people had visited it within three weeks, and a total of 72,105 had passed the turnstiles by the end of July.[91] As usual, admission was 1s.0d for adults and 6d for children. Within its first 106 days, it made a profit of £5,973.1s.4d, the cost of production and display having been some £5,000. A previous panorama of Niagara Falls had made £20,000 in nine months, 'but then all panoramas are not Niagara'.[92] There was a *faux terrain* which included grass brought from the battlefield, tangled undergrowth, 'scraps of tree life', unlit log fires with metal pots, and even 'a rudely built, mossy-thatched hut, and over it is a dry-stone dyke, whose interstices are filled with parasitic growths, while yellow gorse flourishes by its side'.[93] The 'grounding' of the painting alone had consumed 18 cwt of 'white' and 2 cwt of oil and varnish'.[94] The painting was widely praised by the Scottish press.[95]

The viewpoint was behind the rising ground known as the 'Bore-stone' on which Robert Bruce had set his standard:[96]

> The artist has chosen for his picture the most critical moment of the battle, when, after the partial defeat of the English knights and men-at-arms, the centre of the Scottish army, under Randolph Earl of Moray, rushes forward to the attack, at a signal from their King and Commander-in-chief, Robert the Bruce, and by a furious and irresistible onslaught, completes the Scottish victory… His noble figure stands in prominent relief against the delicate hue of the distant height on which the Wallace Monument is seen to-day. His staff and bodyguard are posted in the rear. Nearer to the foreground his captains and their followers are assembled in semicircle… This group… gives a most faithful representation of all the weapons and armour then in use in the Scottish army. Close by some soldiers are executing a war dance to the stirring tunes of the pipes.

Whilst a number of Scottish participants were identified including the Earl of Moray and Sir Robert Keith, the only individuals on the English side identified were the Norman, Giles d'Argentan, celebrated as one of the three most accomplished knights in Christendom, who was killed, and King Edward II who 'watches the course of the battle, his officers urging him to leave the field, lest he might be captured'. The guidebook also pointed

91 *The Scotsman*, 25 June 1888; *Stirling Observer*, 12 July 1888; *Glasgow Evening Post*, 9 June and 30 July 1888.
92 *Brighton Gazette*, 18 May 1889; *Western Morning News*, 17 Aug. 1889.
93 *Glasgow Herald*, 7 June 1888.
94 *Annandale Observer and Advertiser*, 15 June 1888.
95 *Aberdeen Weekly News*, 9 June 1888; *Glasgow Evening Post*, 12 July 1888.
96 BOD, JJC, Dioramas 6 (23) and (24), *Guide to the Great Scottish National Panorama - Battle of Bannockburn* (Glasgow, 1888).

out 'in striking and pleasant contrast to all this turmoil', some 'charming' scenery including the 'silvery Forth', and 'the touching picture of some Scottish women tending a wounded foe'. Interestingly, whilst the guidebook mentioned the celebrated hand to hand duel between Robert Bruce and Henry de Bohun on 23 June 1314, its description of the actual panorama did not, although it showed it, despite the focus being on the battle on the following day.

The guidebook to Fleischer's Bannockburn, with a description of the battle and its background was compiled by Emil Clauss, a Glasgow iron merchant. It did not include a plan, but an album exists in the Yale Center for British Art of nine contemporary photographs taken of the panorama. The album was presented to Robert Cox by Thiem 'as a souvenir, and in grateful remembrance of the ready assistance given in most difficult circumstances in promoting the Company'. This enables an estimate to be made of which parts of the original were used for the hotel dining room.[97] It misses the sections showing Edward II watching the battle and Bruce fighting de Bohun. There is a suggestion that the missing sections may be behind the bar in the hotel. At the time there was some criticism that all the Scots seemed particularly tall, perhaps too tribal, and even Irish in appearance. It must be said that some do appear somewhat 'antique', including one in a horned helmet who seems to have drifted in from a Victorian conception of a Viking raid. Nonetheless, the overall quality of Fleischer's work is evident from the surviving portions.

The Bannockburn panorama returned to Glasgow in 1901 to replace Fleischer's Omdurman panorama. The latter, which was also shown at the Glasgow International Exhibition, was opened by the city's Deputy Lord Provost in November 1900 in the presence of the war correspondent, Bennet Burleigh. The latter noted that many different incidents had been combined to present the impression of the battle, but it was 'an admirable representation of that great day'. Burleigh continued,[98]

> It would be impossible for him and for anyone who was there ever to forget that great tidal wave of humanity that came along at first with a distant murmur, and then broke out into an articulate roar as if swept madly on - a wave of humanity three miles long and very deep, rushing like a torrent of water which was broken and became dismembered by the fire first of the artillery and then our infantry.

Omdurman was an even more one-sided victory than Tel-el-Kebir, memorably characterised by the young war correspondent attached to the 21st Lancers, Winston Churchill, as the 'most signal triumph ever gained by the arms of science over barbarians'. [99] Some 11,000 Mahdists were killed

97 YCBA, A 2019 34.
98 *North British Daily Mail*, 26 Nov. 1900.
99 Winston S. Churchill, *The River War* 3rd edn. (London: Eyre & Spottiswoode, 1933), p.300.

Contemporary photographs of Fleischer's Omdurman Panorama (1900). [Durham Diocesan Registrar and Durham University Library and Collections: SAD A45/1-10]

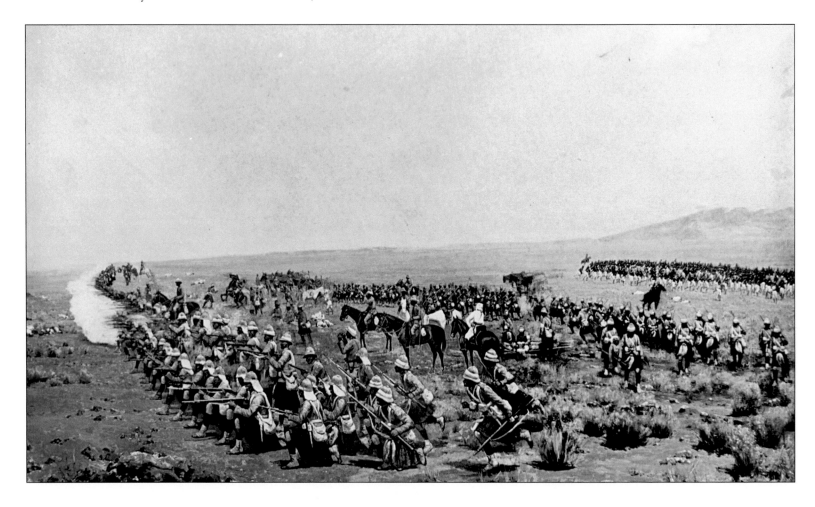

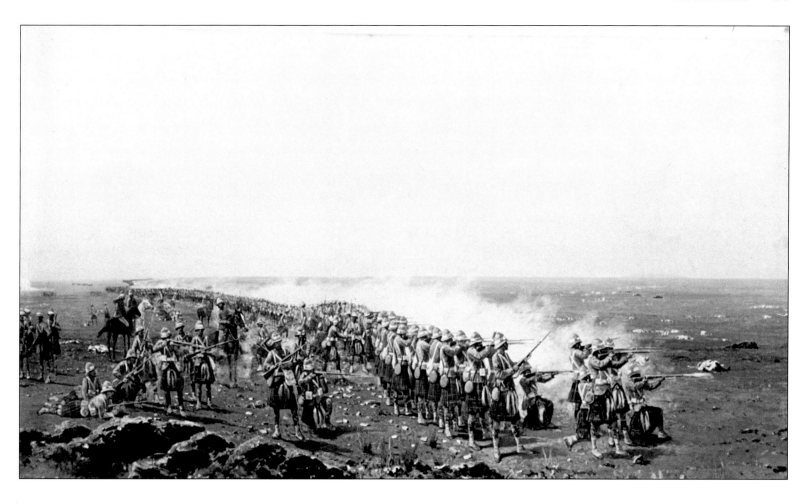

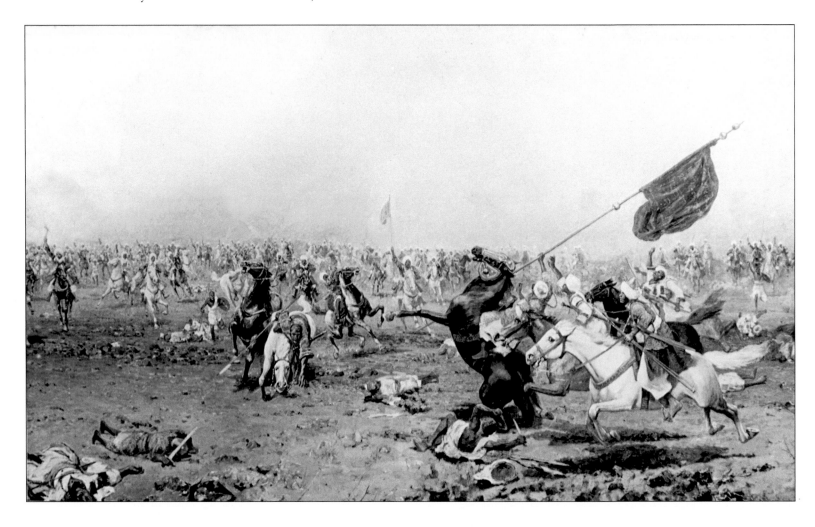

for the loss of just 48 British, Egyptian and Sudanese dead from Sir Herbert Kitchener's Anglo-Egyptian army. Omdurman's particular attraction for a Scottish audience was the participation of the 1st Battalion, Seaforth Highlanders and the 1st Battalion, Queen's Own Cameron Highlanders.

Within the first fortnight, an average of 400 visitors a day was coming through the turnstiles with about 1,000 on Saturdays. A Captain Steel was available to give short talks to visitors, and engaged with one Cameron Highlander with a wounded limb home from the South African War 'who gave a most realistic account of his experiences and paid an honest tribute to the excellence of Professor Fleischer's work'.[100] In addition to those shown on the *faux terrain*, various Mahdists artefacts were on display, some donated by the war correspondent and artist, Frederic Villiers, who contributed to the descriptive booklet. Others came from Kitchener's successor as Sirdar of the Egyptian Army, Sir Reginald Wingate.[101]

According to Villiers, Fleischer had visited the Omdurman battlefield and made elaborate studies of Mahdists as well as British troops.[102] The painting had again cost around £5,000 to produce and display and was 315' x 34'. The view point was from the British firing line alongside the Seaforths and Camerons in the 1st (British) Division. Kitchener was shown with his staff, including Slatin Pasha, Wingate, and Colonel Leslie Rundle, his chief of staff. Brigadier General John Maxwell commanding the 2nd Egyptian and Sudanese Brigade and Major General Sir Archibald Hunter, commanding the 2nd (Egyptian and Sudanese) Division, were in the foreground, the latter pointing out Hector Macdonald and his Sudanese brigade. The Mahdi's tomb was being shelled in the distance. The 21st Lancers were seen to the right before they advanced and famously charged into a force of concealed Dervishes. [103] Villiers noted, 'The atmosphere of the desert, with its lilac tints, is perfect; and one can almost feel the hot glare of the Eastern sun striking and reflecting on the sand rock and mimosa bush.' He also mentioned Hector Macdonald seen directing his brigade at 'a critical point of the battle'.[104] The now Lieutenant-General Sir Archibald Hunter visited the panorama in July 1901 and 'pointed out to the party which accompanied him many points of interest in connection with the fight'.[105]

As with the Bannockburn panorama, a contemporary photograph album survives, this one presented by Thiem to Wingate 'as a mark of appreciation of his valuable services in promoting the Omdurman panorama'.[106] The ten photographs cover around 60 per cent of the original. The surviving four

100 *North British Daily Mail*, 11 Dec. 1900.
101 *Glasgow Herald*, 13 Dec. 1900.
102 Hyde, *Dictionary*, pp.171-72; Harrington, *British Artists and War*, p.271.
103 Mitchell Library, Glasgow: *Grand National Panorama of the Battle of Omdurman by Professor Philipp Fleischer exhibited in the Panorama Buildings, Sauchiehall Street, Glasgow* (1901).
104 *Falkirk Herald*, 25 May 1901; *Highland News*, 1 June 1901.
105 *Edinburgh Evening News*, 5 July 1901.
106 University of Durham, Sudan Archive, Wingate Mss, SAD. A45/1-10.

fragments visible at Peebles appear to be those parts of the canvas adjacent to Kitchener and his staff. Two are of artillery batteries on the move, and one of Highland pipers. A mounted lancer officer seen in front of an artillery battery on the move may represent Churchill whilst he was acting as a liaison officer to the Sirdar, but this is by no means certain. The scenes of the British forces repulsing the Mahdists and the Mahdists' charge are all absent. More of the panorama may well survive behind the panels in the former Ball Room.

Thiem purchased the Hotel Hydro in 1898, but the hotel was remodelled after a fire in July 1905. The architect who designed the 1901 Glasgow Exhibition, James Miller, presided over the rebuild completed in March 1907, and appears to have been involved with the arrangement of the panoramas at the hotel at that stage. Press descriptions of the architecture of the new hotel do not mention the panoramas and no one seems to have thought it odd that scenes of death and destruction should be suitable for a health spa hotel.[107] Consequently, these unique survivals have been there for over a century. Funds are being sought and raised to reveal and restore what remains to view, including a possible recreation for display in the Khalifa House Museum in Omdurman.[108]

107 *The Scotsman*, 23 March 1907.
108 https://winstonchurchill.org/publications/churchill-bulletin/bulletin-151-jan-2021/omdurman-panorama/

Fragments
of Fleischer's
Omdurman
Panorama (1900)
at the Hotel
Hydro, Peebles.
[Author]

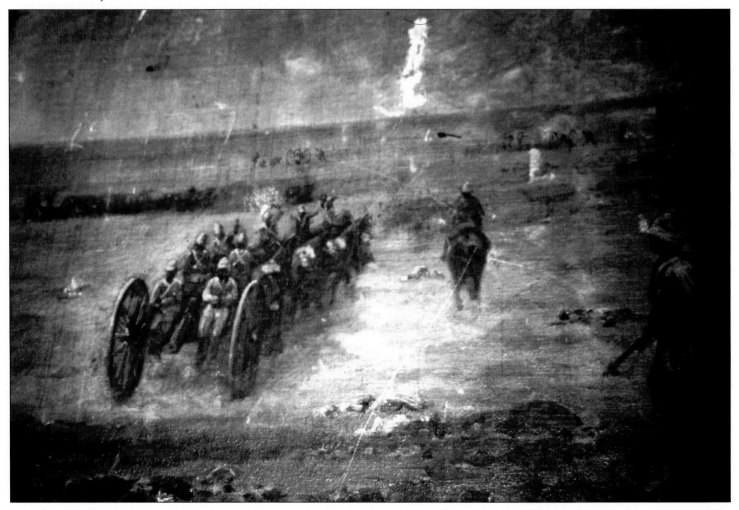

Conclusion

It was perhaps appropriate that the last two 360° British military panoramas should have been devoted to the earliest battle so treated - Bannockburn - and one of the last imperial encounters before the outbreak of the Great War - Omdurman - although some moving panoramas also depicted the South African War.

By the end of the nineteenth century, foreign travel was more common whilst patterns of popular entertainment had changed still further. The growth of mass media, photography, and the early cinema including newsreels all robbed static panoramas of their ability to convey contemporary events or scenes realistically. Together, photography and the moving image 'destroyed the legitimacy of battle painting in the construction of usable pasts'.[1] British Mutoscope and Biograph's film of General Sir Redvers Buller arriving at the Cape to take command of the British forces on 31 October 1899 was shown in London's Palace Theatre on 21 November, dramatically increasing the audience. The company's profits went up by 52 per cent over the first six months of 1900. Before long, scenes of the South African War were being faked on Hampstead Heath.[2] Purveyors of moving panoramas like the Pooles became owners of cinemas. By 1914 there were already over 4,500 cinemas in Britain with an estimated weekly audience of seven million. Legislation in 1897 required separate projection rooms, which encouraged permanent buildings as opposed to earlier bioscope tents

1 Tom Gretton, 'Waterloo in Richard Caton Woodville's "Battles of the British Army" Series for the *Illustrated London News*, 1893–99', *Victorian Periodicals Review* 48 (2015), pp.531-56, at pp.548-49.

2 Richard Brown, 'Introduction', to William Dickson, *The Biograph in Battle: Its Story in the South African War related with Personal Experience* reprint edn. (Trowbridge: Flicks Books, 1995), pp.i-viii; Stephen Bottomore, 'The Biograph in Battle', in Karel Dibbets and Bert Hogenkamp (eds), *Film and the First World War* (Amsterdam: Amsterdam University Press, 1995), pp.28-35; Elizabeth Strebel, 'Imperialist Iconography of Anglo-Boer War Film Footage', in John Fell (ed.), *Film before Griffith* (Berkeley, CA: University of California Press, 1983), pp.264-71. See also J. H. DeLange, *The Anglo-Boer War, 1899-1902, on Film* (Pretoria: State Archives Service, 1991).

and 'penny gaffs'. Tickets were cheaper than for theatres or even music halls so that cinema rapidly became one of the most popular forms of working-class entertainment. Weekly newsreels - 'topicals' - as opposed to news films - 'actualities' - were pioneered by Pathé in 1911.[3]

The colossal losses of the Great War greatly dampened enthusiasm for nationalism at least for the time being. The industrialisation of mass modern warfare also spelled the end of traditional battle art, of the image of the cavalry charge, and of heroic sacrifice. There were only a few late military panoramas in Europe after 1918 such as the Panthéon de la Guerre displayed in Paris, and Alfred Bastien's two panoramas of the Belgian wartime battlefields of the Yser and the Meuse exhibited in Brussels although none of these accorded to the pre-war battle panorama style. In Britain, there was Wylie's 180° panorama of Trafalgar in 1928. This seemed, however, an anomaly despite the specific intention to use it to raise funds.

British battle panoramas in the nineteenth century played a very distinctive but largely forgotten role in the promotion of national and imperial themes amid the wider dissemination of martial virtues. It might not be so surprising, therefore, that the revival of the military panorama and diorama after 1945 was due almost exclusively to authoritarian regimes. Such regimes have continued to favour them, presumably as a reflection of their appeal as propaganda for less sophisticated mass audiences. The art form, however, has also seen a revival in the West primarily in terms of landscapes, although these have often been of an historical nature. Many of the survivors from the late nineteenth century have also been extensively restored and renovated, and presented to new audiences with the all the advantages of modern sound and light systems. It can remain a special experience to visit one. When so few exist in the West the novelty value is arguably much as it was in the 1790s. They are still a marriage of art, entertainment, and commercialism. Robert Barker would most certainly have approved.

3 Ian F. W. Beckett, *The Making of the First World War* (New Haven, CT: Yale University Press, 2012), p.89.

Appendix I: Classic Military Panoramas around the World

Austria

Innsbruck: Panorama Innsbruck - The Battle of Bergisel 1809 (1896). 10m x 100m. Panorama created by Michael Diemer. Depicting the victory of the Tyrolean army of Andreas Hofer over French and Bavarian forces on 13 August 1809. With the exception of a brief display in London at the Royal Austrian Exhibition in 1906, always exhibited at Innsbruck. Relocated and reopened in 2011.

Belgium

Braine l'Alleud: Panorama of the Battle of Waterloo (1912). 12m x 110m. Panorama created by Louis Dumoulin. Depicting the French cavalry attacks on the British positions on 18 June 1815. Always displayed at Waterloo. Fully restored from 2007 onwards for the bi-centenary commemorations in 2015.

Brussels: The Battle of the Yser (1920). 14m x 115m. Panorama created by Alfred Bastien. Depicting the Belgian part in the Battle of the Yser between 18 and 27 October 1914 but also focussing on the destruction of Ypres in the British sector of the Ypres Salient under German bombardment. Badly damaged in 1940. Stored by the Musée Royal de l'Armée et de Histoire.

Brussels: Battle of the Meuse (1937). 8m x 72m. Panorama created by Alfred Bastien. Depicting the Belgian defence of Namur and Dinant in August 1914. Scenes of the massacre of Belgian civilians were destroyed by the Germans during their Second World War occupation of Belgium. Stored by the Musée Royal de l'Armée et de Histoire.

Czech Republic

Prague: Marold's Panorama (1898). 11m x 90m. Panorama created by Luděk Marold. Depicting the defeat of the Protestant Hussite Taborites by the Catholic Imperial Army of the Holy Roman Empire at Lipany, 29-30 May 1434. Always exhibited at Prague. Fully restored and reopened in 2004.

France

Paris: Panorama de la Guerre Russo-Japonaise (Post 1905). 2.31m x 30m. Moving panorama of the Russo-Japanese War (1904-05) created by Franz Gruber. Stored in the Musée des Arts Forains.

Hungary

Opusztaszer: The Feszty Panorama (1894). 15m x 120m. Panorama created by Árpád Feszty. Depicting the arrival of the Magyars in what would become Hungary after crossing the Carpathians in 896 AD. Originally at Budapest although also shown at the Great Britain Exhibition at Earls Court in 1899. Damaged in the Second World War. Fully restored and reopened at its present location in 1995.

Poland

Wroclaw: The Panorama of Racławice (1894). 15m x 114m. Panorama created by Jan Styka and Wojciech Kossak. Depicting the victory of the Polish insurgents of Tadeusz Kósciuszko over Russian forces at Racławice on 4 April 1794. Originally at Lvóv (Lemberg) and damaged in the Second World War. Fully restored and moved to its present location in 1985.

Russia

Moscow: Panorama of the Battle of Borodino (1912). 15m x 115m. Panorama created by Franz Roubard. Depicting the defeat of Napoleon by the Russian army at Borodino on 7 September 1812. Always exhibited in Moscow, but stored after 1918. Restored and re-opened in 1962, but badly damaged by fire in 1967. Fully restored and reopened in 1968.

Switzerland

Lucerne: The Bourbaki Panorama (1881). 10m x 112m. Panorama created by Édouard Castres. Depicting the arrival in Switzerland of General Charles-Denis Bourbaki's French Army of the East to enter internment on 1 February 1871. Originally at Geneva, moving to Lucerne in 1889. Fully restored and reopened in 2000.

Morat: Panorama of the Battle of Morat (1880). 11m x 93m. Panorama created by Louis Braun. Depicting the Swiss victory over the Burgundian army at Morat (Murten) on 22 June 1476. Moved from Morat to Geneva in 1897 and on display until 1909 when it returned to Morat. Stored since 1923, but restored in 2002. A travelling exhibition based on the panorama circulated in Switzerland in 2019. Currently stored.

Ukraine (annexed by Russia, 2014)

Sebastopol: Panorama Defence of Sebastopol 1854-55 (1905). 14m x 115m. Panorama created by Franz Roubard. Depicting the defeat of the Anglo-French assault on Sebastopol on 18 June 1855. Badly damaged in the Second World War. Recreated and reopened in 1954. A copy (2.6m x 18.2m) is displayed in the Tomsk Regional Museum, Russia.

United States

Atlanta: The Battle of Atlanta Cyclorama (1886). 15m x 121m. Panorama created by Friedrich Heine and August Lohr. Depicts the restoration of the Union lines during the Confederate attack on 22 July 1864. First shown in Minneapolis and Chattanooga before arriving at Atlanta in 1892. One of two painted by Heine and Lohr, the other being shown at Detroit and Baltimore. Fully restored and re-opened in 2019.

Barre, VT: Panorama of the Late War (1880s). 2.1m x 45m. Moving panorama created by Charles Hardin Andrus. 10 scenes depicting the American Civil War. Stored by the Vermont Historical Society.

Columbus, OH: The Great Locomotive Chase (1870s). 2.1m x 1.8m. Moving panorama created by Albert Ruger. 17 scenes depicting the Andrews raid to disrupt Confederate rail lines in Georgia on 12 April 1862. Stored by the Ohio Historical Society.

Dearborn, MI: Battle Scenes of the Rebellion (1886). 2.1m x 4.2m. Moving panorama created by Thomas Clarkson Gordon. 15 scenes depicting the American Civil War. Stored by the Henry Ford Museum.

Gettysburg, PA: The Gettysburg Cyclorama (1884). 12m x 115m. One of four Gettysburg panoramas created by Paul Philippoteaux. Depicting the climax of the unsuccessful Confederate assault - 'Pickett's Charge' - on the Union centre on 3 July 1863. Originally at Boston, moving to Gettysburg in 1913. Fully restored and reopened in 2008. A second version of the Gettysburg panorama once owned by Wake Forest University was sold in 2007, and is stored in Fuquay-Varina, North Carolina.

Kansas City, MS: The Panthéon de la Guerre (1918). Created by Pierre Carrier-Belleuse and Auguste-François Gorguet. Depicting over 5,000 figures of ordinary allied soldiers as well as leading political and military personalities. Originally shown in Paris, but brought to New York in 1927. Reconfigured (and massively reduced from the original 14m x 123m to 3.9m x 21m) for the Liberty Memorial (now the National World War I Museum) by Daniel MacMorris in 1959. Fully restored in 2002. Unused fragments have re-appeared for sale from time to time.

Providence, RI: The Heroic Life and Career of Garibaldi (1862). 1.3m x 83.2m. Moving panorama created by John Story. 49 scenes depicting Garibaldi's campaigns for the unification of Italy. Stored by Brown University.

Tulsa, OK: Stevens' Sioux War Panorama, Panorama of the Indian Massacre of 1862, and the Black Hills (1865). 1.8m x 67m. Moving panorama created by John Stevens. 36 scenes depicting the Sioux rising in Minnesota in 1862. Stored by the Gilcrease Museum. Another version is stored by the Minnesota Historical Society, St Paul, and a third of 42 scenes stored by the Glenbow Museum, Calgary, Canada. Stevens painted at least five versions, including added scenes of the Modoc War of 1873.

Washington: The Army of the Cumberland (1865). 2.7m x 78m. Moving panorama created by William Travis. 32 scenes depicting the story of William Rosecrans' Union Army of the Cumberland from 1862 to 1864. Stored by the Smithsonian.

A selection of surviving classic battle panoramas. [Author]

Appendix II: Modern Military Panoramas around the World

Military panoramas and dioramas have remained popular in authoritarian states. Thus, those in Bulgaria and the former East Germany reflect the Soviet past and that in Iraq the former Saddam Hussein regime. Belarus, China, Egypt, North Korea, Russia, Syria, and Islamist Turkey have all produced examples since 1945. North Korean artists are responsible for those in Egypt, Iraq, and Syria.

Some are full 360° panoramas; others are 180° semi-circular panoramas, or simply large-scale curved canvasses with a foreground, which are characterised as dioramas. The latter do not correspond to the nineteenth century concept of dioramas. Many military and other museums display such dioramas as in Belarus, North Korea, Russia, Turkey, and the Ukraine. One of the best known examples of such a diorama perhaps for Western visitors in the past, now effectively closed to them since the Russian annexation of the Crimea in 2014, is 'The Storming of Mount Sapun' on the heights of Balaclava outside Sebastopol. This curved painting (5.5m x 25.5m.) with modelled foreground, created by Nicholai Prisekin in 1959, depicts the Soviet assault on the outer Wehrmacht defences of Sebastopol on 7 May 1944. It is a form that is occasionally seen elsewhere as in the 17 sculptured 'picture models' of Great War scenes that have been a feature at the Australian War Memorial in Canberra since the 1920s.[1] Such dioramas are excluded from the list below.

One modern military panorama produced in a democracy was that exhibited at Leipzig from 2013-2015. This is one of a series of modern creations - often of historical scenes - using photography and computer graphics by Yadegar Asisi. Others have included 'Luther 1517' at Wittenberg, 'Rouen 1431' at Rouen, 'Rome 312' at Pforzheim, and the 'Pergamum Panorama of the Ancient Metropolis' in Berlin.

1 Anne-Marie Conde, 'A Marriage of Sculpture and Art: Dioramas at the Memorial', *Journal of the Australian War Memorial* 19 (1991), pp.56–59; Tom Hewitt, 'Diorama Presentation', *Journal of the Australian War Memorial* 5 (1984), pp.29–35.

Bulgaria

Pleven: Pleven Epopee 1877, Panorama Pleven (1977). 15m x 115m. Panorama created by Nicolai Ovechkin. Depicting the Russian defeat of the Ottoman Turkish forces besieging Plevna on 10 December 1877. Opened for the centenary in 1977.

China

Beijing: Battle of the Io Gou (Marco Polo) Bridge (1988). 16m x 51m. Semi-circular panorama created by Mao-Wen Biao and He-Kong De for the Museum of the Chinese People's War against Japanese Aggression. Depicting the beginning of the Sino-Japanese War (1937-45) on 7 July 1937.

Beijing: Cross Yangtze River (2009). 6.7m x 27m. Semi-circular panorama depicting People's Liberation Army (PLA) forces crossing the Yangtze between 20 April and 2 June 1949 in the closing stage of the Chinese Civil War (1927-49).

Chaoyang: The Battle of Ice Pool (2008). 14m x 37m. Semi-circular panorama depicting Chinese communist guerrillas fighting the Japanese in 1940 during the Sino-Japanese War.

Dandong: Panorama of the Battle of Qingchuanjiang River (1993). 16m x 132m. Panorama depicting the Chinese intervention in the Korean War (1950-53) between 25 November and 2 December 1950, leading to the retreat of the US Eighth Army.

Dogguan: The Sea Battle of Humen (1999). 12.5m x 51m. Semi-circular panorama depicting the British amphibious attack on the Chinese forts in the Humen straits, 23-26 February 1841 during the First China War (1839-42).

Fuzhou: The Liberation of Fujian (2002). 17m x 80m. Semi-circular panorama depicting the PLA's victory over Kuomintang (KMT) nationalist forces on Fujian Island on 11 May 1950. The KMT was forced back to Formosa (Taiwan).

Hebai: Battle of Taking Yuncheng (2000). 17m x 125m. Panorama depicting the PLA seizure of Yuncheng from the KMT in July 1947 during the Chinese Civil War.

Hefei: The Campaign of Crossing the Changjiang River (2012). 5.5m x 47m. Semi-circular panorama depicting the PLA crossing on 20 April 1949 in their advance towards Shanghai during the latter stages of the Chinese Civil War.

Huoshizhai: The Battle of Stone City (2013). 6m x 40m. Semi-circular panorama depicting part of the PLA advance to Nanjing in April 1949 during the Chinese Civil War.

Jing Gang Mountain: Jing Gang Mountain Revolution Battle (2005). 18m x 112m. Panorama depicting the main mountainous base of the PLA established in the summer of 1928 at the beginning of the Chinese Civil War. Seen as the birthplace of the PLA.

Jinan: Panorama of the Battle of Jinan (2002). 18m x 126m. Panorama created by the Luxun Academy of Art depicting the capture of Jinan by the PLA from the KMT, 16-24 February 1948.

Jinzhou: Panorama of the Taking of Jinzhou (1989). 16m x 122m. Panorama created by the Luxun Academy of Art depicting the capture of Jinzhou by the PLA from the KMT, 7-15 October 1948.

Laiwu: Panorama of the Battle of Laiwu (1997). 17m x 119m. Panorama depicting the battle between the PLA and KMT, 22 February 1947.

Lanzhou: Lanzhou Campaign-Shen Jia Ling Battle (2013). 6m x 30m. Semi-circular panorama depicting the campaign leading to the fall of Lanzhou to the PLA on 28 August 1949.

Lingqiu: The Great Victory of Pingxingguan (2007). 10m x 42m. Semi-circular panorama depicting the battle between the PLA 8th Route Army and Japanese forces, 24-25 September 1937 during the Sino-Japanese War.

Nanjing: Defend and Defeat Fighting of Guanghua Gate (2007). 6m x 22m. Semi-circular panorama depicting the Japanese assault on Nanjing in 1937.

Sandong: Panorama of the Ji Nan Battle (2002). 18m x 126m. Panorama depicting the battle between the PLA and KMT forces, 16-24 September 1948.

Su-Zhou: The Flames of War at Yang-chen (1993). 16.5m x 62m. Semi-circular panorama depicting battle between the PLA and the Japanese, 25-30 November 1940 during the Sino-Japanese War.

Weihai: Defending Liugong Harbour (2008). 8m x 38m. Semi-circular panorama of the battle of the Huanghai Sea (also known as the Battle of the Yellow Sea) on 17 September 1894, the largest naval engagement in the Sino-Japanese War (1894-85).

Wuhan: Panorama of Chibi War (1999). 18m x 135m. Panorama depicting of the Chibi War in 208-209 AD fought between northern and southern warlords at the end of the Han dynasty.

Xibaipo: The Three Big Battles (2005). 13m x 46m. Semi-circular panorama depicting the PLA in the Liaoshen, Pingjin and Huaihai campaigns during the Chinese Civil War between 1946 and 1949, Xibaipo having been the PLA headquarters.

Yan'an: The Battle of Yiwa (2010). 17m x 51.4m. Semi-circular panorama depicting the PLA victory over KMT guerrilla elements, 29 March to 7 May 1950.

Yangquan: Battle at Shinao Mountain (2012). 8m x 40m. Semi-circular panorama depicting part of the 'Hundred Regiments' campaign of the PLA against the Japanese between August and December 1940. Displayed in the Museum of the Hundred Regiments' Battle.

Zaozhuang: Panorama of the Tai'erzhuang Battle, 1938 (1995). 16m x 124m. Panorama depicting the PLA in battle against the Japanese between 24 March and 7 April 1938.

Zhumadian: Panorama of the Last Battle (2021). 18m x 35m. Semi-circular panorama depicting the PLA's General Yang Jingyu action against the Japanese on 23 February 1940, which resulted in his death. Liwan village in Zhumadian is where he was born,

Egypt

Heliopolis: Panorama of the Epic of 6th October 1973 (1988). 15m x 136m. Panorama created by North Korean artists. Depicting the crossing of the Suez Canal by Egyptian forces on 7 October 1973 during the Arab-Israeli Yom Kippur War (1973).

Germany

Bad Frankenhausen: Panorama of the Early Bourgeois Revolution in Germany (1989). 14m x 123m. Panorama created by Werner Tübke. Depicting the defeat of Protestant insurgents by the Catholic Army of the Swabian League at Frankenhausen on 15 May 1525 during the German Peasants War. A product of the East German state, it remains on display.

India

Kurukshetra: Maharaja Ranjit Singh Panorama (2006). 12m x 100m. Panorama depicting six victories of Ranjit Singh, the 'Lion of the Punjab' and ruler of the Sikh kingdom between 1802 and 1837.

Iraq

Al-Mada', Baghdad: The Battle of Al-Qadissiyah (1978). 28m x 50m. Panorama created by North Korean artists. Depicting the Arab victory against the Persians in 637 AD. Commissioned by Saddam Hussein. Current status unknown.

North Korea

Pyongyang: Operations for the Liberation of Taejon (1974). 15m x 132m. Panorama depicting the action of the People's Army against the US 24th Infantry Division, 20 July 1950 during the Korean War (1950-53). Displayed in the Victorious Fatherland Liberation Museum.

Russia

Chelyabinsk: The Heroic Defence of Stalingrad (1949) 3.1m x 34m. Panorama created by the Grekov Studio of Military Artists. Depicting the Battle of Stalingrad between 23 August 1942 and 2 February 1943. Formerly displayed at Moscow and Riga. In store at the Museum of Fine Arts in Chelyabinsk since 1952.

Khabarovsk: The Volochaevskaia Battle (1975). 6m x 46m. Panorama created by the Grekov Studio of Military Artists. Depicting the battle between Red Guards and White Russian and Japanese forces in February 1922. Displayed at Grodekov State Museum of the Far East.

Volgograd (formerly Stalingrad): The Defeat of the German-Fascist Forces at Stalingrad (1982). 16m x 120m. Panorama created by the Grekov Studio of Military Artists. Depicting aspects of the Battle of Stalingrad between 23 August 1942 and 2 February 1943.

Syria

Damascus: Panorama of the 4th Middle East War (1998). 15m x 122m. Panorama created by North Korean artists. Depicts the Syrian Army's capture of Kunaittiru in October 1973 during the Arab-Israeli Yom Kippur War. Displayed in the Syria Military Museum.

Turkey

Istanbul: Panorama 1453 (2009). 2,350 sq. m. Panorama created by Haşim Vatandaş. Depicting the fall of Constantinople to the Ottomans on 29 May 1453.

Polatli: Sakarya Pitched Battle Panorama (2013). 15m x 75m. Panorama created by Sergey Prisekin. Depicting the Turkish victory in the battle of Sakayra between 23 August and 13 September 1921, generally regarded as the turning point in the Greco-Turkish War (1919-22).

Ukraine

Khmelnytskyi: Clearing of Proskurova from Fascist Invaders (1989). 3m x 40m. Panorama created by Vladislav Mamsikov and Vladimir Volkov. Depicting the Soviet operations against the Wehrmacht at Proskurova on 25 March 1944.

A selection of contemporary battle panoramas. [Author]

Bibliography

Archive Collections

Anne S. K. Brown Military Collection, Brown University, Providence, RI, USA
Bill Douglas Cinema Museum, University of Exeter
Bodleian Library, Oxford
British Library, London
British Museum, London
Cambridge University Library
Chetham's Library, Manchester
City of Westminster Archives Centre, London
Edinburgh City Art Centre
Edinburgh University Library
Getty Research Institute, Los Angeles, CA, USA
Guildhall Library, London
Hartley Library, University of Southampton
Library of Congress, Washington, DC, USA
London Metropolitan Archives, Clerkenwell

Mitchell Library, Glasgow
Musée des Beaux-Arts, Caen, France
National Art Library, Victoria & Albert Museum, South Kensington
National Army Museum, Chelsea
National Fairground Archive, University of Sheffield
National Library of Scotland, Edinburgh
National Maritime Museum, Greenwich
Royal Academy Collection, London
Royal Collections, Windsor
Royal United Services Institute for Defence Studies, Whitehall
University of Durham Sudan Archive
University of Glasgow Library
University of Kent Theatre Collection, Canterbury
Victoria and Albert Museum, South Kensington
Westminster City Libraries and Archives, London
Yale Center for British Art, New Haven, CT, USA

Books

Contemporary Publications

Angelo, Henry, *Reminiscences of Henry Angelo: With Memoirs of His Late Father and Friends.* 2 vols. (London: Henry Colburn & Richard Bentley, 1830).

Barker, Henry Aston, 'Obituary', *Gentleman's Magazine*, Oct. 1856, 515-518.

Barker, Robert, 'Specification of Mr Barker's Patent for displaying Views of Nature at large, by Oil-Painting, Fresco, Water-Colours, etc.', *The Repertory of Arts and Manufactures* Vol. IV (London: Lowndes, Robinson, Elmsly, Richardson, Debrett, and Bell, 1796), 165-67.

Bury, Charlotte, *Diary Illustrative of the Times of George the Fourth comprising the secret history of the court during the reigns of George III and George IV* 4 vols. (London: H. Colburn, 1839).

Castellani, Charles, *Confidences d'un Panoramiste: Aventures et Souvenirs* (Paris: Dreyfus and D'Alsace, 1899).

Churchill, Winston S., *The River War* 3rd edn. (London: Eyre & Spottiswoode, 1933).

Davis, Theodore, 'How a Great Panorama is Made', *St Nicholas* 14 (Dec. 1886), pp.99-112.

Dickson, William, *The Biograph in Battle: Its Story in the South African War related with Personal Experience* reprint edn. (Trowbridge: Flicks Books, 1995).

Dibdin, Thomas Frognall, *Reminiscences of a Literary Life* 2 vols. (London: John Major, 1836).

Guards, Hussars, and Infantry, Adventures of Harry Austin. By An Officer. 3 vols. (London: Saunders and Otley, 1838).

Gurwood, John, *The Dispatches of Field Marshal the Duke of Wellington* 2nd edn., 8 vols. (London: Parker, Furnivall & Parker, 1844-47).

The Kings' Armies Through the Ages (London: Royal United Service Museum, n. d. [1937]).

McDonogh, Felix, *The Hermit in London: Or, Sketches of English Manners* (London: Henry Colburn & Co., 1821).

Piozzi, Hester, *British Synonymy: or An attempt at regulating the choice of words in familiar conversation* 2 vols. (London: G. G. & J. Robinson, 1794).
Public Characters of 1800-1801 (Dublin: J. Moore, 1801).

Rolt, Margaret (ed.), *A Great-Niece's Journals: being Extracts from the Journals of Fanny Anne Burney (Mrs Wood) from 1830 to 1842* (London: Constable & Co., 1926).
Ruskin, John, *Praeterita: Outlines of Scenes and Thoughts* 2 vols. (London: George Allen, 1886).

[Sala, George Augustus], 'Some Amenities of War', *Household Words* IX (15 July 1854), 520-24.
Stocqueler, J. H., *Memoirs of a Journalist* (London: The Times of India, 1873).

Thornbury, Walter, *Old and New London* 2 vols. (London: Cassell, Petter and Galpin, 1878).

Secondary Sources

Books

Altick, Richard, *The Shows of London* (Cambridge MA: Belknap Press, 1978).
Anderson, Olive, *A Liberal State at War: English Politics and Economics during the Crimean War* (London: Macmillan, 1967), 71.

Beckett, Ian F. W., *The Making of the First World War* (New Haven, CT: Yale University Press, 2012).
Beckett, Ian F. W., *Rorke's Drift and Isandlwana* (Oxford: Oxford University Press, 2019).
Billing, Valerie, *The Panorama of the Battle of Trafalgar* (Portsmouth: Royal Naval Museum, 2002).
Bond, Brian (ed.), *Victorian Military Campaigns* (London: Hutchinson, 1967).
Bonehill, John, and Quilley, Geoff (eds), *Conflicting Visions: War and Visual Culture in Britain and France, c. 1700-1830* (Farnham: Ashgate, 2005).
Brett, Edward, *The British Auxiliary Legion in the First Carlist War, 1835-38* (Dublin: Four Courts Press, 2005).
Buddle, Anne (ed.), *The Tiger and the Thistle: Tipu Sultan and the Scots in India, 1760-1800* (Edinburgh: National Gallery of Scotland, 1999).

Cameron, A. D., *The Man who Loved to Draw Horses: James Howe 1780-1836* (Aberdeen: Aberdeen University Press 1986).

Clayton, Tim, and O'Connell, Sheila (eds), *Bonaparte and the British: Prints and Propaganda in the Age of Napoleon* (London: British Museum, 2015).

Clifton, James and Scattone, Leslie, with Emine Fetvacı, Ira Gruber and Larry Silver, *The Plains of Mars: European War Prints, 1500-1825 from the Collection of the Sarah Campbell Blaffer Foundation* (New Haven, CT: Yale University Press withy the Museum of Fine Arts, Houston, 2009).

Colligan, Mimi, *Canvas Documentaries: Panoramic Entertainments in Nineteenth-Century Australia and New Zealand* (Melbourne, VIC: Melbourne University Press, 2002).

Comment, Bernard, *The Painted Panorama* (New York: Harry Abrams Publishers, 1999).

Curry, Anne, *Agincourt* (Oxford: Oxford University Press, 2015).

Dawson, Graham, *Soldier Heroes: British Adventure, Empire and the Imagining of Masculinities* (London: Routledge, 1994).

DeLange, J. H., *The Anglo-Boer War, 1899-1902, on Film* (Pretoria: State Archives Service, 1991).

Favret, Mary, *War at a Distance: Romanticism and the Making of Modern Wartime* (Princeton, NJ: Princeton University Press, 2010).

Fawcett, Trevor, *The Rise of English Provincial Art: Artists, Patrons, and Institutions outside London, 1800-1830* (Oxford: Clarendon Press, 1974).

Forrest, Alan, *Waterloo* (Oxford: Oxford University Press, 2015).

Foster, R. E., *Wellington and Waterloo: The Duke, the Battle and Posterity, 1815-2015* (Stroud: Spellmount, 2014).

Fruitema, Evelyn, and Zoetmulder, Paul (eds), *The Panorama Phenomenon* (The Hague: Foundation for the Preservation of the Centenarian Mesdag Panorama, 1981).

Fullerton, John (ed.), *Screen Culture: History and Textuality* (London: John Libbey, 2004).

Garrison, Laurie et al (eds), *Panoramas, 1787-1900: Texts and Contexts* 5 vols. (London: Pickering & Chatto, 2012).

Glover, Gareth, *The Great Waterloo Controversy: The Story of the 52nd Foot at History's Greatest Battle* (London: Frontline Books, 2020).

Gordon, Sophie, *Shadows of War: Roger Fenton's Photographs of the Crimea, 1855* (London: Royal Collections Trust, 2017).

Gould, Marty, *Nineteenth-Century Theatre and the Imperial Encounter* (Abingdon: Routledge, 2011).

Grau, Oliver, *Virtual Art: From Illusion to Immersion* (Cambridge, MA: MIT Press, 2003).

Harding, Marion (ed.), *The Victorian Soldier* (London: National Army Museum, 1993).

Harrington, Peter, *British Artists and War: The Face of Battle in Paintings and Prints, 1700-1914* (London: Greenhill Books, 1993).

Harvey, Eleanor Jones, *The Civil War in American Art* (Washington: Smithsonian American Art Museum, 2012).

Herbert, Christopher, *The War of No Pity: The Indian Mutiny and Victorian Trauma* (Princeton, NJ: Princeton University Press, 2008).

Hichberger, J. W.M., *Images of the Army: The Military in British Art, 1815-1914* (Manchester: Manchester University Press, 1988).

Hofschröer, Peter, *The Waterloo Campaign: Wellington, his German Allies and the Battles of Ligny and Quatre Bras* (London: Greenhill Books, 1998).

Hofschröer, Peter, *1815 - The Waterloo Campaign: The German Victory* (London: Greenhill Books, 1999).

Hofschröer, Peter, *Wellington's Smallest Victory: The Duke, the Model Maker and the Secret of Waterloo* (London: Faber & Faber, 2005).

Howard, Martin, *Walcheren, 1809: The Scandalous Destruction of a British Army* (Barnsley: Pen & Sword, 2012).

Huhtamo, Erkki, *Illusions in Motion: Media Archaeology of the Moving Panorama and Related Spectacles* (Cambridge, MA: MIT Press, 2013).

Hussey, John, *Waterloo: The Campaign of 1815* 2 vols. (London: Greenhill Books, 2017).

Hyde, Ralph, and Wilcox, Scott, *Panoramania! The Art and Entertainment of the 'All-Embracing' View* (London: Trefoil Publications for the Barbican Art Gallery, 1988).

Hyde, Ralph, *Dictionary of Panoramists of the English-speaking World*, (2015). Found at https://www.bdcmuseum.org.uk/uploads/uploads/biographical_dictionary_of_panoramists2.pdf.

Keller, Ulrich, *The Ultimate Spectacle: A Visual History of the Crimean War* (London: Routledge, 2001).

Koller, Gabriele (ed.), *The World of Panoramas* (Amberg: Büro Wilhelm Verlag, 2003).

Koller, Gabriele (ed.), *The Panorama in the Old World and the New* (Amberg: Buero Wilhelm Verlag, 2010).

Lalumia, Matthew, *Realism and Politics in Victorian Art of the Crimean War* (Ann Arbor, MI: UMI Research Press, 1984).

Leroy, Isabelle, *Le Panorama de la Bataille de Waterloo: Témoin exceptionnel de la saga des panoramas* (Liège: Commission Royale des Monuments, Sites et Fouilles, 2009).

Lincoln, Margarette (ed.), *Nelson and Napoleon* (London: National Maritime Museum, 2005).

Mackesy, Piers, *British Victory in Egypt, 1801: The End of Napoleon's Conquest* (London: Routledge, 1995).

Mackenzie, John, *Propaganda and Empire: The Manipulation of British Public Opinion, 1880-1960* (Manchester: Manchester University Press, 1984).

Mackenzie, John (ed.), *Imperialism and Popular Culture* (Manchester: Manchester University Press, 1986).

Mackenzie, John (ed.), *Popular Imperialism and the Military* (Manchester: Manchester University Press, 1992).

Markovits, Stefanie, *The Crimean War in the British Imagination* (Cambridge: Cambridge University Press, 2009).

Massie, Alastair (ed.), *A Most Desperate Undertaking: The British Army in the Crimea, 1854-56* (London: National Army Museum, 2003).

Miller, Stephen (ed.), *Queen Victoria's Wars: British Military Campaigns, 1857-1902* (Cambridge: Cambridge University Press, 2021).

More Than Meets the Eye: The Magic of the Panorama (Amberg: Büro Wilhelm Verlag, 2019).

Oettermann, Stephan, *The Panorama: History of a Mass Medium* (New York: Zone Books, 1997).

Oleksijczuk, Denise, *The First Panoramas: Visions of British Imperialism* (Minneapolis, MN: University of Minnesota Press, 2011).

O'Quinn, Daniel, *Staging Governance: Theatrical Imperialism in London, 1770-1800* (Baltimore, MD: John Hopkins University Press, 2006).

Peck, John, *War, the Army and Victorian Literature* (Basingstoke: Macmillan, 1998).

Powell, Hudson, *Poole's Myriorama; A Story of Travelling Panorama Showmen* (Bradford on Avon: ELSP, 2002).

Robichon, François, and Rouillé, André (eds), *Jean-Charles Langlois: La Photographie, La Peinture, La Guerre - Correspondance inédite de Crimée, 1855-56* (Nîmes: Éditions Jacqueline Chambon, 1992).

Russell, Gillian, *The Theatre of Wars: Performance, Politics and Society, 1793-1815* (Oxford: Oxford University Press, 1995).

Sale, Nigel, *The Lie at the Heart of Waterloo: The Battle's Hidden Last Half Hour* (Stroud: History Press, 2014).

Sebé, Berny, *Heroic Imperialists in Africa: The Promotion of British and French Colonial Heroes, 1870-1939* (Manchester: Manchester University Press, 2013).

Shaw, Philip, *Waterloo and the Romantic Imagination* (Basingstoke: Palgrave Macmillan, 2002).

Shaw, Philip, *Suffering and Sentiment in Romantic Military Art* (Farnham: Ashgate, 2013).

Spiers, Edward, *The Late Victorian Army, 1868-1902* (Manchester: Manchester University Press, 1992).

Usherwood, Paul, and Spencer-Smith, Jenny, *Lady Butler: Battle Artists, 1846-1933* (Gloucester: Alan Sutton Publishing for the National Army Museum, 1987).

Wilcox, Craig, *Red Coat Dreaming: How Colonial Australia Embraced the British Army* (Port Melbourne, VIC: Cambridge University Press, 2009).
Willcock, Sean, *Victorian Visions of War and Peace: Aesthetics, Sovereignty and Violence in the British Empire, c. 1851-1900* (New Haven, CT: Yale University Press, 2021).
Wood, Gillen, *The Shock of the Real: Romanticism and the Visual Culture, 1760-1860* (Basingstoke: Palgrave, 2001).

Chapters

Armstrong, Emma, 'Art and War Reportage in the Crimean War I: *The Illustrated London News*', in Alastair Massie (ed.), *A Most Desperate Undertaking: The British Army in the Crimea, 1854-56* (London: National Army Museum, 2003), pp.194-202.

Bottomore, Stephen, 'The Biograph in Battle', in Karel Dibbets and Bert Hogenkamp (eds), *Film and the First World War* (Amsterdam: Amsterdam University Press, 1995), pp.28-35.
Bratton, J. S., 'Theatre of War: The Crimea on the London Stage, 1854-55', in David Bradby, Louis James, and Bernard Sharratt (eds), *Performance and Politics in Popular Drama: Aspects of Popular Entertainment in Theatre, Film and Television, 1800-1976* (Cambridge: Cambridge University Press, 1980), pp.119-37.

Crawford, E. R., 'The Sikh Wars, 1845-49', in Brian Bond (ed.), *Victorian Military Campaigns* (London: Hutchinson, 1967), pp.31-70.
Cullen, Fintan, 'Union and Display in Nineteenth Century Ireland', in Dana Arnold (ed.), *Cultural Identities and the Aesthetics of Britishness* (Manchester: Manchester University Press, 2004), pp. 111-33.

Desmarquest, Luc, 'Le colonel Langlois et la photographie', in *Jean Charles Langlois 1789-1870: Le Spectacle de l'histoire* (Caen: Musée des Beaux-Arts, 2005), pp.25-33.

Griffiths, Alison, '"The largest picture ever executed by Man": Panoramas and the Emergence of Large-screen and 360-Dgree Technologies' in John Fullerton (ed.), *Screen Culture: History and Textuality* (London: John Libbey, 2004), pp.199-220.

Harding, Marion, 'Sebastopol after the Siege, 1855-56', in Marion Harding (ed.), *The Victorian Soldier* (London: National Army Museum, 1993), pp.122-27.

Harrington, Peter, 'Entertaining Battles: Panoramas of War in Victorian Britain', in Gabriele Koller (ed.), *The Panorama in the Old World and the New* (Amberg: Buero Wilhelm Verlag, 2010), pp.64-69.

Hoock, Holger, 'The Battle of the Nile and its Cultural Aftermath', in Margarette Lincoln (ed.), *Nelson and Napoleon* (London: National Maritime Museum, 2005), pp.65-71.

Hyde, Ralph, 'London to Hong Kong in Two Hours: A Victorian Moving Panorama', in *More Than Meets the Eye: The Magic of the Panorama* (Amberg: Büro Wilhelm Verlag, 2019), pp.84-87.

Hyde, Ralph, '"The Campaigns of Garibaldi": A Look at a Surviving Panorama', in Gabriele Koller (ed.), *The Panorama in the Old World and the New* (Amberg: Buero Wilhelm Verlag, 2010), pp.46-51.

Ibata, Hélène, 'The Orient at Leicester Square: Virtual Visual Encounters in the First Panoramas', in Hélène Ibata, Caroline Lehni, Fanny Moghaddassi, and Nader Nasiri-Moghaddam (eds), *Geographies of Contact: Britain, the Middle East and the Circulation of Knowledge* (Strasbourg: Presses Universitaires de Strasbourg, 2017), pp.191-204.

Johnson, Rob, 'Egypt and the Sudan, 1881-85', in Stephen Miller (ed.), *Queen Victoria's Wars: British Military Campaigns, 1857-1902* (Cambridge: Cambridge University Press, 2021), pp.187-219.

Kutzer, Michael, 'Researching the Battlefield: How Exact was the Panorama Painters' Work?' in *More Than Meets the Eye: The Magic of the Panorama* (Amberg: Büro Wilhelm Verlag, 2019), pp.144-49.

Lacaille, Frédéric, 'Napoléon et Louis-Philippe: 'L'Empire dans Les Galeries Historiques de Versailles', in *Napoléon: Images de la Légende* (Paris: Somogy, 2017), pp.40- 46.

Maurer, Kathrin, 'The Paradox of Total Immersion: Watching War in Nineteenth Century Panoramas', in Anders Engberg-Pedersen and Kathrin Maurer (eds), *Visualizing War: Emotions, Technologies, Communities* (Abingdon: Routledge, 2018), pp.78-94.

Mayer, David, 'The World on Fire: Pyrodramas at Belle Vue Gardens, Manchester, c. 1850-1950', in John Mackenzie (ed.), *Popular Imperialism and the Military* (Manchester: Manchester University Press, 1992), pp.179-97.

Pearce, Susan, 'The *Matériel* of War: Waterloo and Its Culture', in John Bonehill and Geoff Quilley (eds), *Conflicting Visions: War and Visual Culture in Britain and France, c. 1700-1830* (Farnham: Ashgate, 2005), pp.207-26.

Robinson, David, 'The Great Pictures of Robert Ker Porter', in Gabriele Koller (ed.), *The World of Panoramas* (Amberg: Büro Wilhelm Verlag, 2003), pp.34-37.
Rohatgi, Pauline, 'From Pencil to Panorama: Tipu in Pictorial Perspective', in Anne Buddle (ed.), *The Tiger and the Thistle: Tipu Sultan and the Scots in India, 1760-1800* (Edinburgh: National Gallery of Scotland, 1999), pp.39-55.

Shepherd, Ben, 'Showbiz Imperialism: The Case of Peter Lobengula', in John Mackenzie (ed.), *Imperialism and Popular Culture* (Manchester: Manchester University Press, 1986), pp.94-112.
Strebel, Elizabeth, 'Imperialist Iconography of Anglo-Boer War Film Footage', in John Fell (ed.), *Film before Griffith* (Berkeley, CA: University of California Press, 1983), pp.264-71.

Wood, Kate, 'Photography in the Crimea', in Alastair Massie (ed.), *A Most Desperate Undertaking: The British Army in the Crimea, 1854-56* (London: National Army Museum, 2003), pp.284-91.

Articles

Bell, John, 'The Sioux War Panorama and American Mythic History', *Theatre Journal* 48 (1996), pp.279-99.
Brown, Kenneth, 'Modelling for War: Toy Soldiers in Late Victorian and Edwardian Britain', *Journal of Social History* 24 (1990), pp.237-54.
Burwick, Frederick, '18 June 1815: The Battle of Waterloo and the Literary Response', *BRANCH: Britain, Representation and Nineteenth-Century History* (2016), found at http://www.branchcollective.org/?ps_articles=frederick-burwick-18-june-1815-the-battle-of-waterloo.

Conde, Anne-Marie, 'A Marriage of Sculpture and Art: Dioramas at the Memorial', *Journal of the Australian War Memorial* 19 (1991), pp.56–59.

Daly, Gavin, '"The Sacking of a Town is an Abomination": Siege, Sack and Violence to Civilians in British Officers' Writings in the Peninsular War - The Case of Badajoz', *Historical Research* 92 (2019), pp.160-82.

Davies, Huw, 'Moving Forward in the Old Style: Revisiting Wellington's Battles from Assaye to Waterloo', *British Journal for Military History* 1, 3 (2015), pp.2-23.

Desmarquest, Luc, 'Jean-Charles Langlois, panoramiste et photographe', *Bulletin de la SABIX* 52 (2013), pp.53-58.

Dias, Rosie, 'Memory and the Aesthetics of Military Experience: Viewing the Landscape of the Anglo-Mysore Wars', *Tate Papers* 19 (2013) at https://www.tate.org.uk/research/publications/tate-papers/19/memory-and-the-aesthetics-of-military-experience-viewing-the-landscape-of-the-anglo-mysore-wars.

Ellis, Markman, '"Spectacles within doors": Panoramas of London in the 1790s', *Romanticism* 14 (2008), pp.133-48.

Gretton, Tom, 'Waterloo in Richard Caton Woodville's "Battles of the British Army" Series for the *Illustrated London News*, 1893–99', *Victorian Periodicals Review* 48 (2015), pp.531-56.

Griffiths, Alison, 'Le panorama et les origines de la reconstitution cinématographique', *Cinémas* 14 (2003), pp.35-65.

Griffiths, Alison, '"Shivers Down Your Spine": Panoramas and the Origins of the Cinematic Re-enactment', *Screen* 44 (2003), pp.1-37.

Hanners, John, 'The Great Three-Mile Painting: John Banvard's Mississippi Panorama', *Journal of American Culture* 4 (1981), pp.28-42.

Harrington, Peter, 'Garibaldi's Panoramic Exploits', *MHQ: The Quarterly Journal of Military History*, 20 (2008), pp.82-87.

Harrington, Peter, 'The Anatomy of a Moving Panorama: John James Story's Ocean and Overland Journey Round the World', *International Panorama Council Journal* 4 (2020), pp.59-65.

Hewitt, Tom, 'Diorama Presentation', *Journal of the Australian War Memorial* 5 (1984), 29–35.

Hinton, Mike, 'Field Marshal Lord Raglan: His Final Illness and Unanticipated Demise', *Soldiers of the Queen* 179 (2020), pp.39-54.

Howard, Martin, 'Walcheren, 1809: A Medical Catastrophe', *British Medical Journal* 319 (1999), pp.1642-45.

Huhtamo, Erkki, 'Penetrating the Peristrephic: An Unwritten Chapter in the History of the Panorama', *Early Popular Visual Culture* 6 (2008), pp.219-38.

Kriegel, Lara, 'Who Blew the Balaclava Bugle: The Charge of the Light Brigade and the Afterlife of the Crimean War', *19: Interdisciplinary Studies in the Long Nineteenth Century* 20 (2015) found at https://doi.org/10.16995/ntn.713.

Marabel, Jacinto, 'Badajoz 1812, provecho y espectáculo de la ciudad tomada', *Boletín de la Real Academia de Extremadura de las Letras y las Artes* 24 (2016), pp.279-92; 25 (2017), pp.315-43.
Melby, Julie, 'William Heath (1794/95-1840): "The man wots got the whip hand of them all"', *British Art Journal* 16 (2015/16), pp.3-9.
Moyano, Neus, 'El panorama de Waterloo a Barcelona (1888-1890)', *L'Avenç* 4 (2008), pp.42-49.
Moyano, Neus, 'Tres fragments del panorama de Waterloo de Charles Verlat (1824-1890)', *Butlletí Museu Nacional d'Art de Catalunya* 11 (2010), pp.127-37.
Musgrave, Gavin, 'The Dublin Waterloo Panorama', *Journal of the Society for Army Historical Research* 99 (2021), pp.396-400.

Nair, Janaki, 'Tipu Sultan, History Painting and the Battle for "Perspective"', *Studies in History* 22 (2006), pp.97-143.

Plunkett, John, 'Moving Panoramas c. 1800 to 1840: The Spaces of Nineteenth-Century Picture-Going', *19: Interdisciplinary Studies in the Long Nineteenth Century* 17 (2013) found at https//doi.org/10.16995/ntn.674.
Putter, Michael, 'A Very Naïve and Completely New Manner: Pieneman, History Painting and the Exhibitions of the Battle of Waterloo', *Rijksmuseum Bulletin* 63 (2015), pp.196-227.

Ramsey, Neil, 'Horrid Scenes and Marvellous Sights: The Citizen-Soldier and Sir Robert Ker Porter's Spectacle of War', *Romanticism on the Net* 46 (2007) at https://www.erudit.org/en/journals/ron/2007-n46-ron1782/016132ar/.
Robichon, François, 'Emotion et sentiment des les panoramas militaire après 1870', *Revue Suisse d'art et d'archéologie* 42 (1985), pp.281-87.

Seaton, A. V., 'War and Thanatourism: Waterloo, 1815-1914', *Annals of Tourism Research* 26 (1999), pp.130-58.
Siegfried, Susan, 'Naked History: The Rhetoric of Military Painting in Post-revolutionary France', *The Art Bulletin* 75 (1993), pp.235-58.
Stevenson, Richard, 'The Cavalry College at Richmond', *Soldiers of the Queen* 145 (2011), pp.18-24.

Theses

Attridge, Stephen, 'The Soldier in Late Victorian Society: Images and Ambiguities', Unpub. Ph.D., Warwick, 1993.

Hornstein, Katie, 'Episodes in Political Illusion: The Proliferation of War Imagery in France, 1804-56', Unpub. PhD, Michigan, 2010.

Milkes, Elisa, 'A Battle's Legacy: Waterloo in Nineteenth Century Britain', Unpub. PhD, Yale, 2002.

Nott, Dorothy, 'Reframing War: British Military Painting, 1854-1918', Unpub. Ph.D., York, 2015,

Reynolds, Luke, 'Who Owned Waterloo? Wellington's Veterans and the Battle for Relevance', Unpub. PhD, CUNY, 2019.

Index

Entries in Bold refer to illustrations

Battles and Sieges

British and Imperial Military Units

French Military Units

Wars and Campaigns

BOOKS IN THIS SERIES: